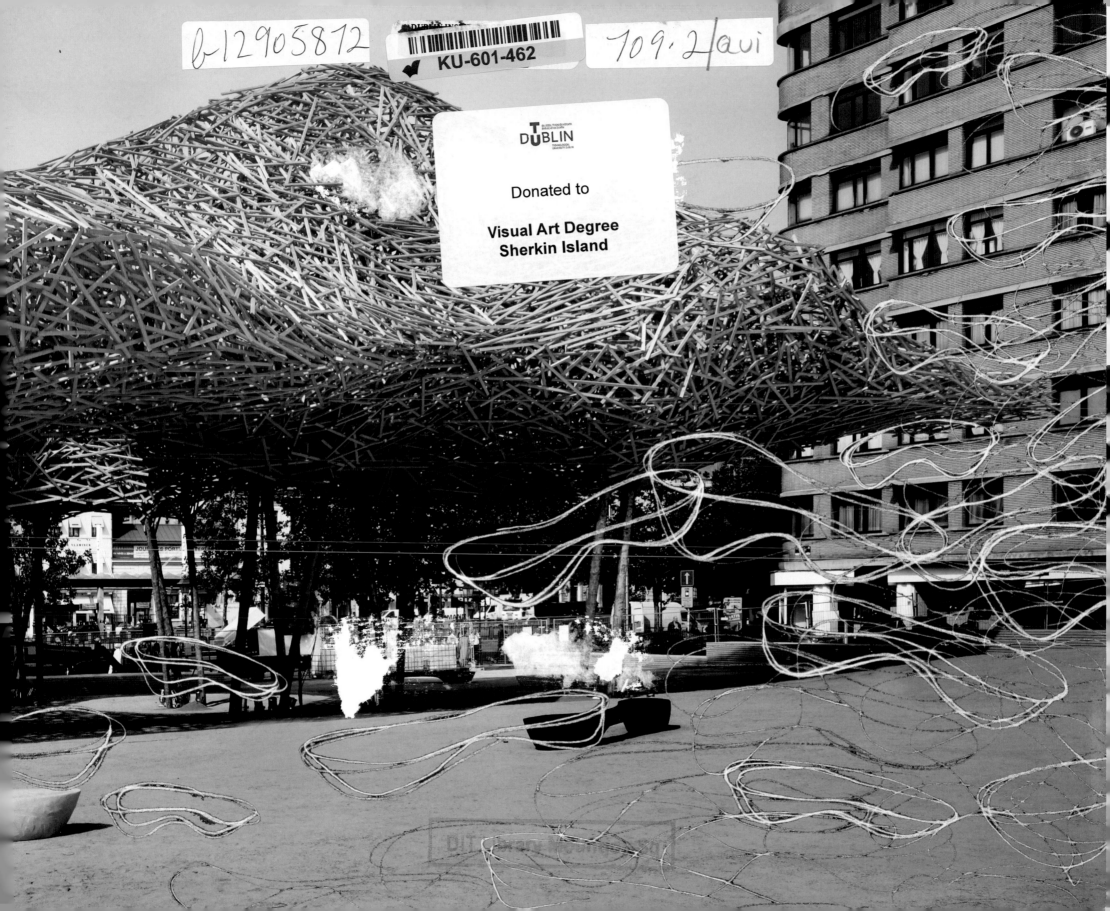

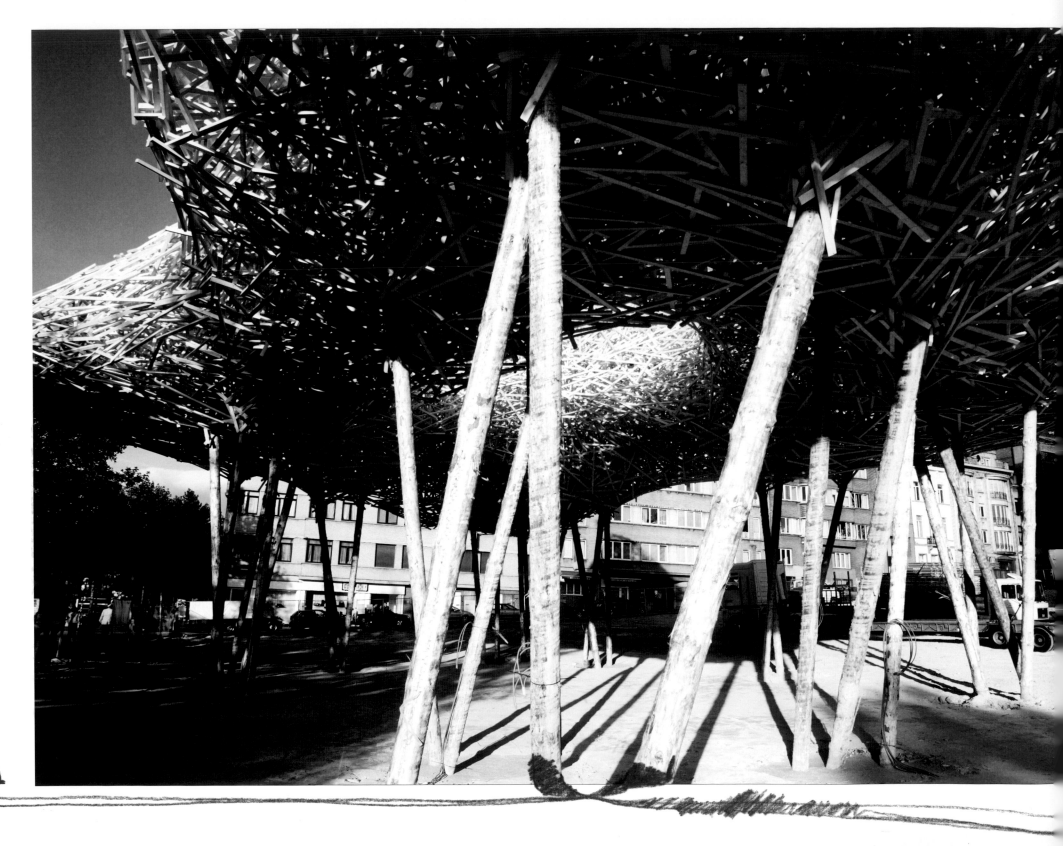

LPTURE

A sculpture, a rupture, capturing a form in full development, a catalyser catching speed, incarnating instantaneity, criss-cross crystalising, connecting into a crown of thorns, a controlled chaos, carefully calculated, challenging, provoking a smile and communication, changing from edgy to curvy, curing a cancer,creating a place for contemplation and silence, opening a hole in time and a gateway to a new dimension, rising from nothing, a wasteland, a Zen garden, a battlefield, interactive, and part of a wider social initiative, inserting something new into the well-known software, intuitive, improvised and randomly latticed, and growing, growing, growing into a nest, a wood, a manta ray, massive, matchstick, amazing, a magnet, a manifesto, a masterplan for the next generation, making the impossible possible, a message, a mountain, a raised middle finger, mutating mushrooms, an endless flow of energy and a startled flock of starlings, a fragmentation bomb, a frozen movement becoming momentum becoming monument, an ever-changing play of light and shadow, a wild Morse and teamwork taming the beast, pinning down 60 kilometres of wooden beams, a straw hat, dazzling, radical, utopian and visionary, pleading for a new community, structured like a self-supporting and reliable organic network, outrageous, a revelation of the sublime, a simple drawing, large-scale, pushing boundaries, embracing, trailblazing, a quiet dream, a quick one, a quintessential Quinze, a temple, a temporary forest, a termite hill, tempting gravity, a getaway, gigantic, dynamic, organic, heroic, the end of an endless saga and a new beginning. This and much more is Cityscape.

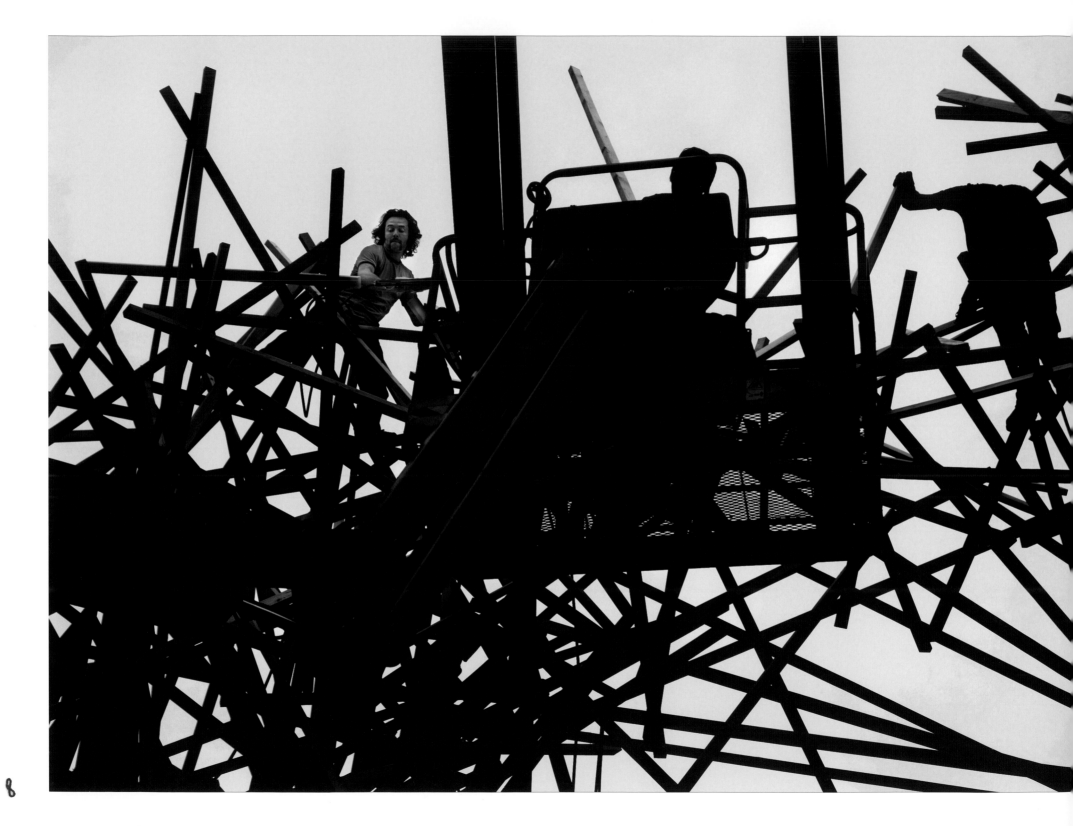

FREEZE

LEAVING MY TAG

I love chaos. Cityscape had to freeze one of these sublime moments when the logic of chaos, the only thing that is real, reveals its incomparable beauty and harmony. While evoking and capturing the frenzied speed of passing traffic and city life, it became the complete opposite – a place of contemplation and silence.

ARNE QUINZE

9

When I was asked to build one of my large wooden sculptures in Brussels, I faced a dilemma. I had just drawn a Cityscape for a top location in Berlin – near the Brandenburg Gate – and it had to be either Berlin or Brussels. I ended up following my heart. I spent a large part of my youth in Brussels, including six months as a homeless fifteen year-old who kept his head above water by stealing food and turning graffiti into a mission. Twenty years passed before I was finally offered a chance to intervene in the Brussels cityscape again, albeit from a slightly different perspective. I've always had a great passion for this city. So it was an offer I simply couldn't refuse, all the more because it provided me with a new mission: in spite of its status as the capital of Europe, this city exhales catastrophe, being one of the few metropolises on this continent where modernisation barely has any grip – and where it does, it's certainly not for the better.

A MASTERPLAN

Cityscape has to breathe new life into a 6,600 square metre wasteland, the immediate neighbourhood, and the uptown area of Brussels, this beeing the original intention of its initiators. However, I hope it will also be a catalyser for Brussels in general, a city that has been dozing for more than half a century. I wanted to provide the kick-start to a project that would lift Brussels to another dimension. In the long run, I even hope to find partners to help me draw up a masterplan for Brussels – something, for want of ambition, it still doesn't have. We owe this to our children, the next generation, and there's so much talent living in this city.

CRISS-CROSS

Just like Cityscape, this masterplan will have chaos as its mainspring. I've always been an ardent defender of chaos. It's the driving force behind all my work. Because my future sculptures will constantly grow bigger and more complex, Cityscape was the first to be linked to a stability study, as well as being based on a vast number of drawings and a series of strategies and procedures that had to be followed. But these only served to determine the framework within which we were allowed to improvise. The way in which the wooden slats –

equivalent in total length to more than 60 kilometres – were criss-crossed, connected and pinned down by some 240,000 nails to form Cityscape was largely a matter of intuition. One hardly had any overview while working high up amongst that unruly jumble, supported on 12 metre-high stilts.

MUTATING

Cityscape is not just one single sculpture. It is the end result of a series of sculptures that succeeded each other in the short and intense period during which it was built – sculptures that faded and melted into each other, mutated from deconstructive to organic, and from edgy to curvy, until the last slats where nailed together and the final form was generated. Because of this continuous transformation, and the experience shared by the team members, the creation process was just as important to us as the final outcome.

A FROZEN MOVEMENT

It also explains why we wanted a book that would give others the opportunity to enjoy the many sculptures that preceded the final one, which I like to describe as a frozen movement, a shape in full development and a work in progress that was brought to a halt at a well-considered moment. It was a moment in which the controlled chaos of Cityscape suddenly revealed its hidden logic to the outside world. Chaos, whilst keeping its discordant character, also became its opposite, sublime harmony.

LIQUID LOGIC

This liquid logic is much more complex, broader and holistic than the rationality to which we usually commit ourselves, for convenience's sake. It is a logic that is profoundly irrational and almost impossible to grasp. But it is also the only true logic. At moments it reveals itself, when elements that appear lost in randomness suddenly synchronise and turn into formations and patterns. There have been several moments like this during the building of Cityscape, when it became a cloud, a wood, or a nest. But the last moment, when we froze the sculpture, was the most harmonious and beautiful one. It was perfect.

A WILD MORSE

Similar wooden sculptures preceded Cityscape – in Cologne, Miami, or in the Black Rock Desert, Nevada during the Burning Man festival. They all had in common the short and long wooden slats and the wild Morse code made by nail guns. The final form always looked different, largely as a result of disparities in location and conditions. In Brussels, Cityscape was built on a wasteland alongside the Avenue de la Toison d'Or/Guldenvlieslaan that forms part of the busy ring road around the city centre – a fact that was of decisive importance.

A DAREDEVIL RHYTHM

I love cars. I love speed. I particularly love car racing. The lines in the corner of your eye left by cars whizzing by are often a personal source of inspiration. To me, they're an expression of freedom. The traditional frame that determines our perception – the classical notions of time and space – seems to evaporate and vanish. All that remains are some elusive traces of pure energy, the essence. Cityscape had to capture the commotion of the hectic traffic surrounding this wasteland, and the city in general. I wanted to catch its speediness by the tail. That's also why Cityscape was executed in record time. Not only was the period between the first idea and the political go-ahead improbably short, in a city where such a project is almost impossible by definition, but also the construction itself took little more than 20 days. I hope this daredevil rhythm and speed will still be tangible for all those who come into contact with Cityscape.

A RUPTURE

I had a dynamic sculpture in mind that would incarnate the instantaneity of that one moment when you shout FREEZE, and bring everything to a standstill. I wanted Cityscape to be a caesura, a hole in time, an eye in the storm, the motionless centre of all permanent movement, a rupture, where the hectic would cease to exist, offering a pause and shelter, a peaceful spot that people can walk in and out of, meet, be silent, contemplate, dream away and recover in. But on the other hand, I also wanted the sculpture to remain in continuous movement. Even when viewed from a distance, the sun creates an

ever-changing play and pattern of light and shadow, giving the whole
structure a quavering, hovering and floating appearance.

A MESSAGE FROM THE FUTURE

Cityscape wants to be more than just another sculpture. I call it
a sculpture of sharing, not only because of the team spirit out of which
it was born, but also because it's meant as a communication tool,
a medium and magnet, a place that neighbours and travellers feel
irresistibly attracted to – and meet in. Its size – 40 by 20 metres on the
ground and reaching peaks of 18 metres – makes it impossible to ignore.
It commands respect but is also very open and accessible. I'm already
more than satisfied when it elicits a smile from those confronted by it –
although I secretly hope that some might also look a bit further.
Because this sculpture can also be seen as a message from the future:
its method of construction is an allegory of a society in which people
live in harmonious chaos.

A PERFECT SPONSOR

This project would have been unthinkable without the support of MINI,
which seized the opportunity to organise a worldwide launch of the
MINI Clubman at the opening. I couldn't have dreamt of a better
sponsor, not leastly because of the enthusiasm, collaborative spirit,
modesty and openness of this company. Ever since the first MINI
appeared on the market, it has dramatically changed and rejuvenated
the urban landscape. The brand stands for a strong combination of
communication, speed and design. It's also impossible not to smile when
you see a MINI. These are all qualities I wanted Cityscape to have.
So Cityscape can certainly also be seen as a tribute to its sponsor's
achievements.

NEW ZEST

Other partners also made this project possible: the Brussels Capital
Region and its government, and in particular the Minister of Economy
and Employment, Benoît Cerexhe, who was not only a fan of the project
from the outset, but also became a good friend as it neared completion.
Then there is the Commune of Ixelles/Elsene, upon whose territory

Cityscape was built, the real estate agency ProWinko, which put the
land at our disposal in anticipation of a more permanent project, and the
association Brussels Louise, recently founded to give new zest to a
somewhat neglected neighbourhood and for whom Cityscape became a
maiden project. The role of Patrick Grauwels as an initiator was also of
decisive importance.

A HARD ROCK BAND

Last but not least, there are the people of Quinze & Milan, and
especially the team who built Cityscape helped by a list of partners too
long to mention. I still have this habit of comparing Quinze & Milan to a
hard rock band with a front man or singer who is of little value if not
surrounded by musicians who instinctively know how and when to
anticipate. But with a company that grew to more than 60 employees
and workers, it's probably better to use the image of a symphony
orchestra.

A SOCIETY MODEL

I have been fortunate to be able to call upon the services of many
experts across a diverse range of disciplines – from architecture and
graphic design, to carpentry. To these, I only have to give a very rough
outline of a score and then I can conduct and trust them almost blindly.
The result is a perfect symbiosis, a synergy and ensemble in which each
member of the orchestra, including myself, merges into a larger whole.
In that sense, even the making of Cityscape is nothing more than a
reflection of the harmonious chaos I'd like to propagate as a model of
future society.

Like I did so many times in past decades in the streets and tunnels of
Brussels, I've once more left my tag. It could be seen as strictly
personal. But it also stands for the project's architect, Fré Van Dooren,
his team, and so many others.

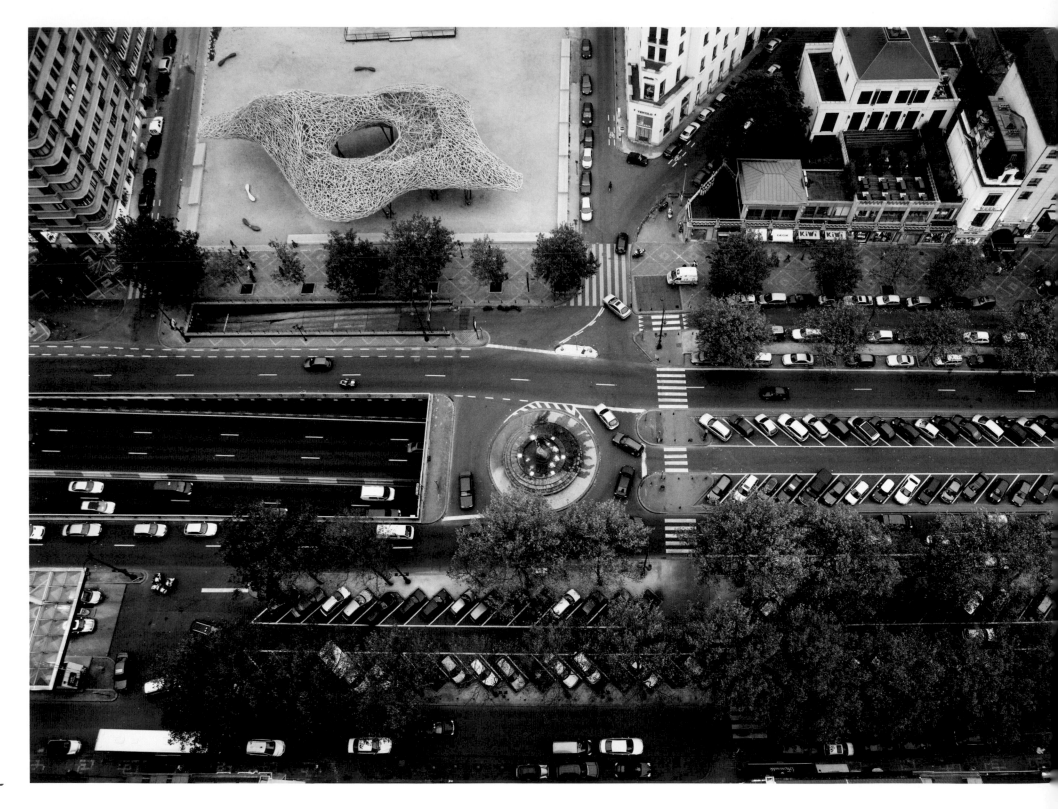

12

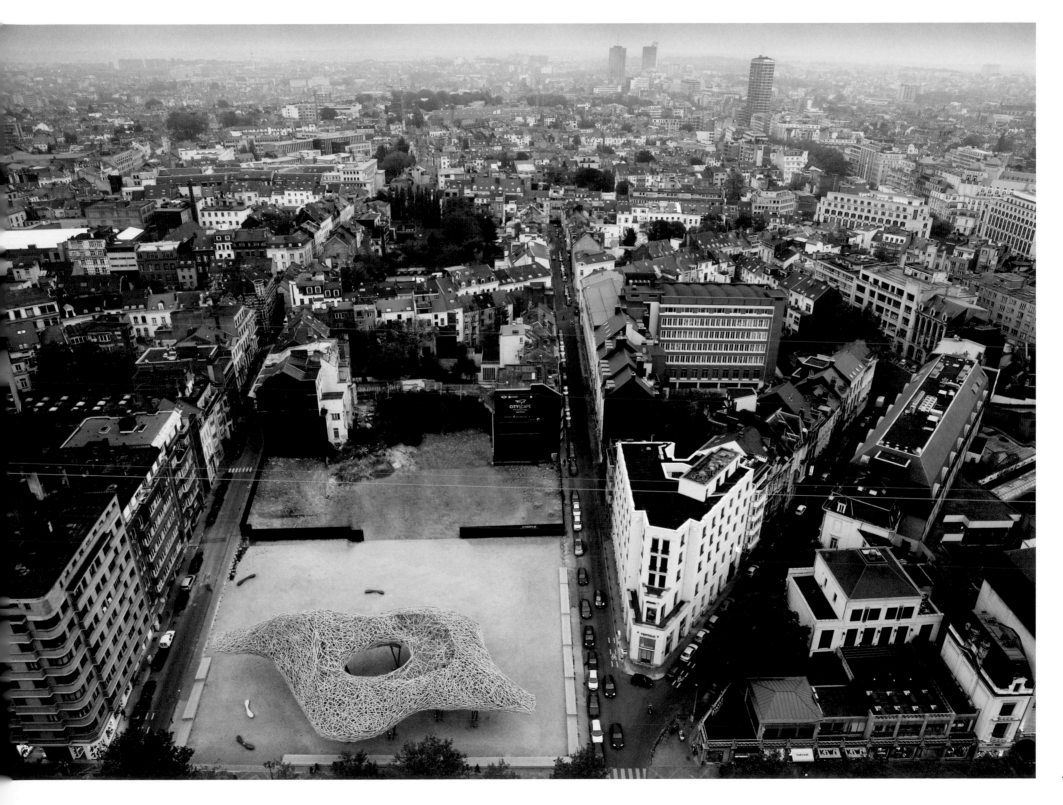

13

14

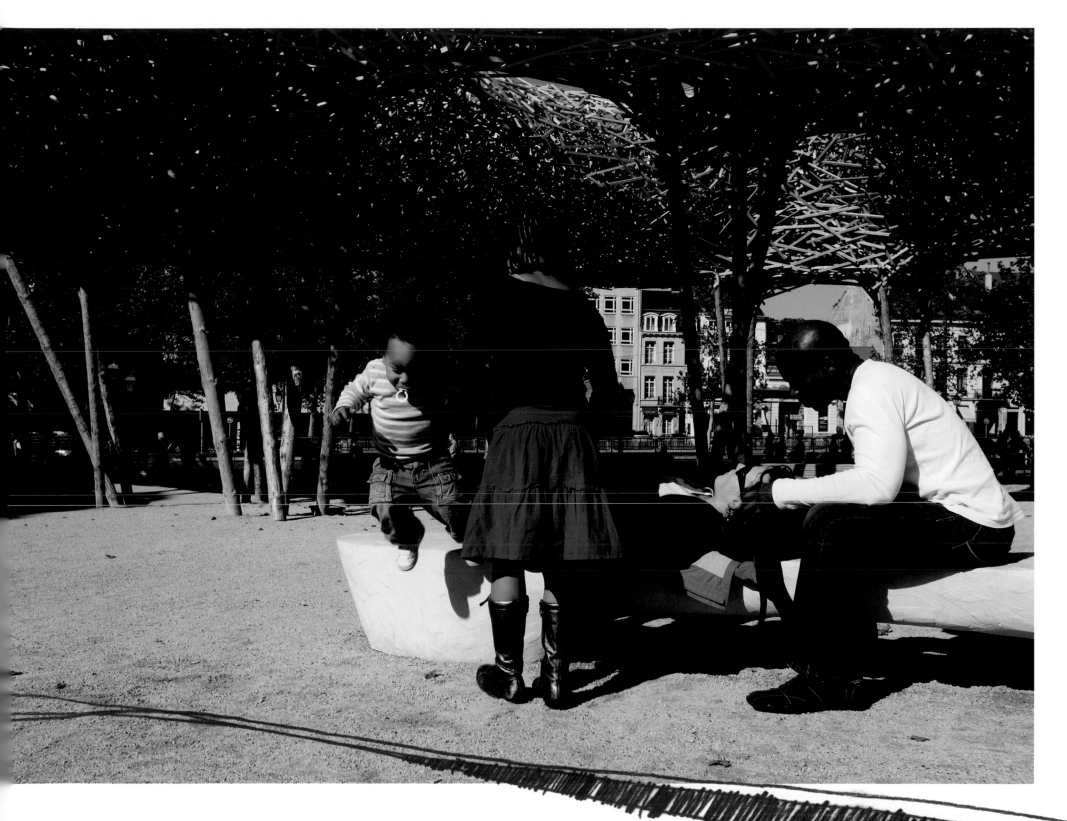

16

A QUICK ONE

INTO THE LIQUID LOGIC

Cityscape is not just one sculpture. Before the work in progress was frozen in a final shape, there was a constant flow of sculptures, merging into one another. Frantically built and composed of thousands of fragments, it is also meant as an effort to do away with our everyday rationality and our conventional frames of perception, an attempt to bring us back to the heart of the matter.

MAX BORKA

A passion for speed and racing cars, a belief in chaos as the ultimate driving force, an almost megalomaniac urge to go big, a constant desire to push borders and to go where nobody else has ventured before – what do these have in common? In the case of Arne Quinze, it is a craving for the moment when conventional frames of perception – time and space as we know them – start to break up and fall into pieces, or blur, implode, dissolve and vanish. It is the moment when structure turns into rupture and things explode into a myriad of fragments, revealing the true essence of the matter of which they're composed and which we mostly prefer to ignore: an endless flow of energy beyond our control. It explains Quinze's personality: "I am an erupting volcano." It also explains his work, born out of a desire to make this energy visible and palpable.

BIG & SPEEDY

Would I like to write a book about a giant sculpture he'll start to build in Brussels – asks Arne when he calls me, out of the blue, late afternoon on July 31 – and could I come to the Brussels Hilton the next morning. I'm hardly given any time to reflect. Speed is one of Arne's middle names, Big being the other. This is once again confirmed when I hurry out of the elevator on the top floor of the Hilton the very next morning, on my way to what I think will be a private meeting with Arne on an umpteenth Brussels project that will take years of negotiation. I end up in a press conference presided by the highest local authority, Minister-President of the Brussels Capital Region Charles Picqué, who proudly announces that the building of Cityscape will commence the very next day on a wasteland at the other side of the ring road, opposite the hotel, where Arne will have his temporary headquarters in Suite 2005. Just on principle, the sculpture has to be higher than the one Arne built last year in the Black Rock Desert, Nevada, which brought him instant fame. With the opening foreseen in mid-September, Cityscape will also be completed in record time.

CURING A CANCER

Big and speedy – all the quintessential Quinze characteristics are there. His fascination for speed even contaminated the local authorities. The project was ratified in less than two months, while building permission was delivered in less than 48 hours – again an absolute record in a city where little seems to be possible. "The sculpture will remind us to forget," says Charles Picqué – referring to the unsavoury history of the wasteland, described by his colleague Benoît Cerexhe as 'a cancer' and to 'the endless saga' of real estate projects to transform the site over the last decade, only to be contested and rejected one after the other, turning the location into a battlefield of great symbolic value. As part of a city marketing project, Cityscape would not only upgrade this strategic site, halfway between the two city gates that connect the ring road to the Louise area, but also boost the somewhat degraded uptown area itself. Last but not least, it was also meant to herald in a wind of change in Brussels' urban policy, with changing priorities and new and different criteria, such as creativity and quality.

WILD URBANISM

No other European metropolis is more fragmented than Brussels. Belgium, the country of which it is capital, is a no man's land shared by two communities that are totally different in spirit – the Flemish and Walloon – forced into a marriage that is close to divorce. Brussels, a no man's land in the middle of this no man's land, belongs to both communities but also to none, and as a result was largely left to its own devices. It became a plaything in the hands of speculators and property developers, whilst the largest part of the Belgian population lived with its back to the capital. This resulted in such rampant demolition that Brusselisation became a synonym for wild urbanism and a city that destroys itself in peacetime.

A FRAGMENTATION BOMB

Its status as the capital of Europe also turned Brussels into a magnet for immigrants. No other European city can pride itself in housing so many nationalities and cultures. Also because of the lack of something like a Belgian identity, each of these cultures holds onto its own identity, with none holding an absolute majority, not even the Walloons or the Flemish. And while every other European metropolis has transformed its centre into a kind of Disneyland, evicting poor immigrants to the suburbs, in Brussels these immigrants established themselves in the centre, a crater that renders its multicultural character and fragmentation bomb-syndrome highly visible. It gives Brussels a character of its own, shocking to some, painful for others, but extremely attractive to those who are looking for what's new, different and rebellious.

EXORCISING

With his Cityscape, Quinze tried to capture the fragmented structure of the Brussels metropolis, and more specifically, the hectic traffic of the adjacent ring road. It was also an act of exorcising, showing how all this Sound and Fury – which is also at the heart of our human condition – could be turned into something harmonious and peaceful, silent even, while keeping its chaotic identity. His material: countless wooden slats that were nailed to each other at a staggering speed in a tangle that kept revealing new figures and patterns. Until the moment when the last slats were pinned together and the surrounding wasteland was turned into a slightly undulating landscape, covered with shiny, white dolomite.

A DECONSTRUCTIVE MANIFESTO

This publication is meant to be much more than a book on Cityscape. In many ways, it is Cityscape. The images it contains are the only remnants of the many forms the sculpture took during the three weeks in which it was built, before it found its final form – growing from bare, angular, jagged, and chaotic, to organic, full, and harmonious. While at a certain point – and despite its city marketing mission – it could certainly also be considered to be 'a deconstructive manifesto', showing a middle finger to what is still considered to be Belgium's most stylish and smartest shopping neighbourhood, the artwork successively mutated from something that resembled a field of gallows into a giant crown of thorns, a nest, a cloud or a shuttle, to end up with a final form that closely resembles a manta ray, not accidentally the largest, but also the most elegant fish ever seen.

A TERMITE HILL

The marvellous pictures by Thierry van Dort and Lionel Samain, the two photographers who closely followed the project from the very beginning, also show how the sculpture came to resemble more and more a termite hill on stilts, as team members kept pinning down the long and short slats in a frantic and risky rhythm. Like birds building a nest, a wooden lattice, criss-crossed, and with little overview once they were up there, they intuitively and flawlessly improvised, as if driven by a collective subconscious. This alone turned Cityscape into a beautiful metaphor during the creation process: for while the insects remain frail and insignificant on their own, together they form a formidable army. Its seemingly chaotic movements and manoeuvres prove to be of incredible beauty and efficiency, creating continuously changing formations, patterns and networks that are unyielding and meaningful.

A FLOCK OF STARLINGS

The final result also has the astounding precision of a startled flock of starlings, that hangs still in the air, just for one moment, in perfect formation, before dissolving in a seemingly chaotic pattern, but without touching each other, in perfect control. It is a moment in which the DNA of disorder reveals its order. Elements or particles that seemed to be organized at random suddenly synchronise and combine into a revelation of the sublime.

A TEMPLE

Whilst aiming to build the tallest and fastest, Quinze also wanted his Cityscape to be 'a frozen movement' – bringing it to a halt at the very moment and momentum in which it would reach this state of harmonious chaos. 'Incarnating instantaneity' it was also meant to create a 'silent place' and 'temple' where the visitor would be able to contemplate and recover. This may sound paradoxical, but it isn't. Size and speed, extreme fragmentation and acceleration, were the weapons in his attack on classical notions and perceptions of time and space, creating 'a hole in time'. And although it may be hard to believe because the sculpture is adjacent to an extremely busy ring road, he succeeded.

A GATEWAY

Walking in and out of Cityscape, the visitor is constantly confronted with other perspectives: the countless wooden slats keep vibrating with energy, they change colour because of the play of light. But the overall atmosphere is calm and Eastern, not unlike a Zen garden, an open invitation to meditate or muse on one of the benches that Quinze specially designed for the occasion, or to gaze through the hole in that massive canopy and let your daily troubles evaporate. A gateway to another dimension, where chaos and order, movement and momentum have been interwoven, a universe ruled by a liquid logic that does away with our classic notions of time and space and goes far beyond the rational, by being much more holistic.

QUANTUM

In today's science, Liquid Logic stands for a way of thinking that is totally ambivalent, uniting all that is fundamentally opposite in one and the same entity, such as chaos and harmony. Linked to recent quantum computer developments, it is also considered by many to be the future's only possible philosophy. "We live in the Age of The Global Net, whether or not we are inclined to accept it," writes Georg Flachbart in *Mind 21, the Mind of the Nets*. "A net is a mixed reality environment, dominated by Liquid Logic, a place which is nowhere in particular but everywhere at once; a space which is fundamentally and profoundly anti-spatial. Our relation to this liana-like world connection – the globality – is in many respects the same as it was once to the forest: irrational." While building his Cityscape, Arne Quinze created a forest and web that offered a perfect illustration of Flachbart's argumentation.

A HEALTHY FUNGUS

While Quinze has created similar sculptures elsewhere in the recent past, such as Cologne, Miami and Black Rock – the splintered com-position of Brussels turned it into the perfect location to demonstrate the power of a harmonious chaos. Starting from a wasteland – already a perfect symbol for Brussels – Quinze made a cancer grow into a healthy fungus, a couple of mutating mushrooms, that were also meant to house a whole series of events, re-activating the neighbourhood.

A RAISED MIDDLE FINGER

In doing so, he also wanted Cityscape to be the first step in a process that might even lead to a new masterplan for a city that has been drowsing for more than half a century, in order to raise it to a new dimension. Unlike so many other masterplans, the nature and spirit of the masterplan Quinze is dreaming of might already be indicated by the fact that Cityscape is only temporary, and its footprint will soon be erased. When, one year after its opening, the sculpture is broken down to make room for a permanent real estate project and the wood recycled down to the very last slat, this book will be the only palpable thing remaining from this flamboyant, megalomaniac and equally elusive and humble platform, a memory of a grand gesture, an embrace, a challenge and provocation, a raised middle finger, but also a plea or a smile, fragile and brief, like a lover's drawing on a beach. A quick one.

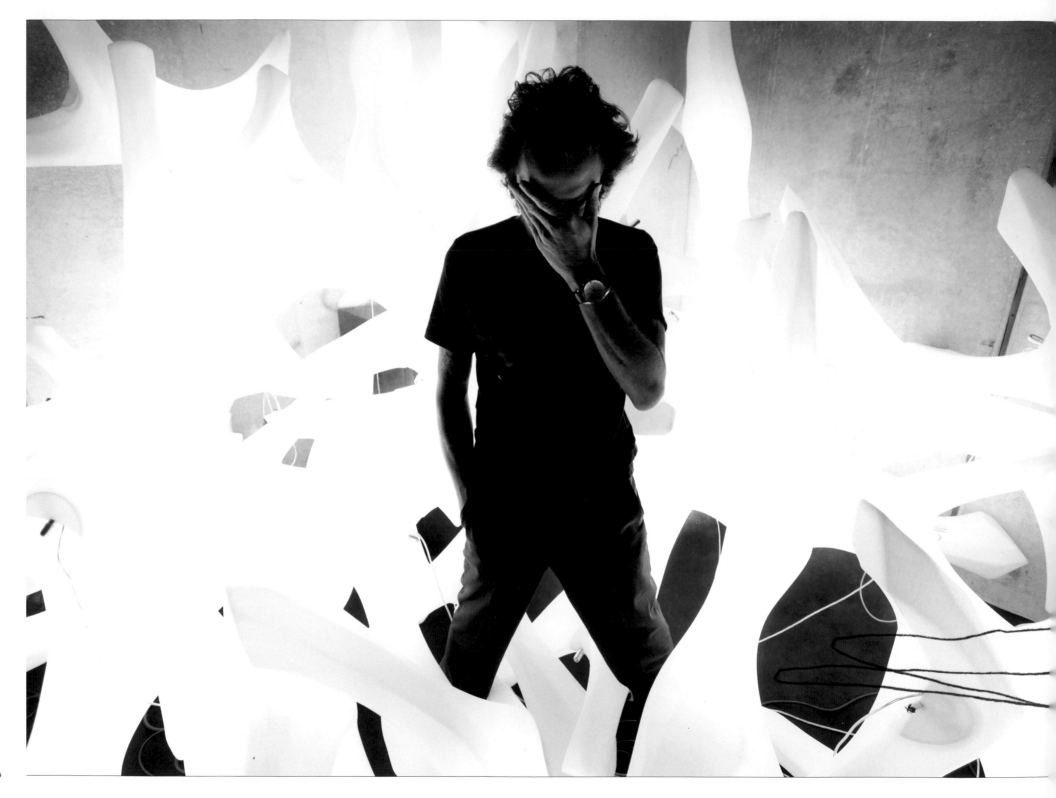

20

THE QUINTESSENTIAL QUINZE

ARE YOU EXPERIENCED?

His ambitions are too big to categorise as art or design. And besides, he loves to push boundaries, go for extremes, to attempt the impossible, to create a universe filled with Stilthouses, Skytracers and Dreamsavers. Are you prepared? Then get ready for the Quintessential Arne Quinze: unbridled, wild, impetuous, rash, fast, chaotic and impossible to grasp.

MAX BORKA

He's a drifter. Much of his time is spent at his new headquarters in Kortrijk, a quiet provincial town in Belgium that also doubles as a capital for the international design world when it hosts the design biennial Interieur. But he's also on the move for at least a hundred days a year, all over the world, scanning for new vibrations and tremors – like a seismograph – on trips that are his main source of inspiration. This wandering spirit might also explain why he keeps on repeating the story about his nomadic youth in interviews, as if it was the primal experience that dictates the alpha and omega of his work. How he left home at fifteen and roamed the streets of Brussels for six months. How he had to steal his food. How he kept himself afloat by painting graffiti. How he travelled all over Europe for the next two years with a motorcycle gang and left his tag on thousands of trains, walls and bridges. How he learned then and there what it means to have something worth fighting for. How he realised that this something is creativity. How he also kept a healthy dose of arrogance and perseverance from that time, allowing him to clear every obstacle in his path and get things done that others see as impossible. And how this was a key to his later work. Even when he had traded the two-dimensional for the three-dimensional, he remained the same – a wanderer with an unstoppable urge to leave his tag, over and over again, as if to prove his very existence.

CROSSOVERS

An obsession with obstacles and borders largely determines his vast and rapidly growing body of work. Next to paintings, ceramics, sculpture, installations and other artworks, it comprises almost the entire furniture collection of Quinze & Milan and designs for other furniture companies, such as Dark and Moroso, footwear, an Experience Truck, architecture and urban planning. Its force and uniqueness stem, to a great extent, from the effortless way in which he succeeds in combining different disciplines, hopping from one to the other, playing them off against each other, constantly generating crossovers that make these disciplines mutate and merge into something that is unique and entirely his own, the Quinze universe.

GALACTIC

All that became very clear in his first major solo exhibition, Mutagenesis, a 4,000 square metre show he built in September 2007 as a guest of honour at the prestigious Italian furniture fair Abitare Il Tempo in Verona, just a few days after the opening of the Brussels Cityscape. As well as furniture and lighting, the exhibition included his videos of Cityscape plus models of residences and the Galactic Transporter, a giant variant of Cityscape, three floors high that would be able to take visitors on a trip through time. It was a most unusual blend, especially by the standards of a furniture event.

PREHISTORIC

Whilst trying to offer a glimpse of the "myriad of mutagens" that will transform the DNA of the future, Mutagenesis also majestically unfolded Quinze's passion for cars, speed, travelling and transporters. Next to his Experience Truck and as an alternative to a Lamborghini was his Magna, a gigantic, shiny sculpture, somewhat resembling a prehistoric serpent's head, but at the same time an early prototype of the "the super car of the future". In Quinze's imagination this car would no longer need any wheels and would consist of "a jet engine propelled by the magnetic field surrounding it". It would be "the most beautiful, most elegant, most primal of animals, and a burst of energy that cleaves skies in two as she navigates through space". An abstract sculpture that can be appreciated for what it shows, without further explanation, but which is also meant to be a model of a design object. Such is the quintessential Quinze approach – crossing boundaries.

FUTURISTIC

Other pieces in Mutagenesis included the Skytracer, slick, perfectly polished, and again a model of a futuristic transporter ("Streamlined like an aquatic organism, and propelled by gravity, its friction with the atmosphere and the push and pull of other matter in its vicinity") and a herd of colourful Walking Lighthouses: "Nomads of the future, extracting all the energy they can – from wind, water, sun or frequencies – to satisfy their own requirements as well as the needs of

their inhabitants, treading carefully as they relocate in their search for an ideal biotope". Homeless homes.

ORGANIC

Last but not least, and scattered over the exhibition space, were his Stilthouses: hut-like constructions on stilts, wildly hammered with wreckage, half completed, and painted in primary colours, an ominous black or a shrieking red. Although these sculptures could also be read as models for the housing of the future, the contrast with the shiny and organic transporters was extreme. High-tech versus primitive, futurism versus atavism, organic versus deconstructive, rational versus irrational, shiny versus rough – as if the Mad Max crew had invaded the set of A Space Odyssey.

TIME BOMB

Somehow linked to this confronting, combining, and merging of extremes – as in his Magna, the car of the future, but also a prehistoric serpent – Arne Quinze cites some other clues to the essence of his oeuvre, or the Quintessential Quinze. His love of chaos – which he describes as his main driving force – is but one. His aversion to walls is another. One of the models of a Stilthouse bears the inscription: "Men created God / God made people fear / Fear made people buy weapons / People build walls to protect against weapons / Walls equal fear equal madness". To build walls is usually considered the main occupation of architects. But Quinze builds to eliminate. Some of his sculptures are even equipped with a self-destructing time bomb. His Brussels Cityscape will be demolished and recycled, down to the very last wooden slat. Its predecessor, Uchronia, a 15-metre-high cathedral, also a criss-cross latticework of wooden slats, which he built in collaboration with the Belgian radiator manufacturer Jaga in Black Rock Desert, Nevada, was set on fire as a climax.

TIME MACHINE

Uchronia rhymes with Utopia, and when describing his team as "a multifaceted fellowship that is out to conquer the universe with a unique language", the tone of that language must certainly also be

understood as radically utopian. The self-concocted name Uchronia literally stands for a hole in time, a place where the classical notion of time ceases to exist, a gateway to another dimension and a time machine that offers a view on what is to come: a society and an economy that is not to be ruled by mathematical profit margins only, and gives priority to creativity, tolerance, innovation and flexibility – a society that structures itself like an organic network, or a harmonious chaos, parallel to the way in which his team built the sculpture. "We simply owe that to the next generation," Quinze explained, as the father of four, when he announced his intention to draw up a masterplan for Brussels while building Cityscape, created in the same spirit as his Uchronia. The plan had to breathe new life into the European capital, a city that has been drowsing for more than half a century.

EMPIRE

So how can such a social and political commitment come to terms with a flamboyant megalomania and an irrepressible tendency for self-glorification? Free from modesty, when asked who his favourite designer is, Quinze first mentions himself, followed by Tom Ford, Giorgio Armani, and Richard Branson: "Because they succeeded in creating an empire of their own." To turn his name into an empire – that also seems to be one of Arne's wet dreams. It sounds like the old dream of the graffitist: tattooing everyone and everything, making it all his own, or just to get noticed.

PORNO STAR

He's been noticed all right. Especially since the images of the burning Uchronia brought him instant fame, even the most respected international media now assign him star status. Not only is he praised as a shooting star, but also as a bit of a porno star, and above all as the pop star of furniture. One journalist even discovered a likeness to Ringo Starr. Others call him the Robin Hood, the pirate, the enfant terrible, or the bad boy of the design world. A bit of punk, but also a bit of Prada, and the leader of a hardcore rock band, while Quinze & Milan, the company which he once co-founded and is at present the art director, is described as the darling among European design groups.

TATTOOS

Many of these epitheton ornans seem to be less inspired by an in-depth analysis of Quinze's work than by details such as his trashy but extremely well-featured windsurfer-on-the-retreat looks – his wind tunnel hairdo and his mutton chop dockworker's style moustache, his T-shirts and windjammers, often embellished with his own portrait and signature, his tattoos that are all over his body, and the asymmetrical sports shoes he designed for the Japanese brand Onitsuka Tiger.

WILD AND SEXY

Arne Quinze not only gladly submits to the hype and controversy aroused by his striking appearance – and his work that is in many ways a reflection and extension of it, be it only because of his preference for smashing and fluo colours in an otherwise pale art and design world – he's also constantly in search of the means to add fuel to the flames. Already in 1999, when Quinze, unhampered by too much training or knowledge ("Hardly any idea who Starck was") launched Quinze & Milan in partnership with Yves Milan, the duo haughtily refuted the word design, calling the design world 'a bore', and opted for the motto 'Creators of Atmosphere' instead. Again, it was a matter of going beyond the limitations of categories. Quinze & Milan were not dealing in furniture. Their business was Experience with a capital E. Likewise, a piece of furniture was never the aim in itself. It was only the medium. It had to smuggle a whole new way of life into the home, which up until then had hardly found its translation in furniture: wild and sexy, loud and blinky, trashy and pop, carefree and fun. It had to amuse and seduce, and so much the better if it also shocked and provoked.

RAISED MIDDLE FINGER

Their first design, Primary Pouf, set the tone immediately. A cube on legs made out of cold foam, it was as simple as the stir it caused. Not only was the one-seater made from a new polyurethane foam with an elastic skin upon which Quinze & Milan had taken out a patent, it could also be seen as a raised middle finger to all that was common in the design world. Like the collections that followed, Primary Pouf still had the clear and tight lines so typical of the ruling minimalism, but the

materials and the trendy, delirious colours used by Quinze & Milan heralded in a new generation. One year after the launch of Primary Pouf, the company was already crowned in three categories of the prestigious Belgian Henry Van de Velde awards.

KOOLHAAS

The proverbial sky had been the limit from the very beginning. Not even the lack of investors or budget could prevent Quinze & Milan from starting its own factory, in which it produced its patented foam. What followed was a story of ups and downs, growing success and debts that grew proportionally. Change only came in 2003, when a young businessman, Tom De Gres, gathered a group of investors around Quinze & Milan – that was continued without Yves Milan. One year later, an order was made for seating in one of the most talked about buildings of the past decennium, Rem Koolhaas' Public Library in Seattle. It was the beginning of a collaboration that led to assignments for a series of other notable Koolhaas buildings, such as Casa da Musica in Porto and the Charles and Dee Wyly Theatre in Dallas, Texas. Quinze & Milan was catapulted to the Champions League.

KORTRIJK

Today, the company employs more than 60 people, and recently moved its headquarters to a historic industrial complex in Kortrijk, with a total surface of 10,000 square metres, just a skip and a jump away from the fair complex where the design biennial Interieur takes place. "It is therefore extremely well situated," says Arne Quinze, "The who's who of the international design world will visit us every two years." Boasting a gallery and showroom, its own design studio, workshops and a factory, the headquarters are even unique by international standards.

ASYMMETRICAL

At the world's most prestigious furniture fair, the Salone del Mobile in Milan, Quinze & Milan can count on the privilege of being given one of the very best stands on which to exhibit. Its furniture can be found in some of the world's hippest lobbies and lounges. As the company's

24

art director, Arne still draws most of the collection, while also designing for other companies, such as Dark and Moroso, Italy's leading brand in design furniture. Asymmetrical forms, often inspired by nature, have thereby become his signature. But despite the success, furniture is no longer his main point of interest. "I'm not the kind of designer who can concentrate for days on the form of a chair's legs. I'm much more interested in the project market, and the possibility of creating a global experience. Furniture is only one part of that."

EXPERIENCE LAB

Assignments for interiors – not only private residences, but also shopping malls and hotels – stretch from Nigeria to Norway. The word that links most of them is pleasure. Quinze designed a houseboat ("as if it was a holiday") and created quite a stir with the refurbishment of Villa Tinto, a brothel with 51 suites in Antwerp, clad from top to bottom in sultry red. For the Belgian radiator company Jaga, he designed Experience Lab, and later the Experience Truck, with a VIP lounge inside, fitted out in immaculate and seamless white leather, magically lit by 182 tiny asymmetrical windows and computer-generated colours.

SKETCHES

He never uses the computer himself, except for some Googling and e-mails. His drawings are still by hand, little more than sketches, rough and fast. But back in his studio in Kortrijk, his team is waiting. Architects, urbanists, product and graphic designers, artists or carpenters: "They do the rest". The activities of the studio cover not just interior architecture. Up until now, its greatest achievement in product design is the basketball classic, redesigned for the Japanese sneaker manufacturer Onitsuka Tiger, asymmetrical and with a sole that leaves tracks on soft ground. But new projects include rethinking entire brands, down to the smallest detail, including the personnel's attire or even working hours. "It's only the beginning," says Arne. One of the things he's dreaming of most is to be able to design a complete new city – where the traffic would be automated and oceans and rivers could be exploited as "the new real estate". "Expect the unexpected", he adds.

GALLERY

The factory at his Kortrijk headquarters comprises a carpentry atelier, a workshop specialising in furniture coating, and a department that produces handmade sculptures in fibreglass and polyurethane. But above all he sees his company as "a factory of ideas and experiences". Next to a selection of Arne's artworks, the 1,500 square metre gallery cum showroom, Gallery 113, also highlights the Quinze & Milan and Moroso collections – in a unique blend of art and design. The emphasis of the collections lies on furniture that is tailor-made for the project market. "Moroso is also an ideal partner from that perspective", says Quinze, "because of their unmatched craftsmanship in upholstery. And I love Patrizia Moroso's unbridled energy."

CLASH

Energy! That might well be one of the common denominators we were looking for, the missing link between all the above mentioned characteristics that make the Quintessential Quinze: his love of speed, chaos, the asymmetrical, Patrizia Moroso, and the unexpected. His tattoos, his flamboyant megalomania, this urge to go for big-bigger-biggest and the impossible, his desire for an empire of his own, and this longing for a society that structures itself like an organic network, or an harmonious chaos, his aversion to walls, his Walking Lighthouses, his Skytracer, his wandering spirit, his pushing of the boundaries in which art becomes design becomes architecture becomes urbanism, and last but not least, his capacity to make extremes clash and merge.

SEISMOGRAPH

Reading the above list of characteristics, one might conclude that the Quintessential Quinze must be little more than a bundle of contradictions. It is, but then again, aren't we all? And isn't the world which Quinze sees as his research laboratory? Scanning the globe, like a seismograph, he does little more than catch the vibrations that predict the future, but have remained unnoticed to others. In doing so, he proves to be extremely sensible: "I approach life with an open mind but at the same time with the reservations of a scientist. Behind every

story, I tend to suspect another hidden story, a censored story that cannot see the light of day for one reason or another. I also suspect and believe there are energies that do not take a physical form, but nevertheless exert much influence in our lives and humanity. I believe in other life forms in the universe. I think UFOs are factual rather than science fiction. Much of my inspiration comes from so-called fantastic literature. For me, Moebius, for instance, is not so much an epic from a parallel – non-existing – world, but rather part of reality."

MIND-BLOWING

"Energies that do not take a physical form…" The wildness and impetuousness of the energies that do take a physical form – be it a table, car, or newspaper – are mostly ignored by us as such, because they are too complex, mind-blowing and threatening. And taking another look at the list above, one might detect that Quinze's work consists of, to a great extent, in making these energies visible and palpable again, by manipulating and extrapolating the parameters and conventions that allow us to disregard them, by speeding up or freezing time, making the future prehistoric, blowing things up, making them asymmetrical, pushing them to extremes and the impossible and so on. By kicking in and smashing our obsolete doors of perception, time and space, through which we mostly see nothing at all, Quinze tries to reveal and make us experience what all this is really about: energy, unbridled, rash, fast, chaotic and impossible to grasp.

FLAMES

Arne Quinze does not stand for a style, but a state of mind, a philosophy. When starting to build Uchronia, his original sketch was only halfway finished, and halfway through the works he gave the sculpture a totally different direction: "To me it was extremely important that we didn't know where we were going – even when many blew a fuse. Likewise I also enormously enjoyed the fact that the sculpture went up in flames in the end. You sometimes have to burn if you want to go for a change."

Burn, Arne, Burn.

26

skytracer, mutagenesis, Abitare il tempo
VERONA 2007

27

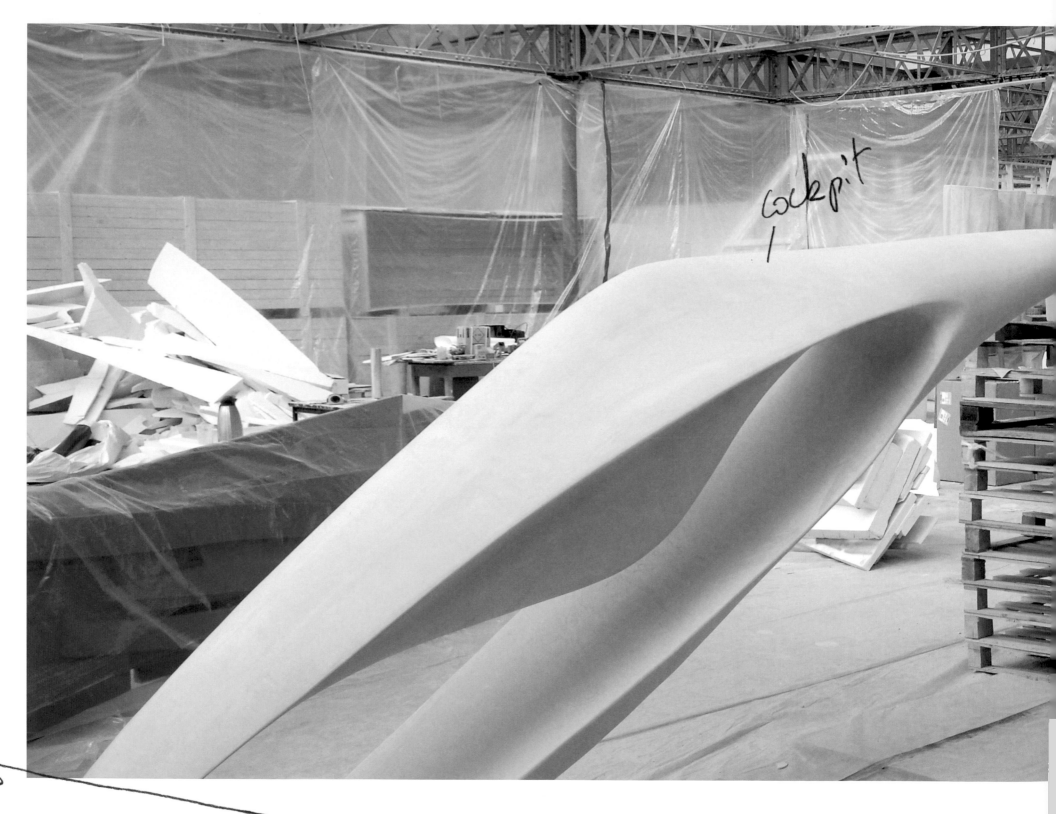

cockpit

28

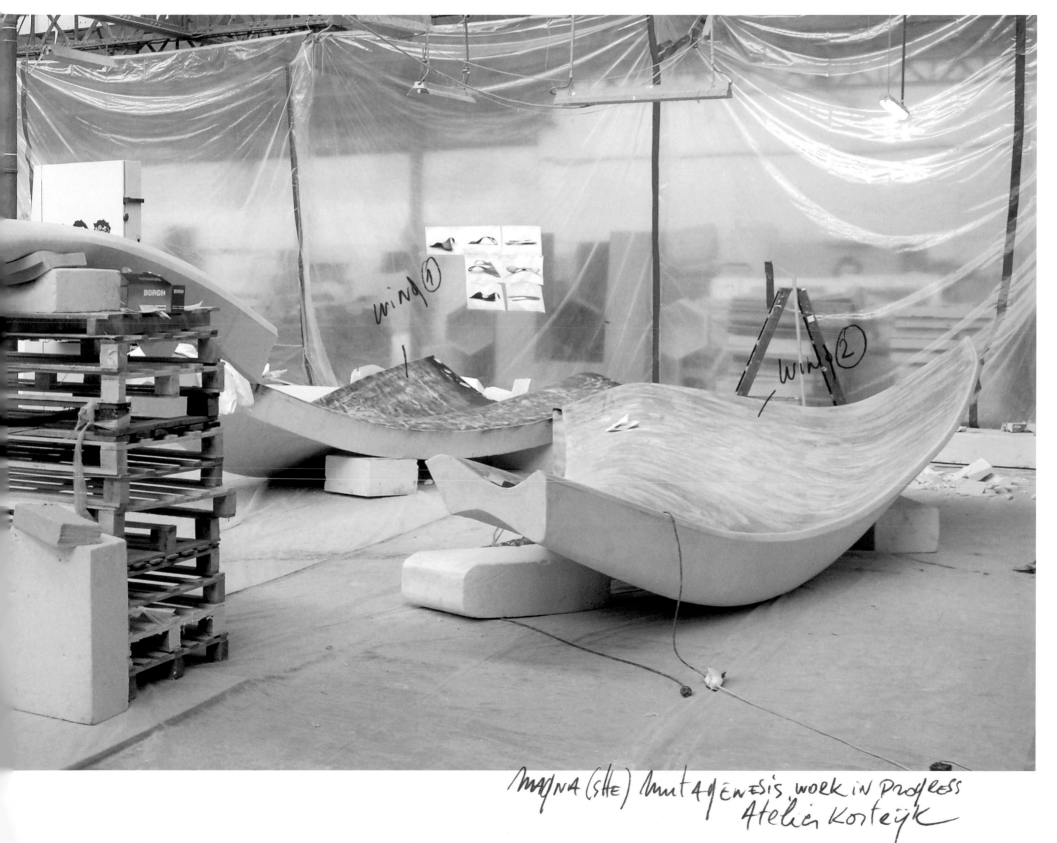

wing ①

wing ②

MAGNA (SHE) MATER GENESIS work in progress
Atelier Korteijk

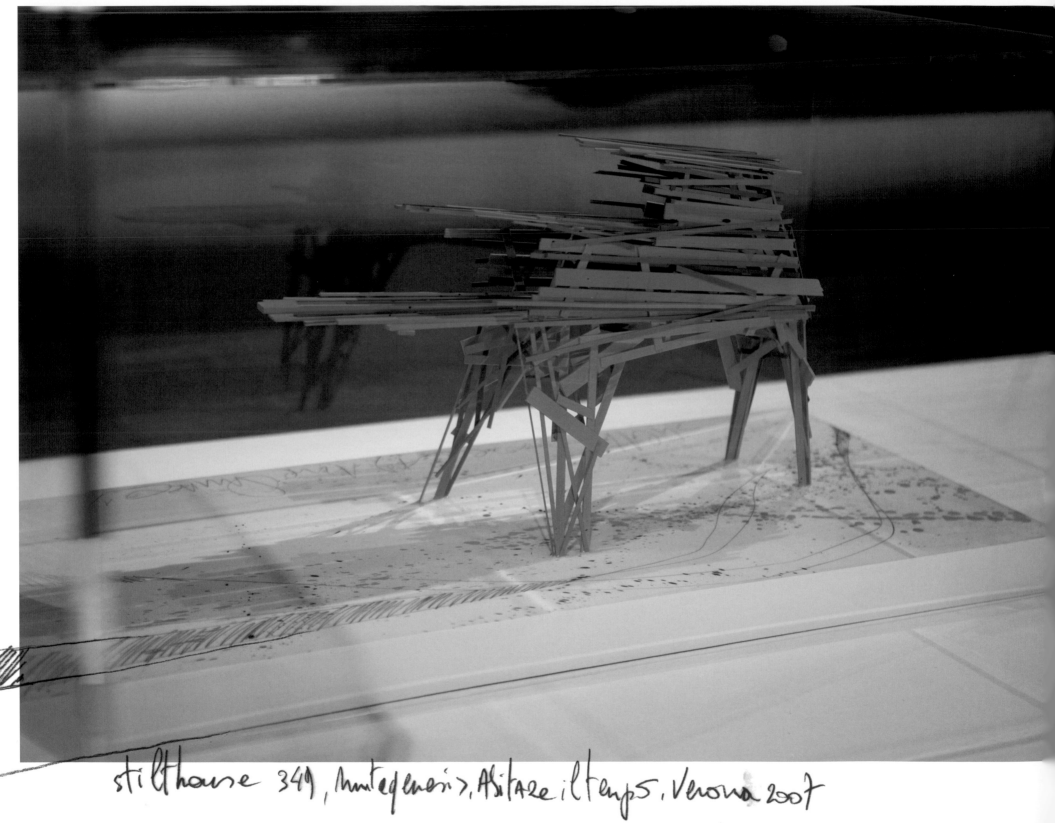

30

stilthouse 349, Montagenerin, Abitare il tempo, Verona 2007

stretch, montagenenis, ARtaleil temps 2001

31

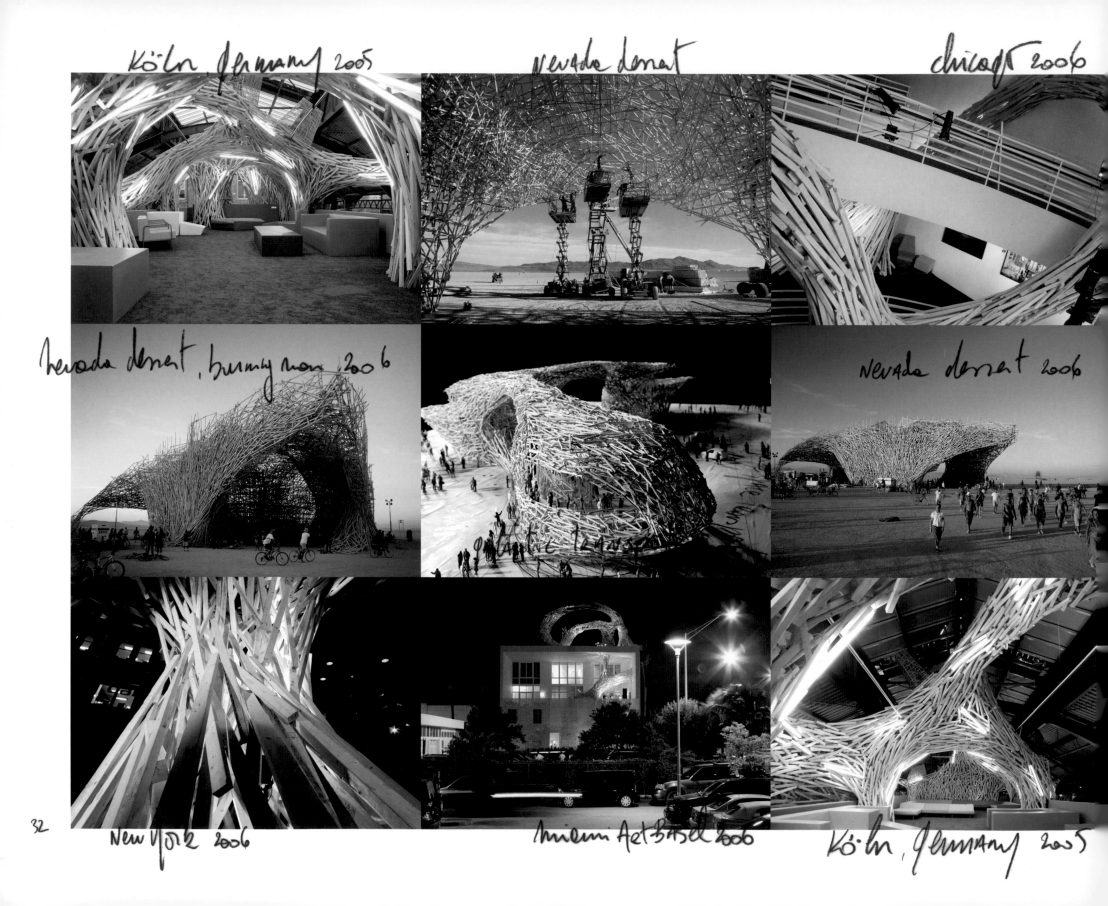

Köln, Germany 2005

nevada desert

chicago 2006

nevada desert, burning man 2006

nevada desert 2006

32

New York 2006

Miami Art Basel 2006

Köln, Germany 2005

London 2005

Miami Art Basel 2006

L.A Beverly hills 2006

Victoria - Burning Man 2006

Köln Germany 2005

Art Basel Miami

L.A Beverly Hills

Galactic Transporter

Nevada Desert Burning Man

33

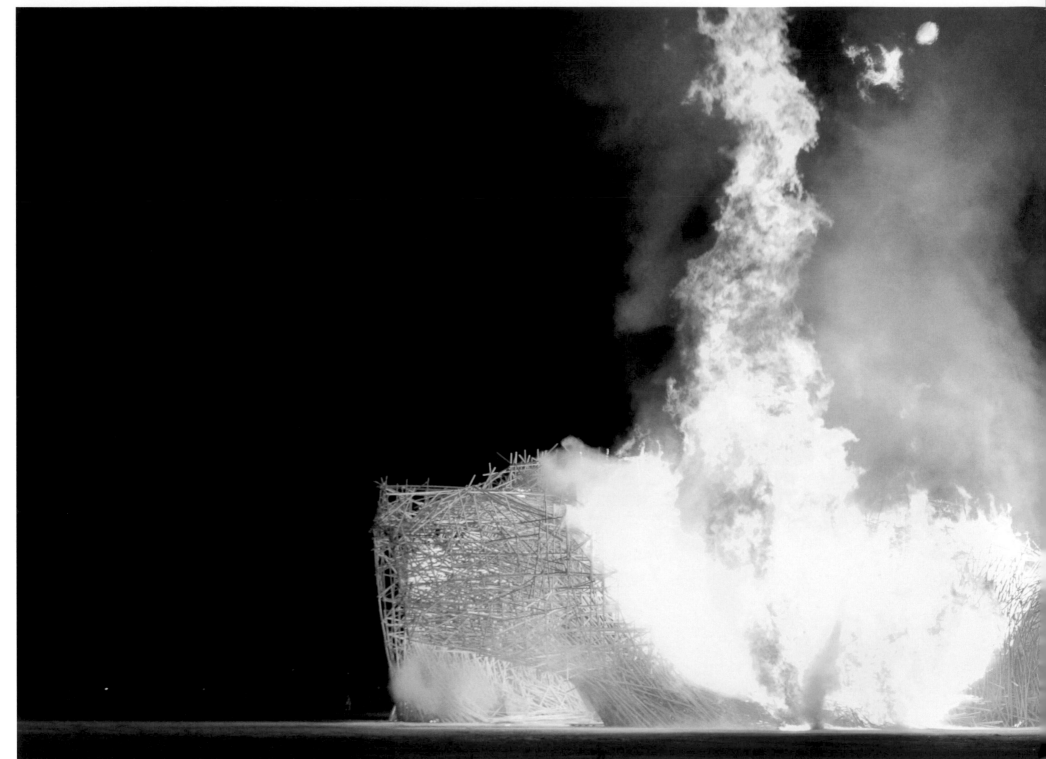

34

Vchronia, Burn of wooden sculpture, Burning non Block

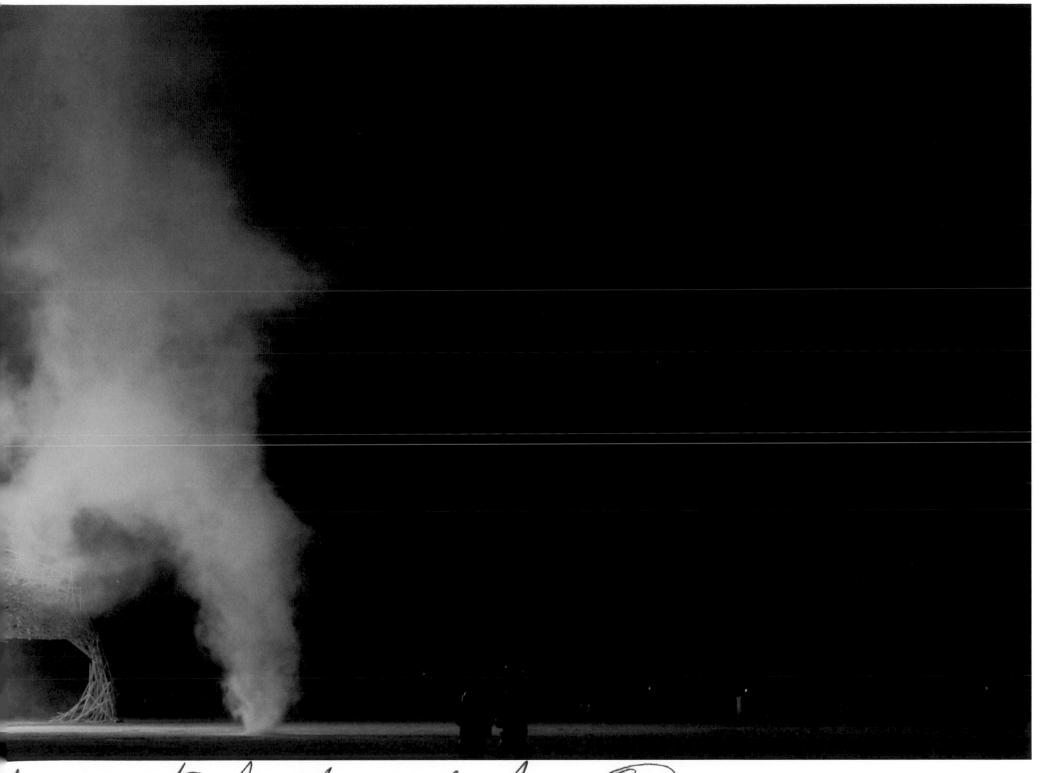

e _desert, nevada 2006, Anne Quinze_

36

RE-DESIGNING BRUSSELS

BRINGING PEACE TO A BATTLEFIELD

Situated in the heart of Belgium's smartest shopping district, the wasteland on which Cityscape was going to be built had become one of the pre-eminent examples of (the lack of) urban policy in Brussels. Much more than just a sculpture, Cityscape was therefore meant by its initiators to be a powerful communication tool. Whilst bringing an endless saga to an end, it was to become the gateway to a new beginning for the capital of Europe.

MAX BORKA

DEMOLITION

No sooner had the old shops and houses in front of the Brussels Hilton been torn down to make way for the leisure dome Heron City, with no fewer than thirteen cinemas, a fitness centre, offices, and a swimming pool, the resulting 6,600 square metre wasteland became a battlefield. Local residents and environmental associations protested strongly, not only because the condemned buildings had included historically valuable features, but also because the owners, the British developers Heron, had not waited for a judgment by the National Trust before going ahead with demolition plans.

SAGA

Because of its position, right at the centre of Belgium's smartest shopping district, the Quartier Louise/Louizawijk, the vast and empty terrain and its unsavoury history became a symbol, not only for the degradation of the neighbourhood, but also for urban policy in Brussels in general. Despite the fact that the Brussels-Capital Region authorities and the Commune of Elsene/Ixelles, on whose territory the terrain was situated, had already issued a building permit, and that Heron had adapted its original plans under pressure from local committees and action groups, adding shops and apartments, the Council of State agreed with the protesters by withdrawing the permit – even after Heron had sold the ground to the investment company ProWinko, thus forcing the latter to stop works it had already started.

LOUISE

But ProWinko certainly appeared to have a more established track record when it came to urban redevelopments in Belgium. After all, it had already successfully transformed the nearby restaurant Adrienne together with some old shops into a commercial complex and had several other interesting projects to its credit, such as the Zilverpand in Bruges and the Inno and Pathé Empire in Ixelles. ProWinko decided to redesign the project. The hotel was dropped from the plans and more retail and residential surface was added, resulting in a better balance throughout the project and its surroundings. It was also renamed Entre les Deux Portes, a reference to the strategic position of the wasteland,

in between the Porte de Namur/Naamsepoort and the Porte Louise/Louizapoort, the two city gates that lead from the ring road around Brussels centre into the Quartier Louise.

ALARM

Until recently, this uptown quarter had the reputation for being Belgium's chicest neighbourhood, especially for upper class shopping – and it probably still has. But this did not stop local politicians and business people from raising the alarm. Partly because of competition with nearby cities like Antwerp, Lille and Ghent, the neighbourhood has lost a lot of its credit and public, whilst the shops have become far less exclusive. Brussels' fragmented structure – a territory spread over 19 communes with a policy shared by an even greater number of authorities, both national, regional and local – is partly responsible for the fact that little was being done to turn the tide.

FRACTIONALISATION

The Quartier Louise extends over three communes – Brussels City, St. Gilles, and Ixelles – each with its own council and administration. The resulting fractionalisation has led to the founding of Brussels Louise, a non-profit association that – beyond the borders of the three communes and with the support of the Brussels Minister of Economy Benoît Cerexhe – has set itself the task of reviving the neighbourhood by giving it a more coherent image and brand, whilst also attacking problems like mobility and security and attracting new and smart brands to the area – so that it might once again become a must for shoppers from Brussels and elsewhere.

ELEGANCE

With an allowance of 175,000 euros from Brussels-Capital Region, the job of Bernadette Erpicum is still a solitary one. She is the sole employee and therefore also the director of Brussels Louise but this doesn't temper her ambition or enthusiasm. Elegance is the first word that comes to her mind when she describes the new image she wants to give the neighbourhood. "Therefore also the name Brussels Louise," she says, "we were thinking more of a gracious lady who finds her second youth."

STRONG

The elegance of a gracious lady is probably not the first thing that springs to mind when thinking of Cityscape. And yet, whilst looking for a first, strong gesture, it was Brussels Louise that came up with idea of contacting Arne Quinze – on the suggestion of Patrick Grauwels, who had been told about Uchronia, which Quinze had built and burned in the Black Rock Desert, Nevada, one year earlier.

RECORD

What followed was du jamais vu in Brussels. In less than two months, all the public and private partners were not only gathered round the table but they also approved the project, an absolute record that was only equalled by the fact that the Commune of Ixelles gave building permission in less than 48 hours.

CANCER

ProWinko generously put the wasteland at the project's disposal and MINI became the main sponsor. But also leading local politicians, and especially Minister Benoît Cerexhe, who became the project's greatest fan, and who had cursed the wasteland as a cancer, made it very clear that there was great urgency involved: as part of a wider social initiative the monumental and ephemeral structure was meant as a communication tool, to bring new energy to the discarded neighbourhood, reinforcing the link between uptown and downtown, and symbolising a new start for Brussels in general.

MATCHSTICK

For Arne Quinze, who had already installed similar constructions in Berlin, Miami, London and elsewhere, it was not only the first time he got an offer to build one of these giant sculptures in Belgium, but also in Brussels, the city where he'd lived as a homeless youth some twenty years previously, an experience that turned him into an artist. Composed of wooden slats with a total length of more than 60 kilometres, and supported by 12-metre high wooden stilts, the sculpture he had in mind for Brussels had the same characteristics and precarious oversized matchstick quality as her earlier siblings. But from the very beginning,

Demolition, SAGA, Louise, Alarm, Fractionalization, Elegance strong, Record,

Quinze also made it very clear that its form and atmosphere should explicitly refer to Brussels, in tune with the initiators' desire to turn the sculpture into a communication tool.

HYPHEN

In so doing, Cityscape had to make the impossible possible, by marrying minimal to monumental and massive to matchstick. Not only the immense size of the sculpture – 40 metres long, 25 metres wide and at certain points 18 metres high – was of decisive importance in the message he wanted to convey, but also its volatile and floating quality. "My sculptures always let themselves be defined by the nature of the place," says Quinze, "Here, on the avenue de la Toison d'Or/Guldenvlieslaan, which is part of the ring road, you can literally feel the city move. I made the sculpture volatile because I wanted it to resemble a frozen movement and to express speed caught in time. While capturing a form in full development and the hectic traffic of the adjacent ring road, it would also bring them to a halt, like a hyphen, a pause, a place for silence and contemplation. An effect of lightness permeates the sculpture: from a distance, pure movement seems to keep the structure in the air, as if it were floating, while rays of sunlight play on the wooden beams, and this game of light and shadow creates ever-changing patterns. On the other hand, I also wanted the installation to be monumental. I wished it to act as a magnet that would irresistibly absorb inhabitants and passers-by, and call for instant reactions. Hence its size: this makes it impossible not to feel anything."

MASTERPLAN

Size also turned the sculpture into a highly visible symbol of the neighbourhood and into a catalyser of something that could start to grow in a city that had been drowsing for half a century. During the building of Cityscape, staff at the nearby Pulp café terrace worked long hours to provide a headquarters for the press who kept coming to interview Arne, especially after he announced that he didn't want to limit himself to the wasteland and revealed that he'd been playing for some time already with the idea of a Brussels masterplan, an urbanisation project that would span over 50 years, and totally redraw the city.

DISASTER

Returning to Brussels after a gap of twenty years led Arne to conclude that it is one of the few cities in Europe that doesn't grow or modernise much, and when it does, certainly not for the better. "I have a great passion for this city, but at the same time it's a disaster. If you look at what happened to Paris or London, or even to much smaller cities such as Lille or Rotterdam: things are changing fast while Brussels seems to have fallen asleep. I simply don't understand. I want to help Brussels out of this lethargy. Belgium has a great history, and we still profit from that. When it comes to quality of life, this tradition has provided us with everything one can dream of – like good food and a lively fashion scene. But there's little room for innovation. We seem to be so attached to the comfortable life that we're scared to death of change. Belgium doesn't stand for anything universal anymore. The ambition is totally lacking. This also goes for Belgian urbanism and architecture: little to nothing has changed since 1945. What we need is a vision and people to make it work; creative people, but above all decision-makers, officials. We have a huge number of talented people in this country. But they always bump into laws or officials. It's not their fault; it's mostly the system that blocks them. I would love to take these people on a world trip to show them what is possible."

IMAGINE

His keyword is imagine: "Just imagine: if Brussels was sending teams of officials to Japan or South Africa to live and work there for six months, to feel the energy and be confronted with new ideas, while at the same time these countries were sending one of their teams to Brussels... Imagine the interaction, openness and dynamics this would generate. Or imagine that right now and next to Cityscape, five other sculptures would be erected on strategic spots in Brussels. Image-wise it would have had a tenfold result."

GENERATION

The first line of the masterplan still has to be drawn. "I first want to look for other creative people who would collaborate in creating such a plan," says Quinze, "Because it makes no sense that I would do this alone. I don't want it to be an ego trip. I want it to be the result of a permanent dialogue with a whole new generation of talented people. This is very common in Italy or the Netherlands, but over here we seem to lack chauvinism and the audacity. We don't seem to realise that we simply owe this to our heirs, the next generation. I have four children, the oldest being fourteen: it will be very sad and frustrating for them if things don't change."

DYNAMICS

In the meantime, the success of Cityscape can already be measured by the fact that the sculpture will remain in place for 18 months instead of the one year originally planned, and by the great number of non-profit organisations wanting to rent the sculpture for events. "We have received nothing but compliments," says Bernadette Erpicum, who is also responsible for this events programme, "The sculpture has a greater effect than we could ever have dreamt of. Brussels-Capital Region even took a model of Cityscape to the leading real estate fair Mapic in Cannes, as a symbol of a new dynamic in Brussels, and an example of perfect collaboration between private and public partners." One of these partners is ProWinko whose original plan for a permanent building on the site was rejected. At the time when Cityscape was built, a whole new procedure still had to be set up and approved by the authorities before drawing a final plan was even conceivable. But Rick Bakker of ProWinko feels far from frustrated: "On the contrary. All this has given us the opportunity to start from zero and to drop the neo-classicist architecture of the original plan in favour of a landmark that will not only be modern and contemporary, but also perfectly adapt itself to the neighbourhood and the Brussels' situation in general. Time is short, and at this moment we have little more than a first draft at our disposal. Even the architect still has to be chosen. But this will allow us to go for an open dialogue with all the stakeholders. All the parties involved agree that the last great architectural landmark in Brussels is the Atomium, dating from 1958. It would be fantastic if we could finally succeed in giving it a worthy successor when its 50th birthday is celebrated – by creating a building that would not only end this saga, but would also announce a new beginning, a new era."

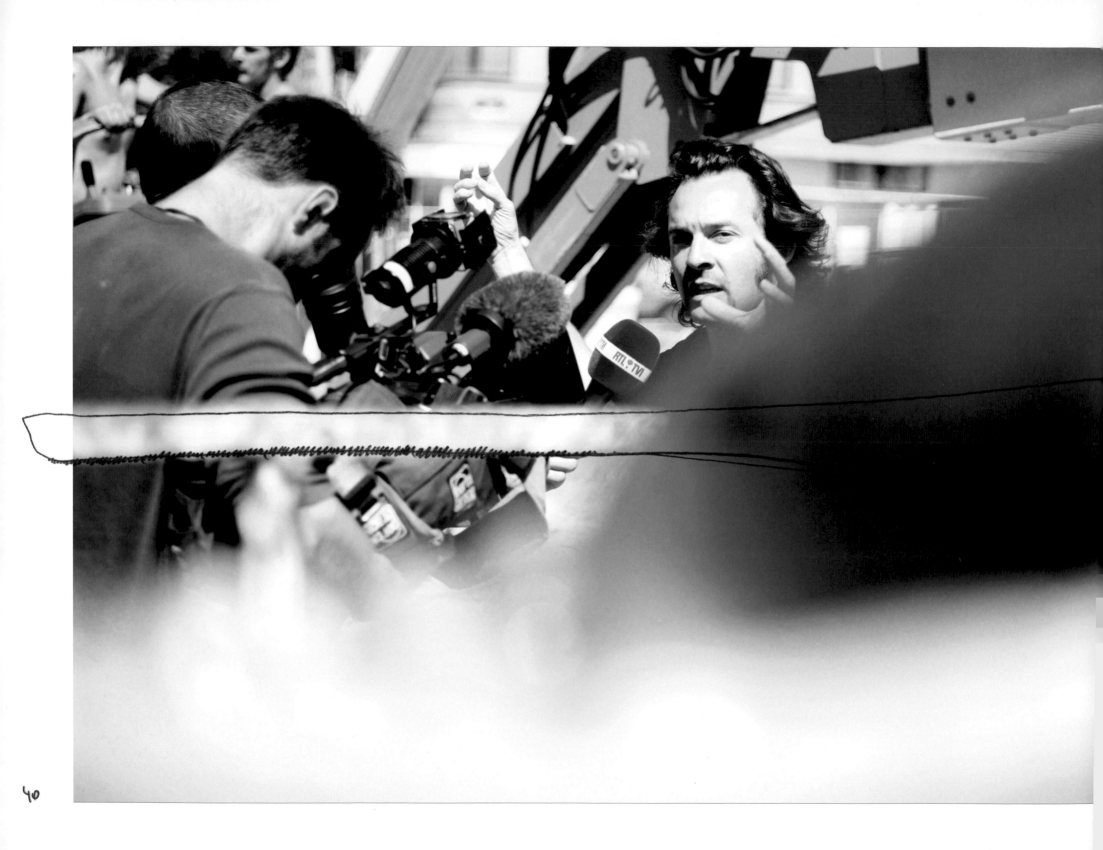

40

"

I spent a large part of my youth in Brussels, including six months as a homeless fifteen-year-old who kept his head above water by stealing food and turning graffiti into a mission. Twenty years passed before I was finally offered a chance to intervene in the Brussels cityscape again, albeit from a slightly different perspective. I've always had a great passion for this city. So it was an offer I simply couldn't refuse, all the more because it provided me with a new mission: in spite of its status as the capital of Europe, this city exhales catastrophe, being one of the few metropolises on this continent where modernisation barely has any grip – and where it does, it's certainly not for the better. Cityscape has to breathe new life into a 6,600 square metre wasteland, the immediate neighbourhood, and the uptown area of Brussels. However, I hope it will also be a catalyser for Brussels in general, a city that's been dozing for more than half a century. I wanted to provide the kick-start to a project that would lift Brussels to another dimension.

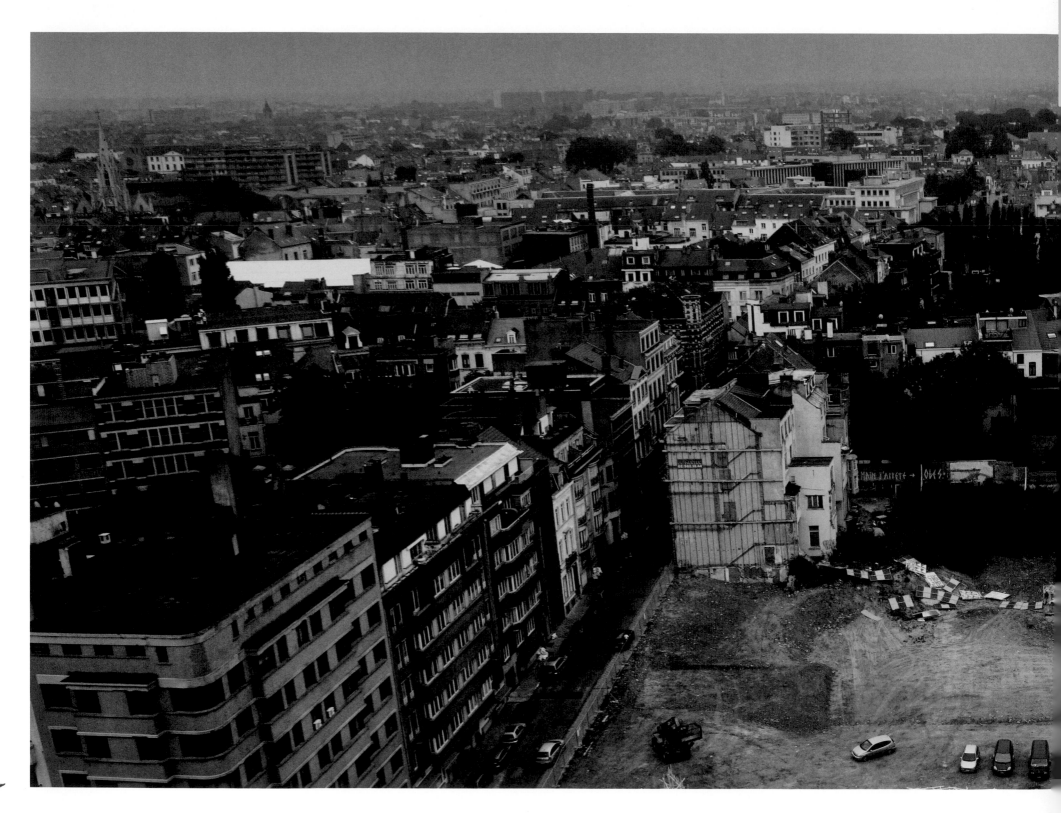

42

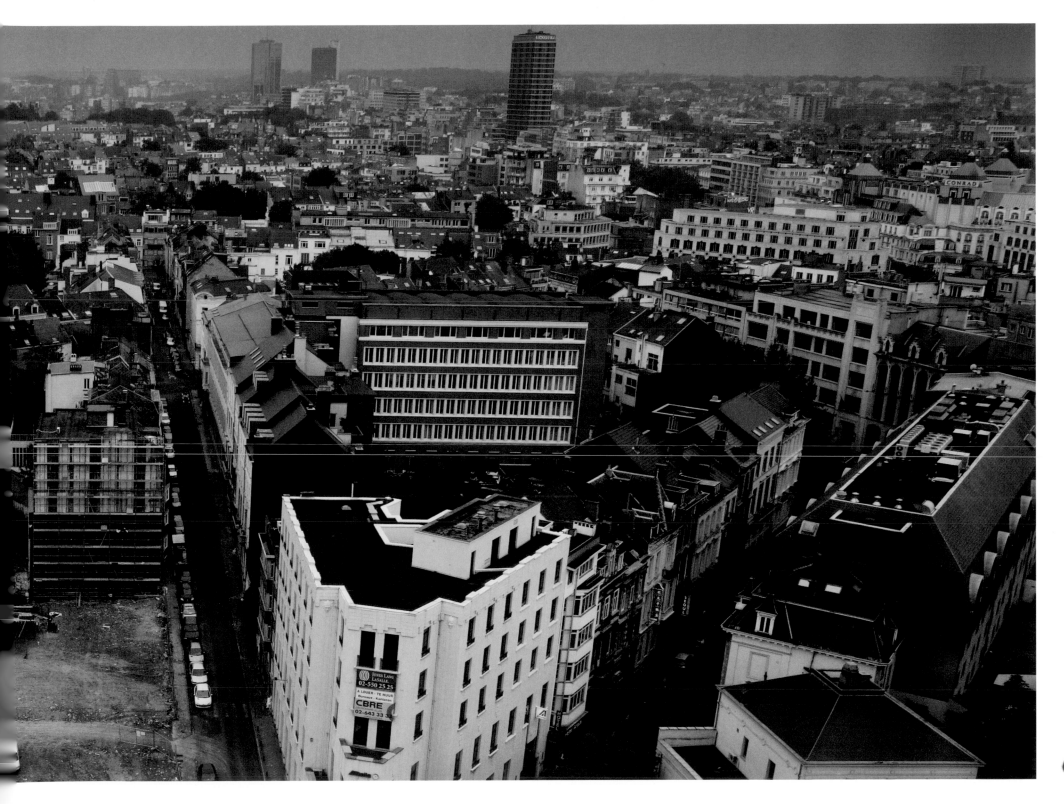

43

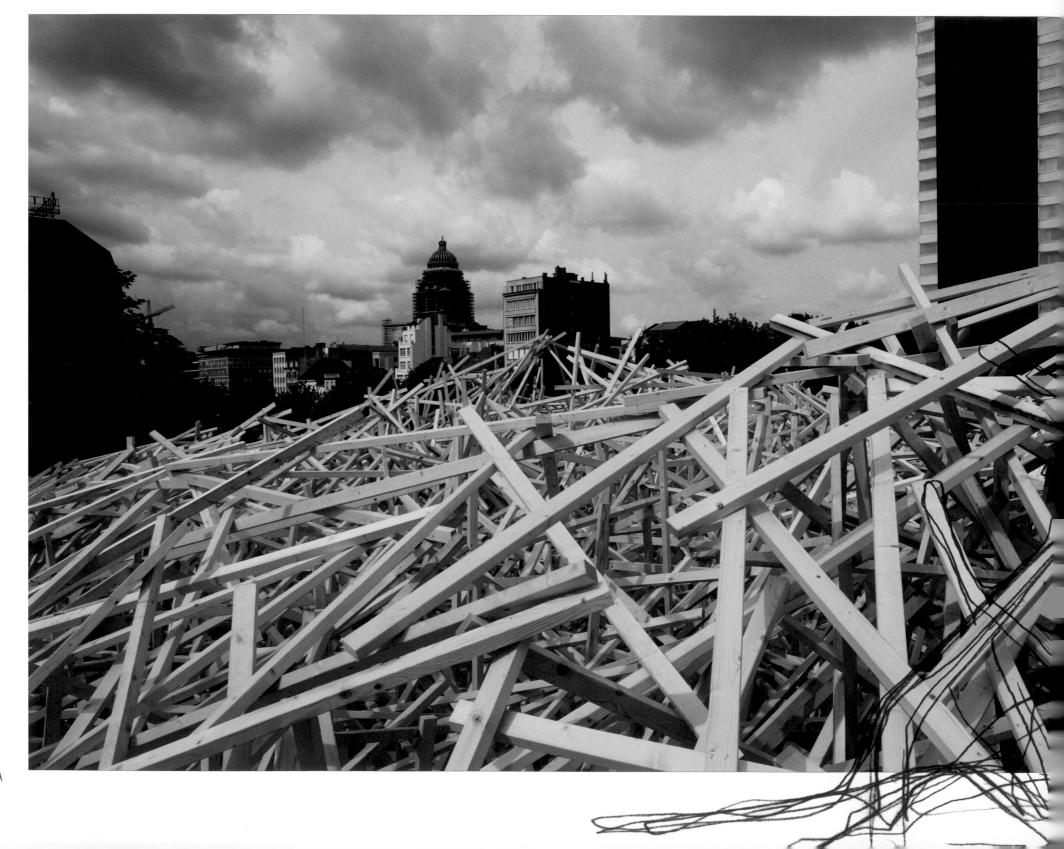

44

A WILD MORSE

THE MAKING OF THE CITYSCAPE

As carefully calculated as it was improvised and intuitive, Cityscape grew from some bare trees on a field of gallows into a giant crown of thorns, and consequently into something that resembled a nest, a cloud, a wood, a shuttle, before it finally took on the size, beauty and looks of a manta ray. Photographers Thierry van Dort and Lionel Samain followed the mutating day by day.

MAX BORKA

45

→Hilton

Goethe Bridge→ ←

46

gulden vlies toon cityscape

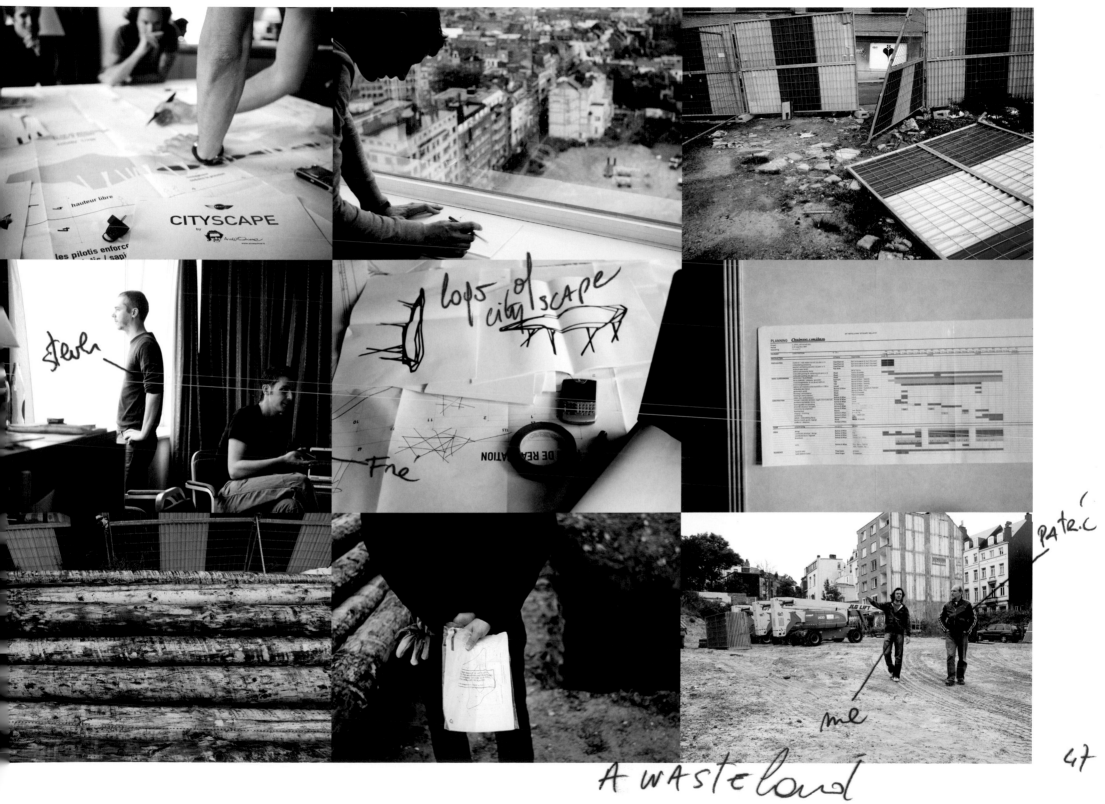

stage

DAVID

jelle

soul

Eveline

Yvonne

48

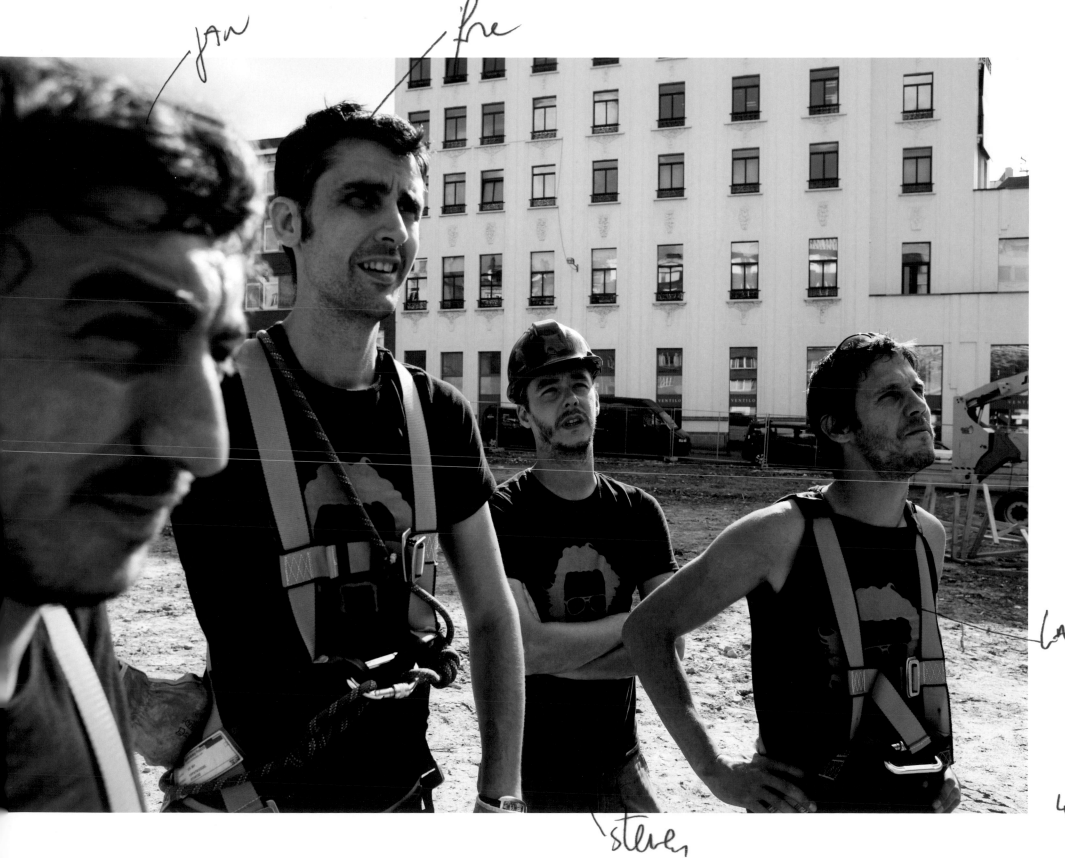

Jan

Fre

steven

Lau

49

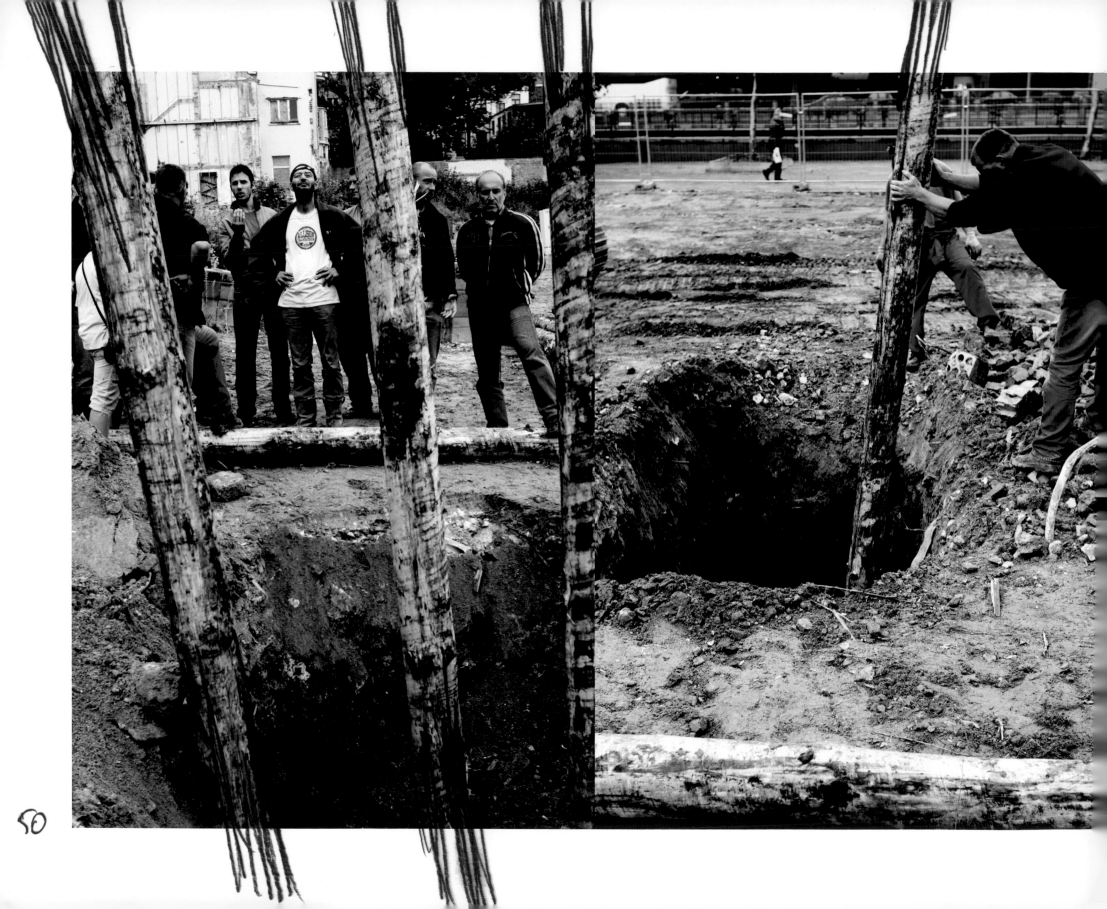

50

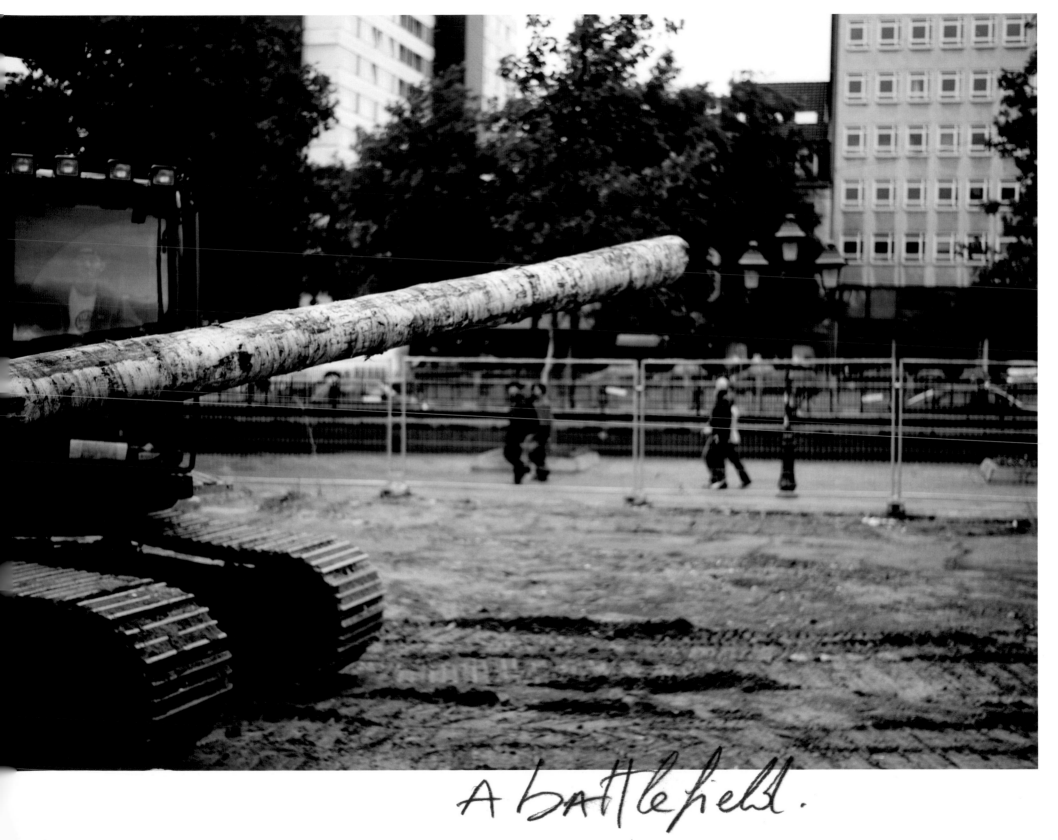

A battlefield.

51

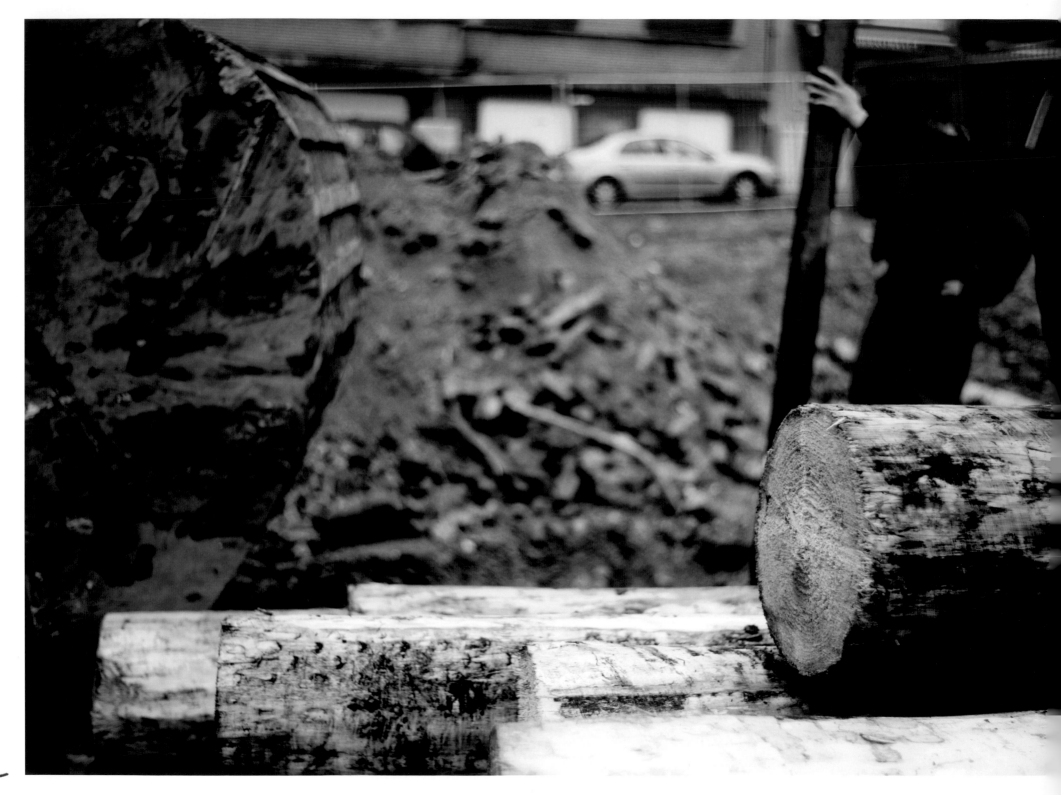

52

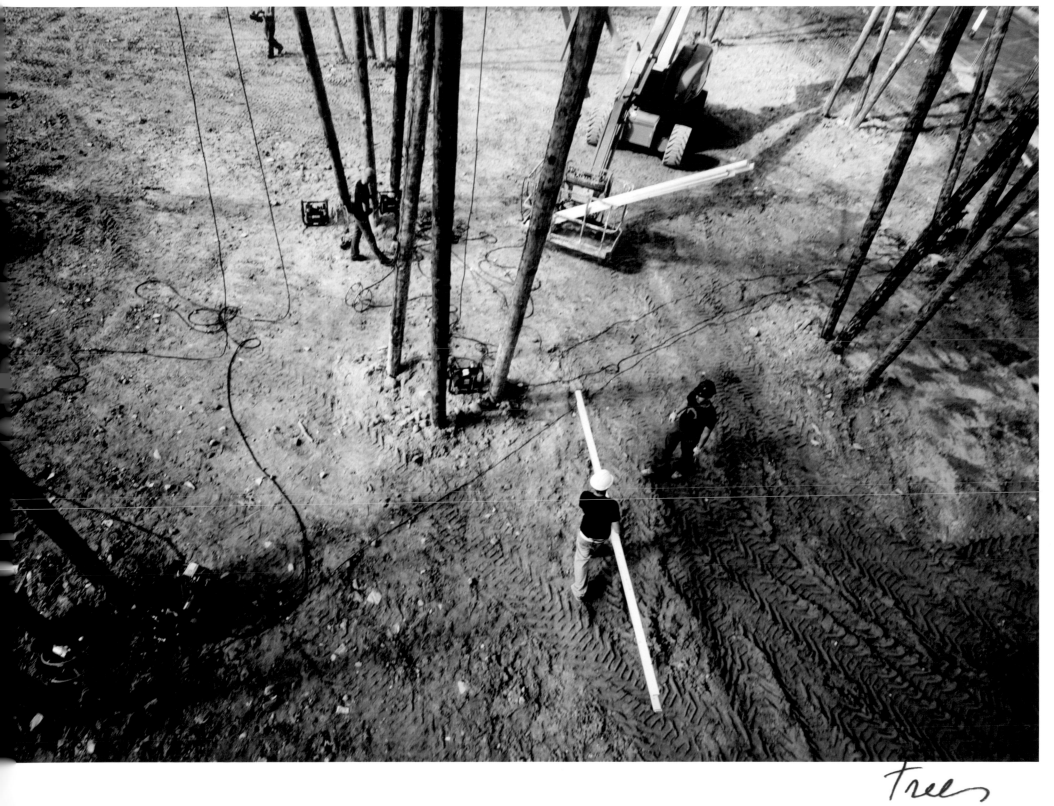

53

Trees

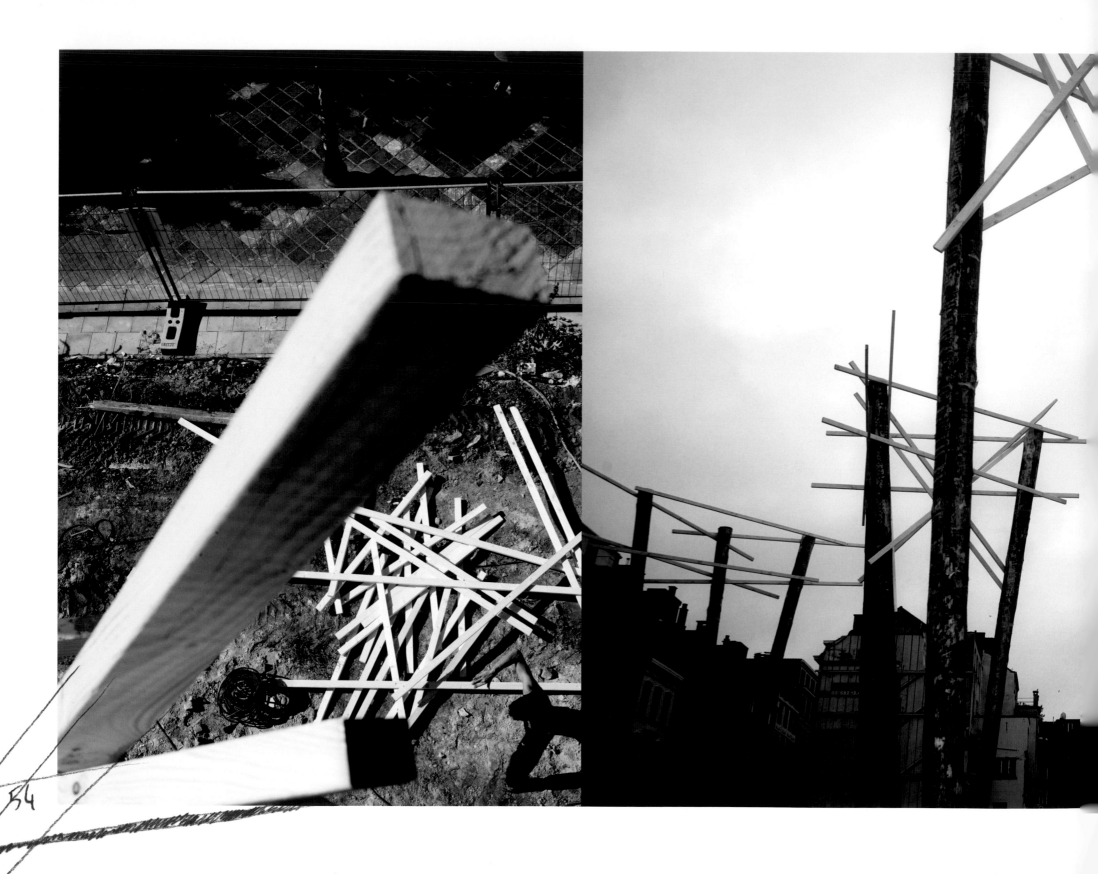

54

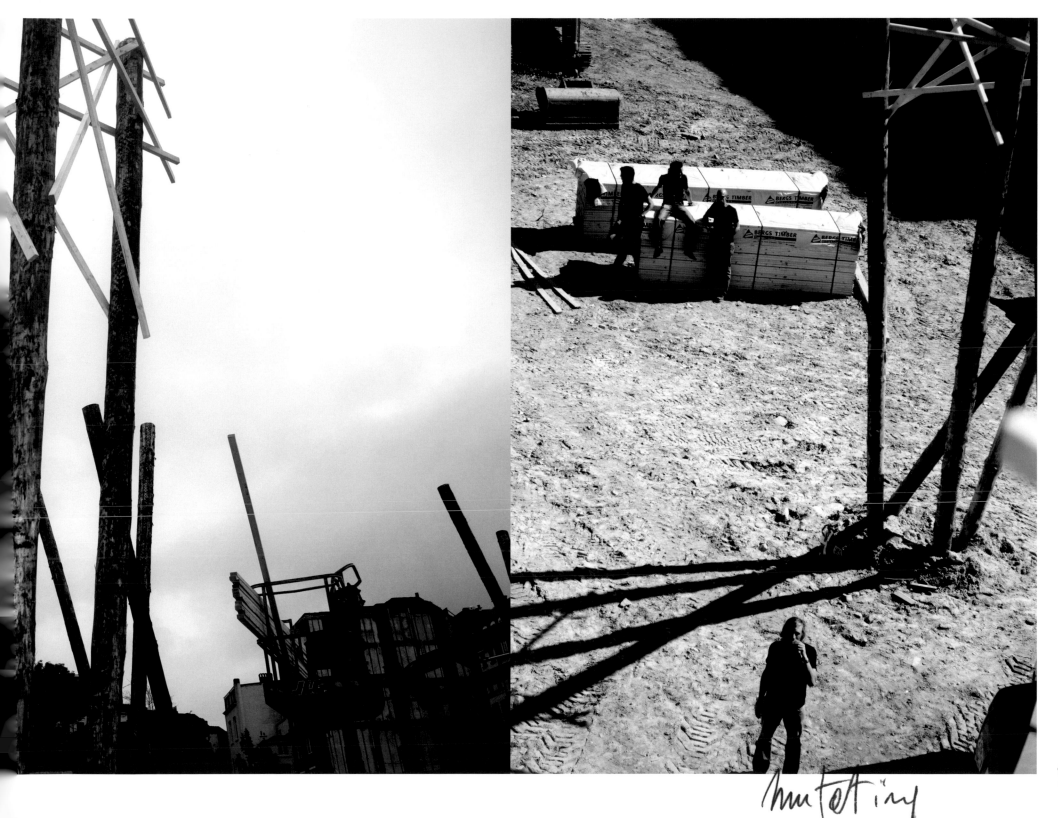

mutating

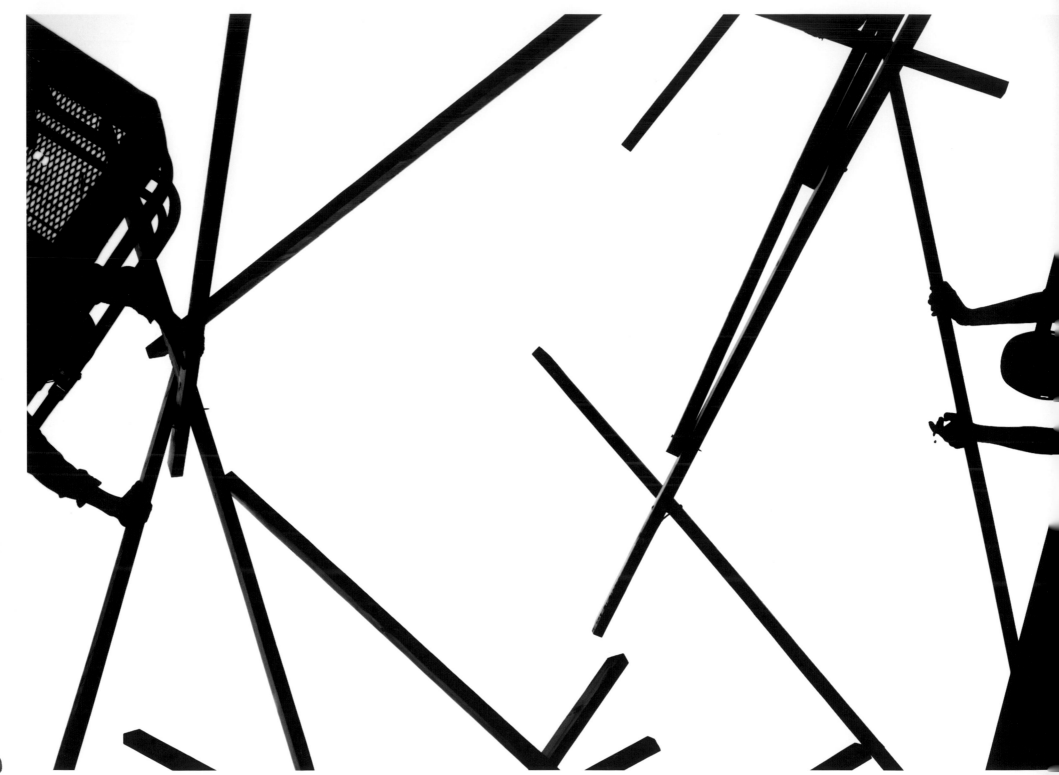

56

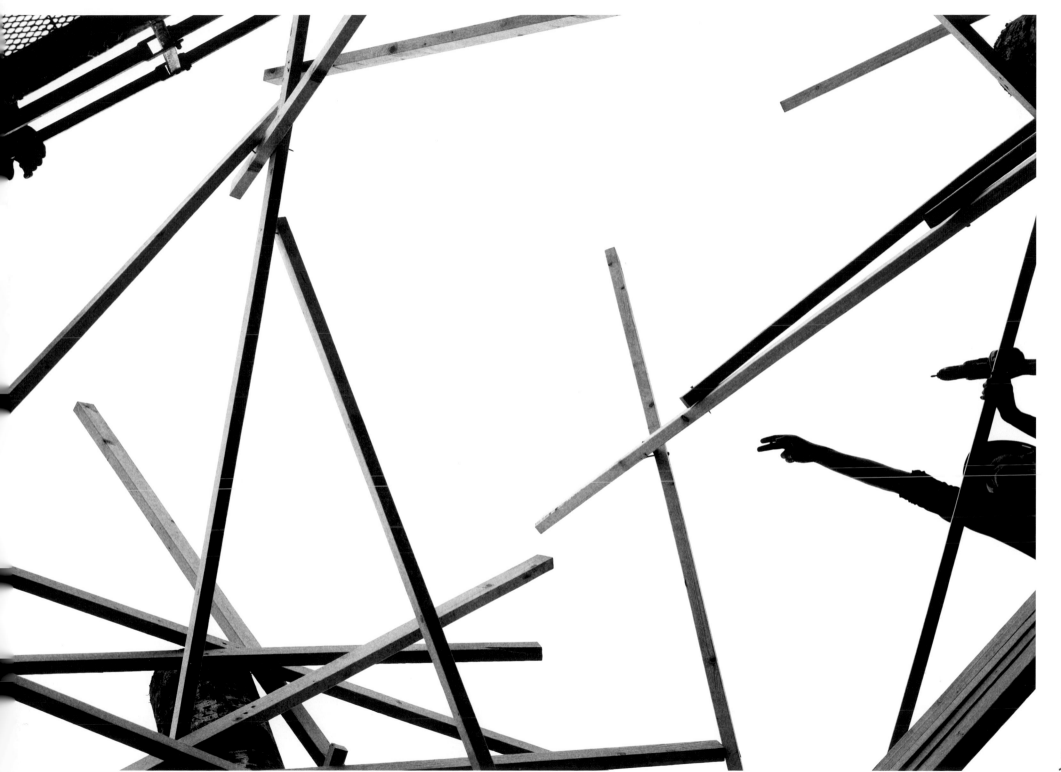

57

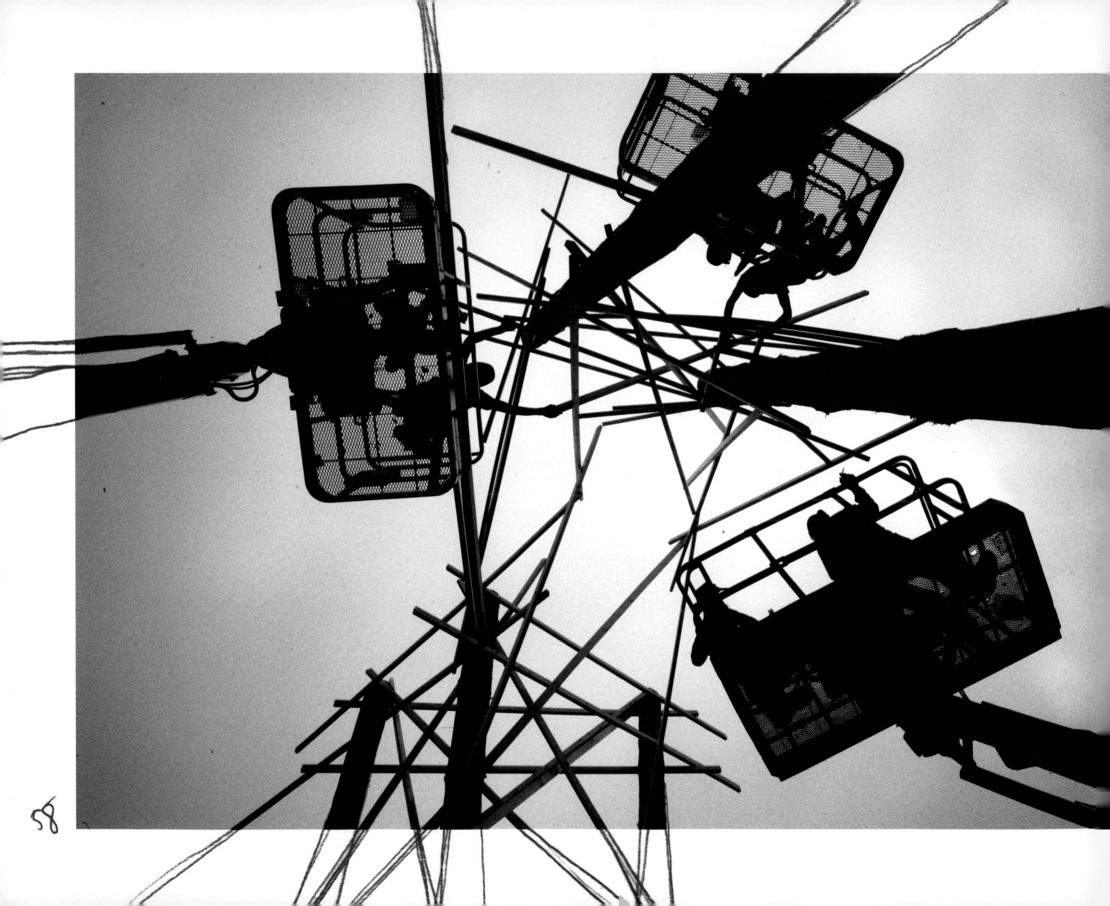

58

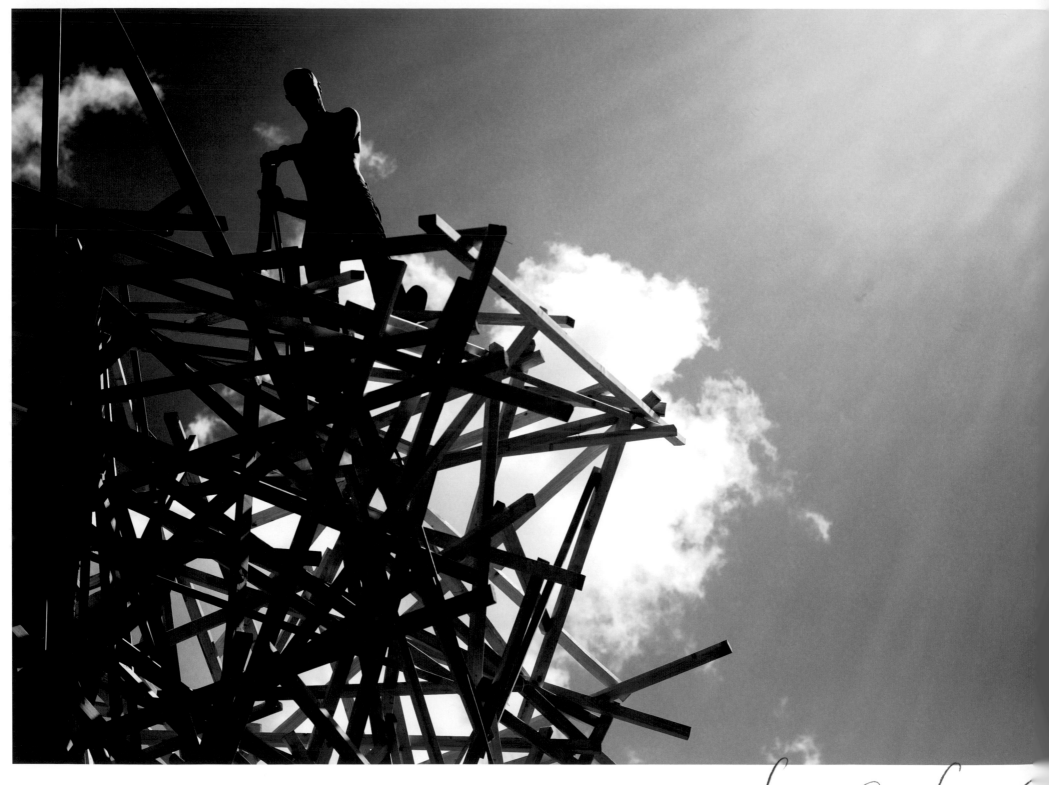

60

Criss Cross Cross

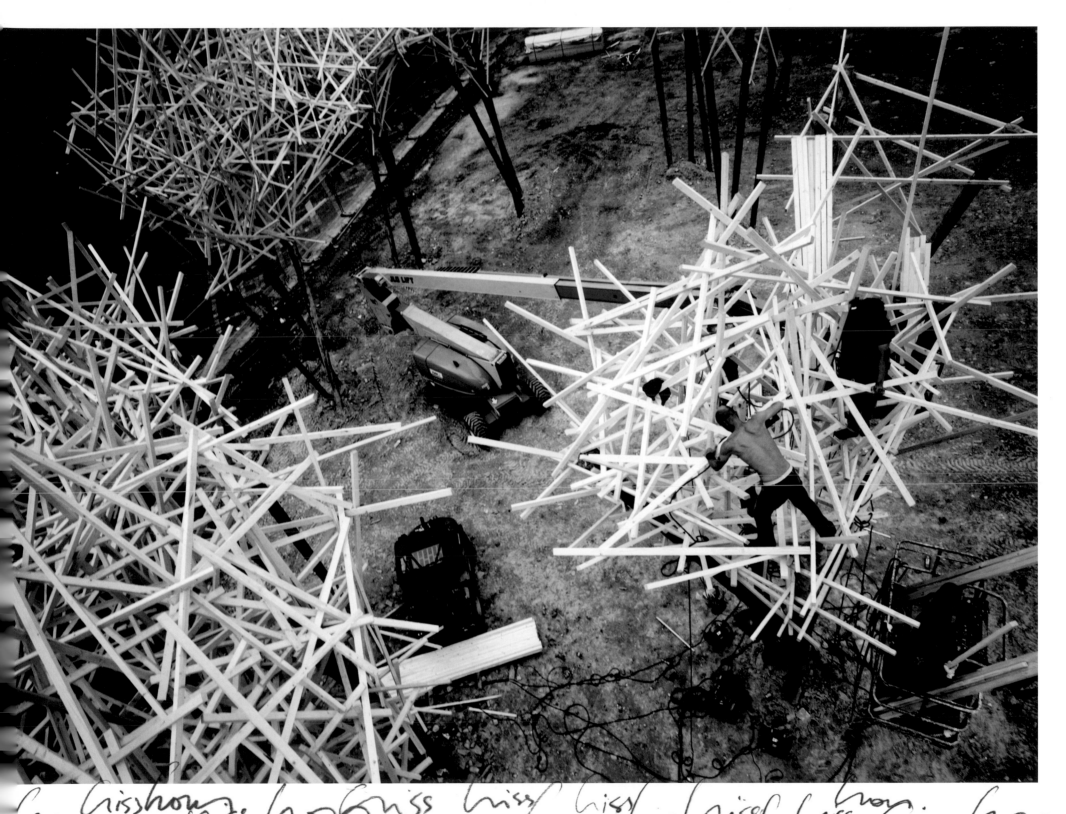

criss cross criss cross criss criss criss cross criss cross criss criss cross

61

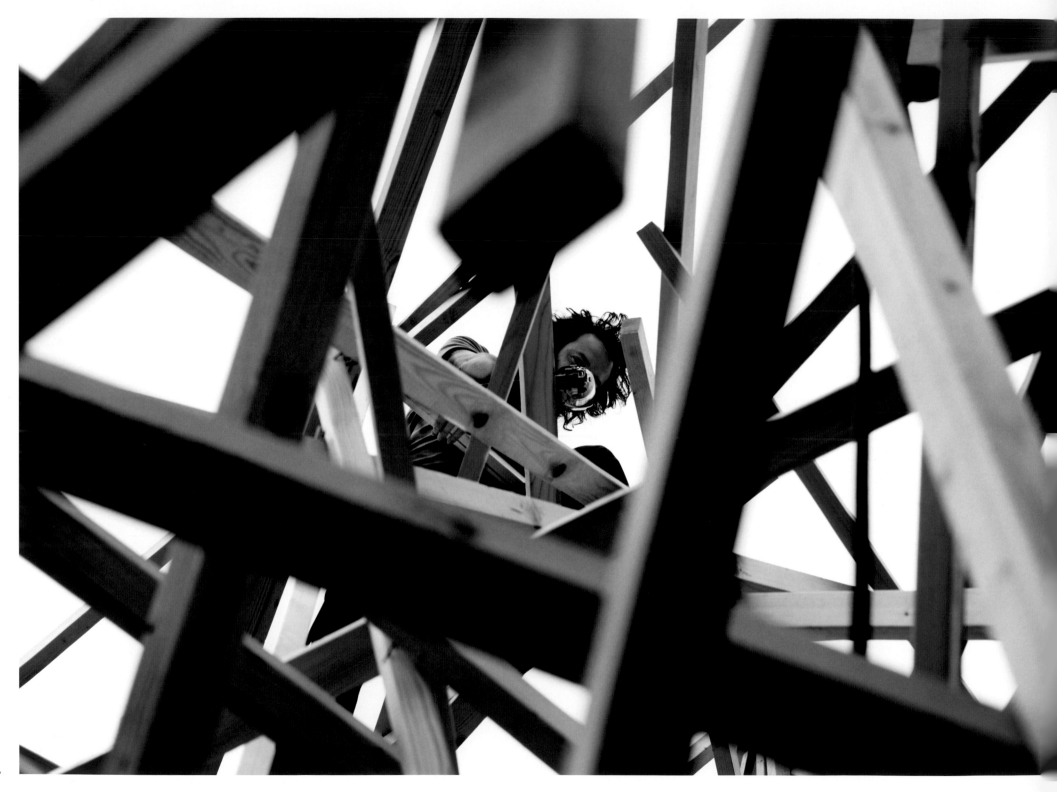

62

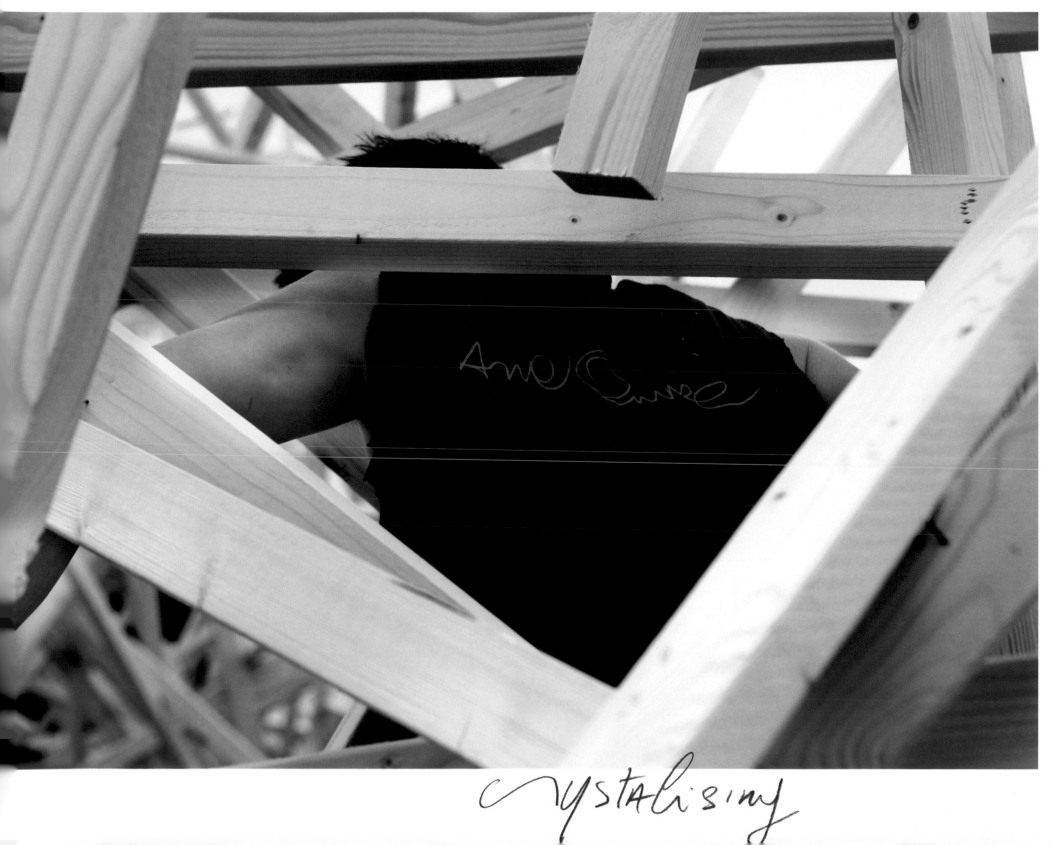

crystalising

63

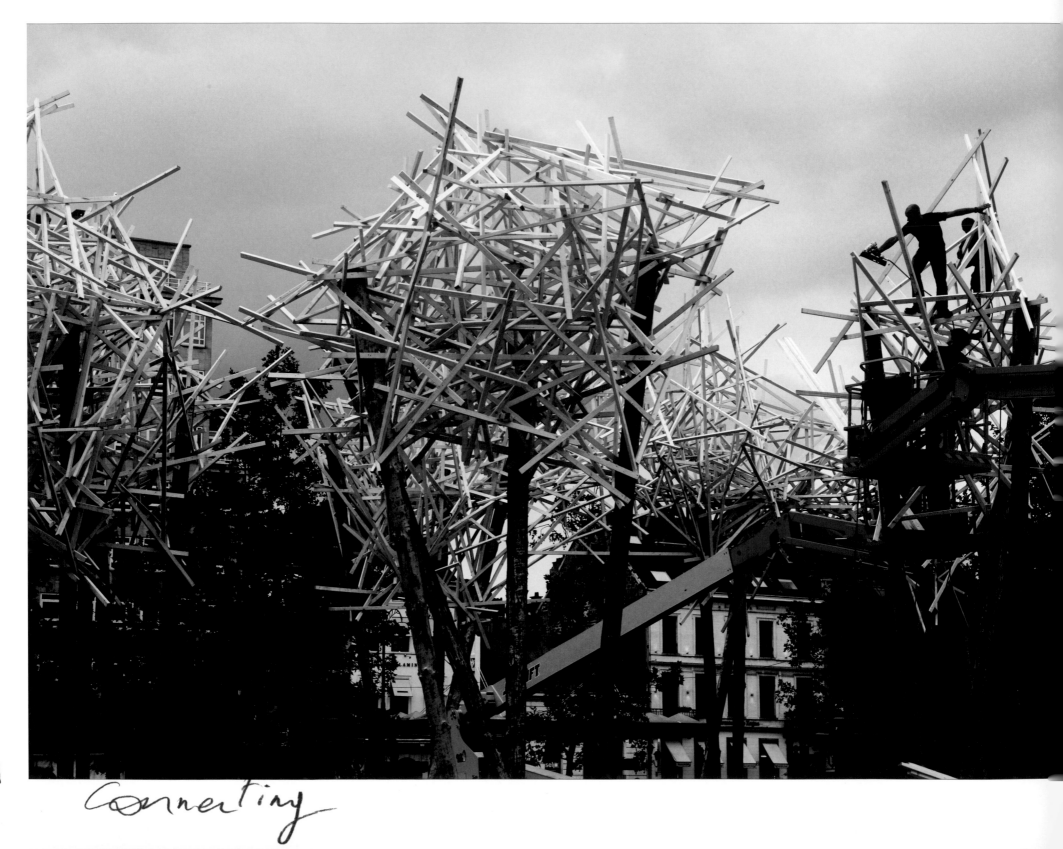

04

Connecting

Suite 2005 in the Hilton hotel, where the Cityscape team has its headquarters, is a disconsolate sight. Disconsolate is also the panoramic view it offers of Brussels. And disconsolate is the wasteland we see from up here, and where the very last of the 33 stilts that have to support the flow of wood, is being fixed into the ground. Maybe it all has to do with the fact that it's been raining cats and dogs. The Dutch team fixing the stilts already fell a day behind schedule when it was discovered that the ground had been secretly filled with concrete and other detritus. This means the stilts cannot be driven properly into the earth. So a series of holes, four metres deep, have to be dug and then filled again with hardened sand, once the stilts are planted. Meanwhile, in the room, the team discusses figures. The notorious Uchronia, built by Arne at the Burning Man Festival in Nevada, reached a height of 15 metres. And Arne would not be Arne if he didn't wish Cityscape to go higher still. "Some of the peaks will reach a height of 18 metres." says the project's architect Fréderic Van Dooren – aka Fré. Until today, all Arne's sculptures, whether in London or Cologne, were intuitively built. But this time – and for the first time ever – an engineer's study analysed the stability of the project. "It was largely for training purposes rather than necessity.", Fré says, "Future sculptures will be elaborated on a much grander scale. That's why we decided to look for engineering support while building Cityscape. We're always looking out for young people who identify with our approach. So we chose UTIL, an engineering office based in Schaarbeek, Brussels." "Not even by a long shot," says Rolf Van Steenwegen from UTIL, when asked if he's ever been confronted with a situation like this before. The reason why, reveals itself during the course of Rolf and Fré's discussions inside headquarters. "Being up there is far from easy", says Fré. Surrounded by the wooden beams, it's hard to have an overview of what's happening. Building the sculpture remains largely a matter of intuition and improvisation, leading to a final result that will be quite different from the model. So the artificial forest on the ProWinko site will be inevitably planted according to the rules of the philosophy of controlled chaos that Arne loves so much. "I'm more into mathematics." says Rolf, "One stilt can support about 1000 kilos. We will calculate things in such a way that one stilt will only have to support one 10th of that weight. Above all, we want to play things safe."

Crystals of beams have been created around each of the 33 stilts that support the structure. They have now been connected to form a giant crown of thorns, floating five metres above the ground. "The lining is getting important now," says Arne, "we're reaching a crucial point, where we leave the construction phase and move into the organic and aerodynamic phase. Where chaos gives in to discipline. The beast has to be tamed now. We'll first work out the extensions of the crown in essentials, and after that, tighten up the network."

Even Arne feels totally amazed when observing other people's reactions today. "What surprises me is their bewilderment – from politicians to passers by despite the pouring rain. Compared to a few days ago, their reaction is entirely different. It's as if people only now start to see the direction the sculpture is taking." Only a week ago, little more was visible than the crystals of beams connected to form a crown of thorns. Now, the builders start to work away from that circle, tempting gravity. Arne: "The beast is spreading its wings."

 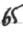

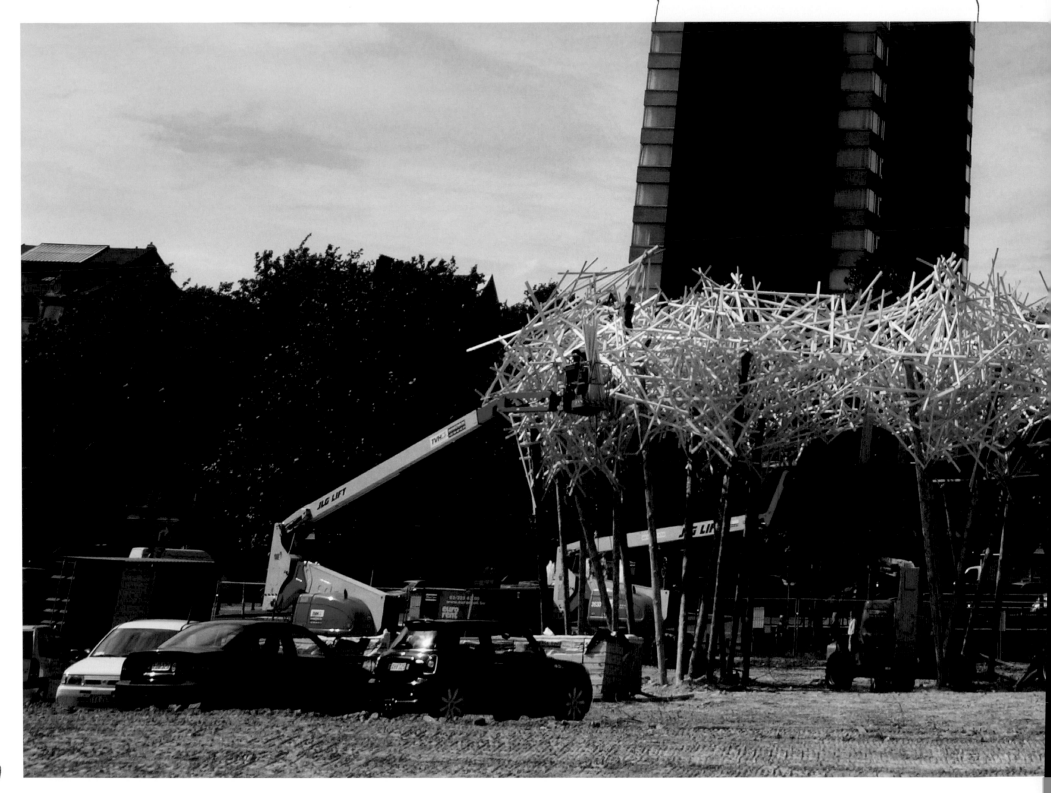

66

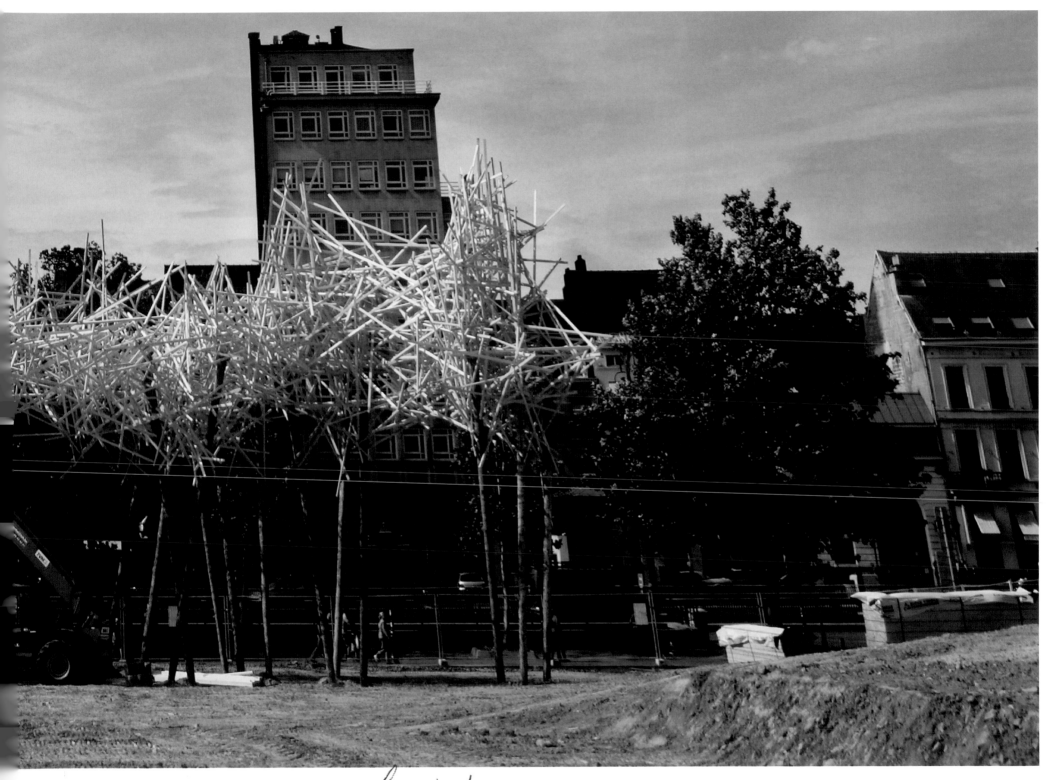

into & crown of thorns

67

68

controlled

69

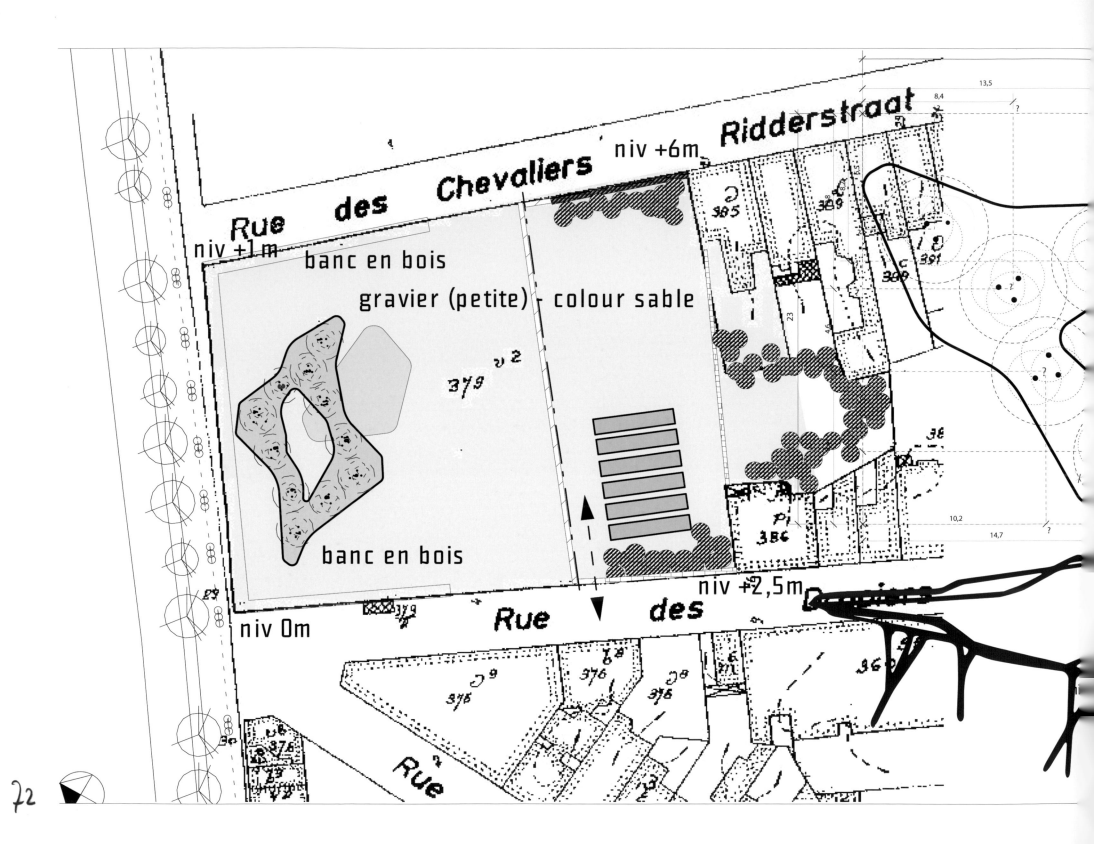

Rue des Chevaliers / Ridderstraat

niv +6m

niv +1m

banc en bois

gravier (petite) - colour sable

379

banc en bois

niv +2,5m

niv 0m

Rue des

Rue

72

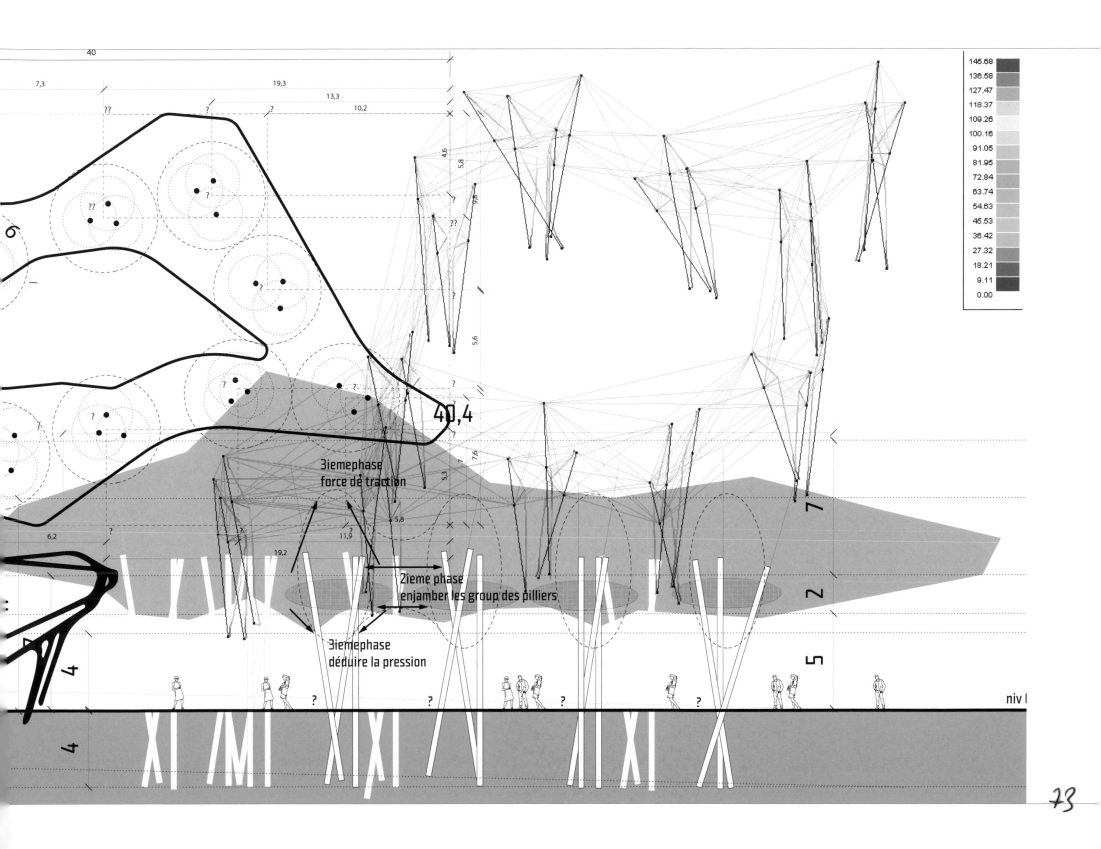

3iemephase
force de traction

2ieme phase
enjamber les group des pilliers

3iemephase
déduire la pression

niv

73

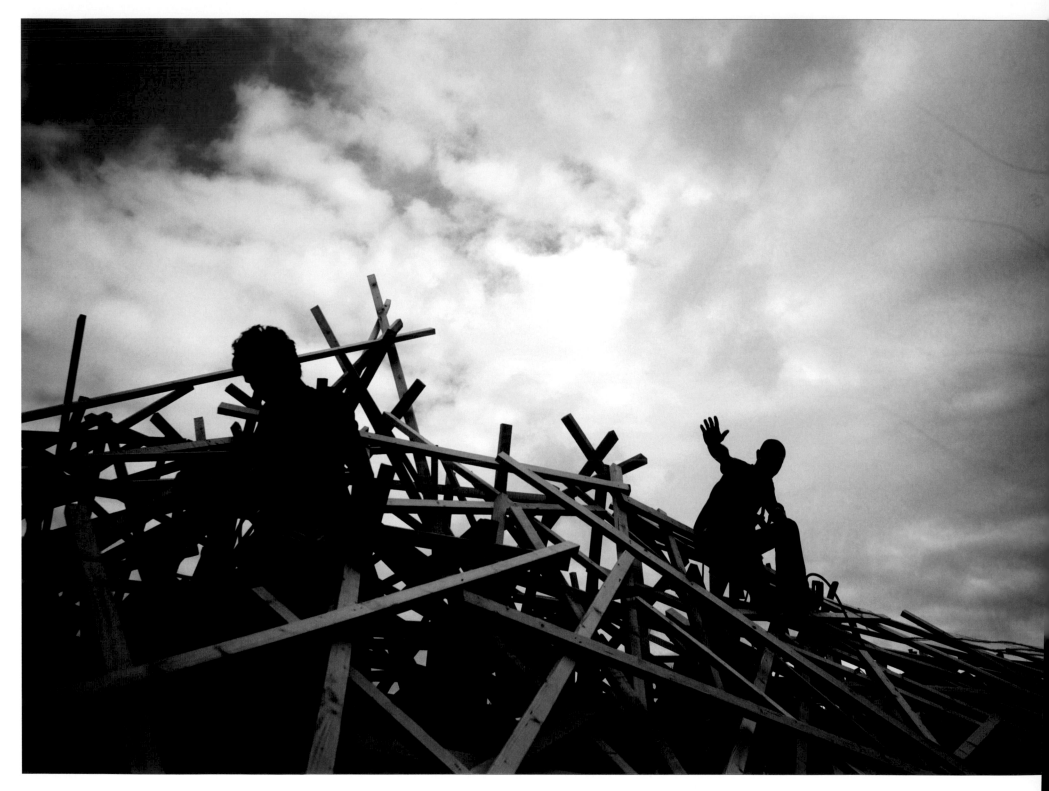

74

"

I've always been an ardent defender of chaos. It's the driving force behind all my work. Because
my future sculptures will always grow bigger and more complex, Cityscape was the first to be linked to
a stability study, as well as being based on a vast number of drawings and a series of strategies and procedures
that had to be followed. But these only served to determine the framework within which we were allowed to improvise.
The way in which the wooden slats – equivalent in total length to more than 60 kilometres – were criss-crossed,
connected and pinned down by some 240,000 nails to form Cityscape was largely a matter of intuition. One hardly had
any overview while working high up amongst that unruly jumble, supported by 12 metre-high stilts.

"

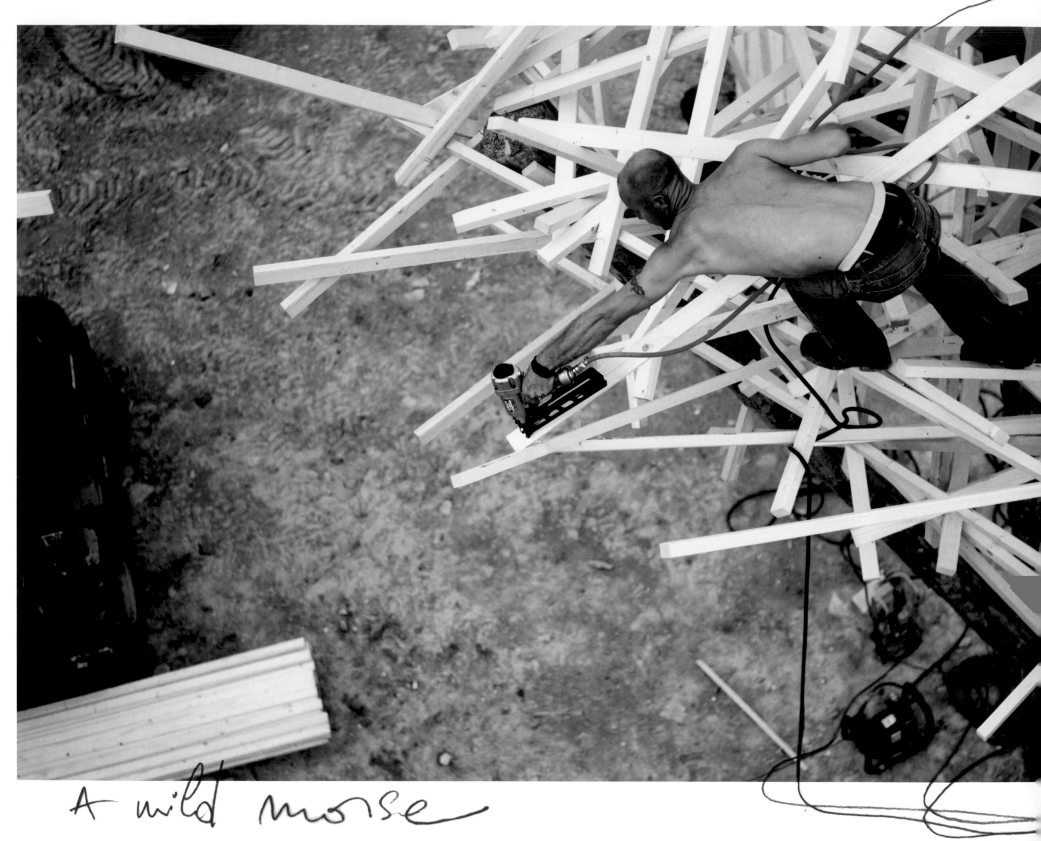

76

A wild moose

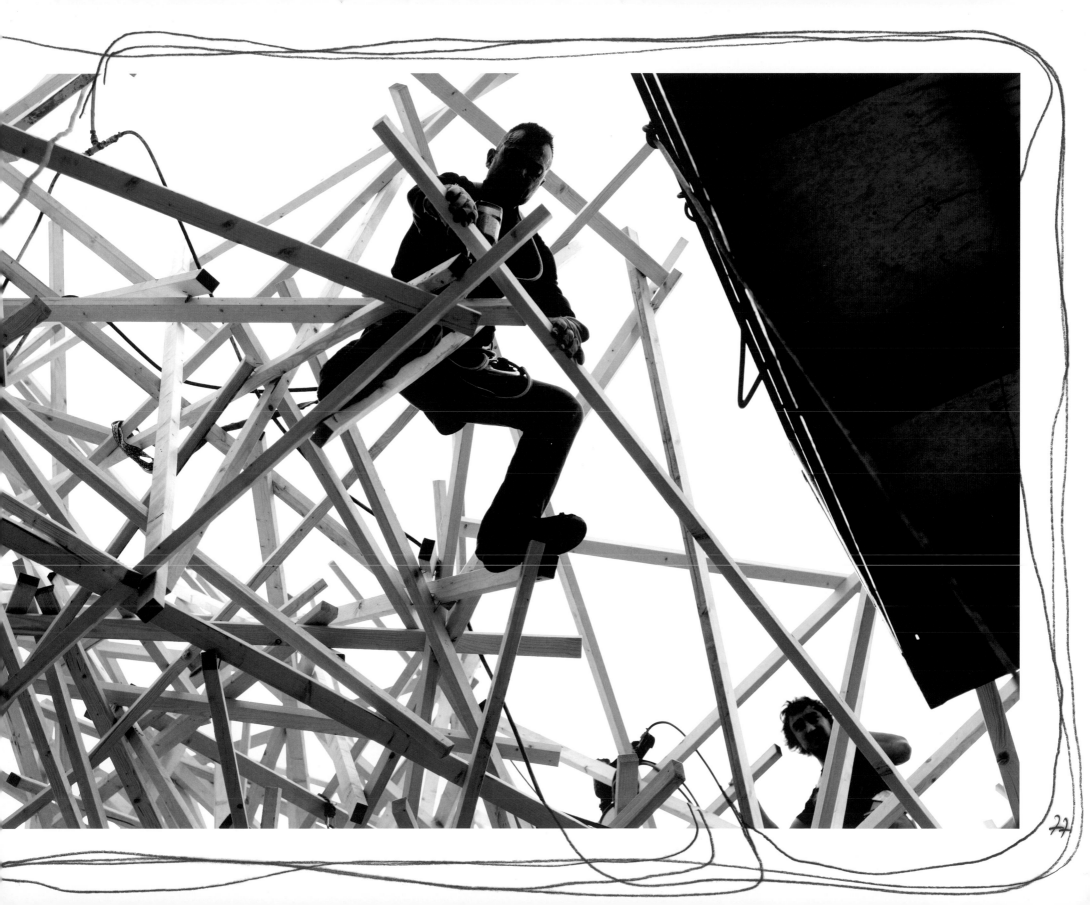

78

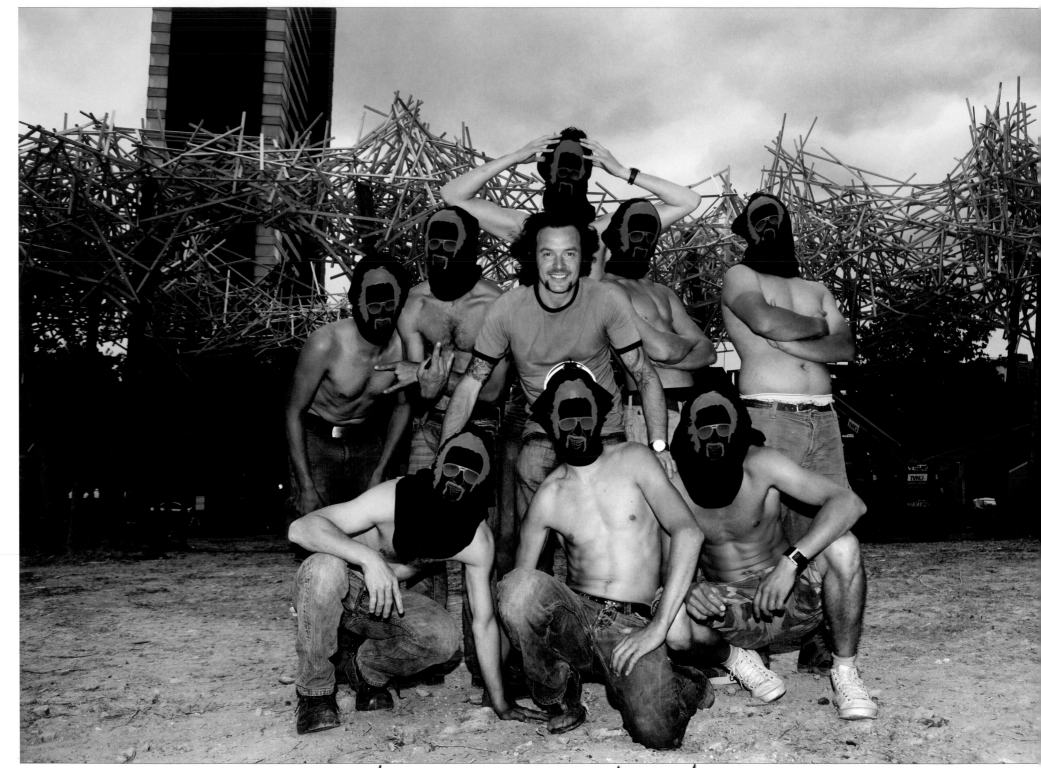

A symphony orchestra

"

I still have this habit of comparing Quinze & Milan to a hard rock band with a front man or singer who is of little value if not surrounded by musicians who instinctively know how and when to anticipate. But with a company that grew to more than 60 employees and workers, it's probably better to use the image of a symphony orchestra) I have been fortunate to be able to call upon the services of many experts across a diverse range of disciplines – from architecture and graphic design, to carpentry. To these, I only have to give a very rough outline of a score and then I can conduct and trust them almost blindly. The result is a perfect symbiosis, a synergy and ensemble in which each member of the orchestra, including myself, merges into a larger whole. In that sense, even the making of Cityscape is nothing more than a reflection of the harmonious chaos I'd like to propagate as a model of future society.

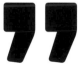

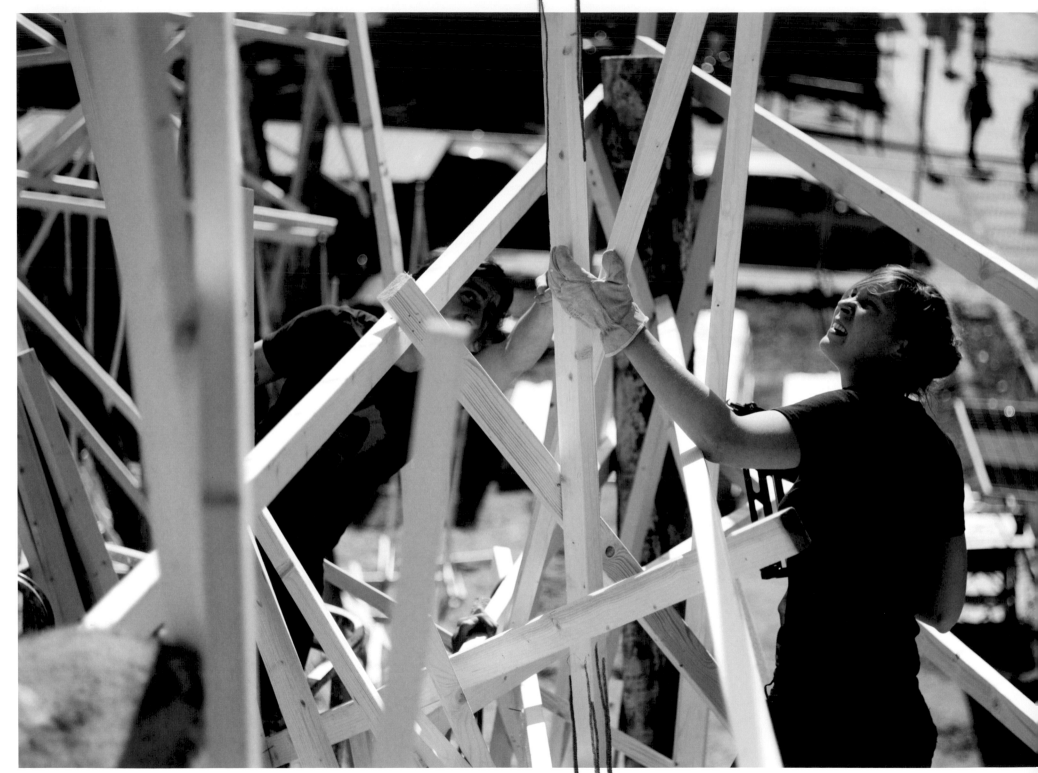

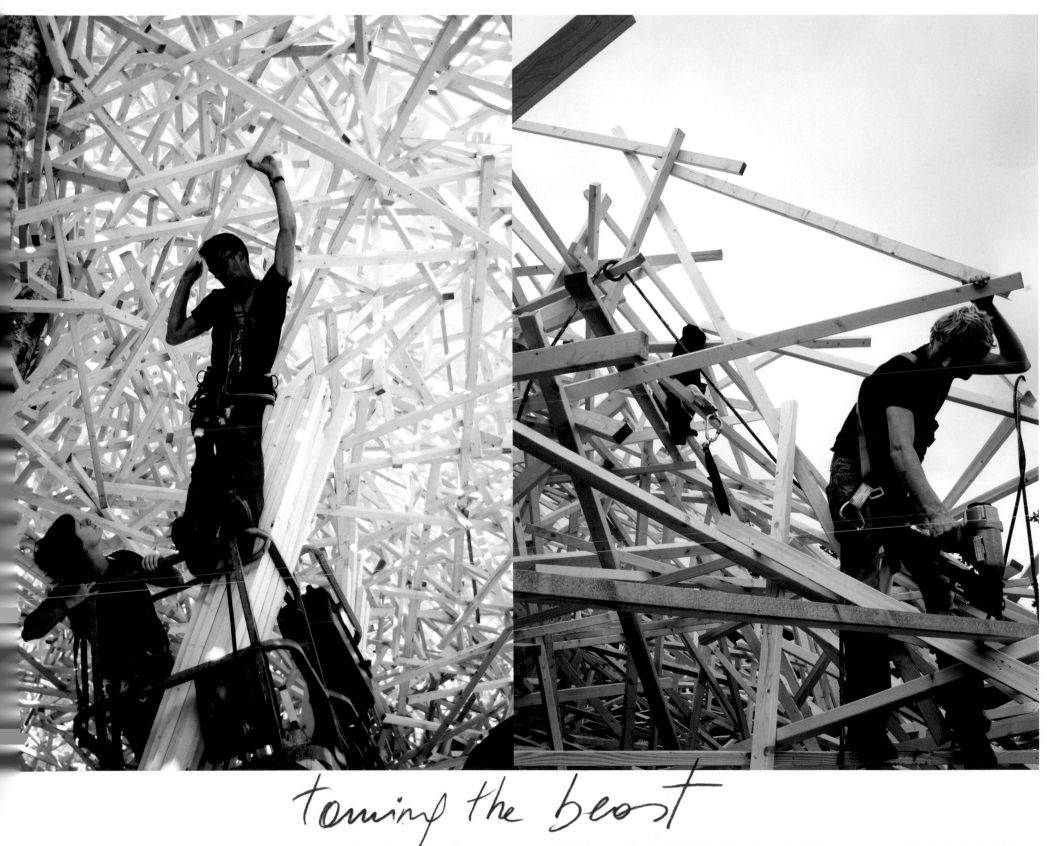

taming the beast

81

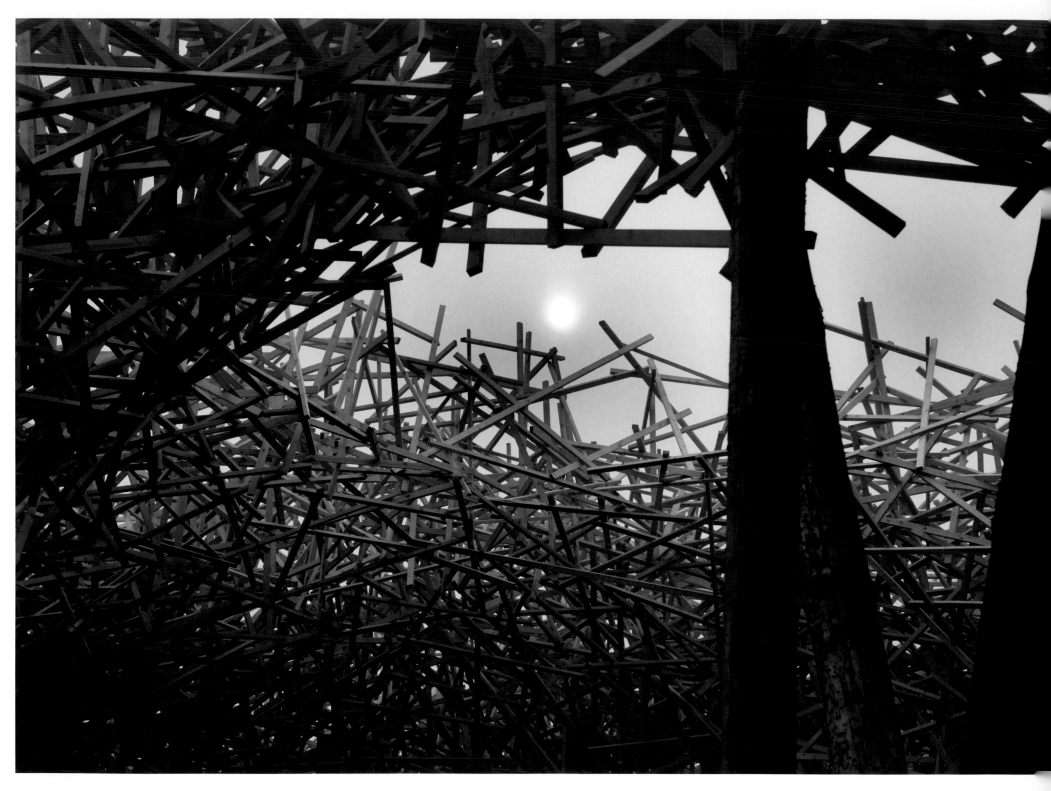

82

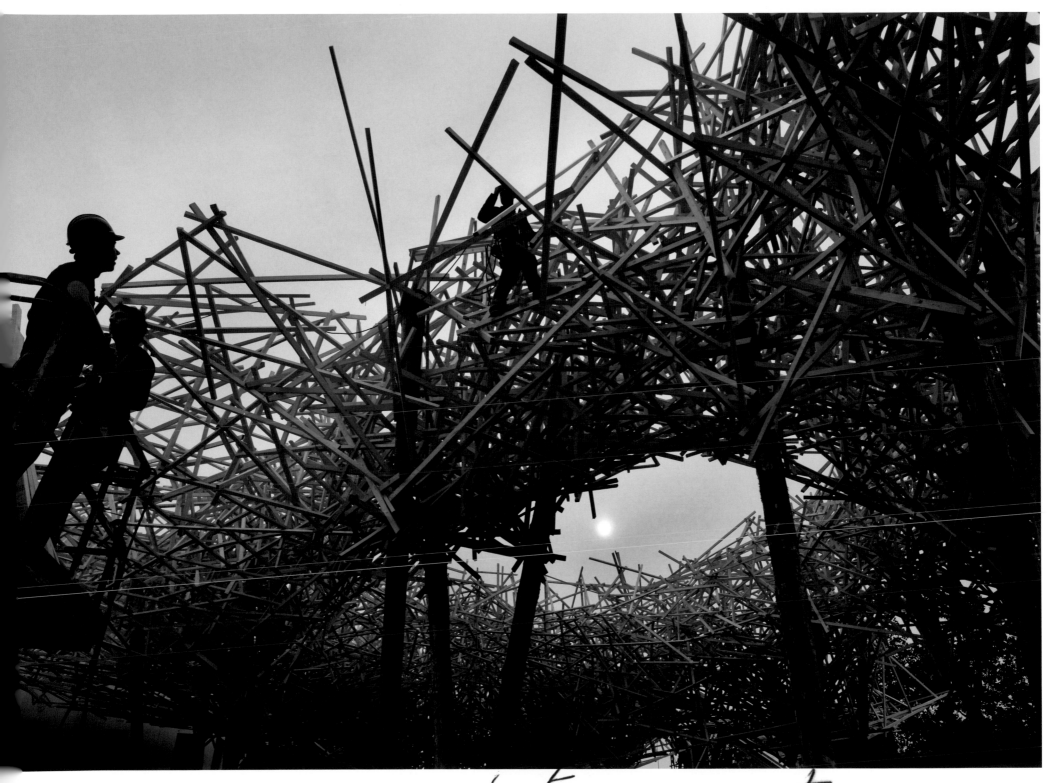

into a nest

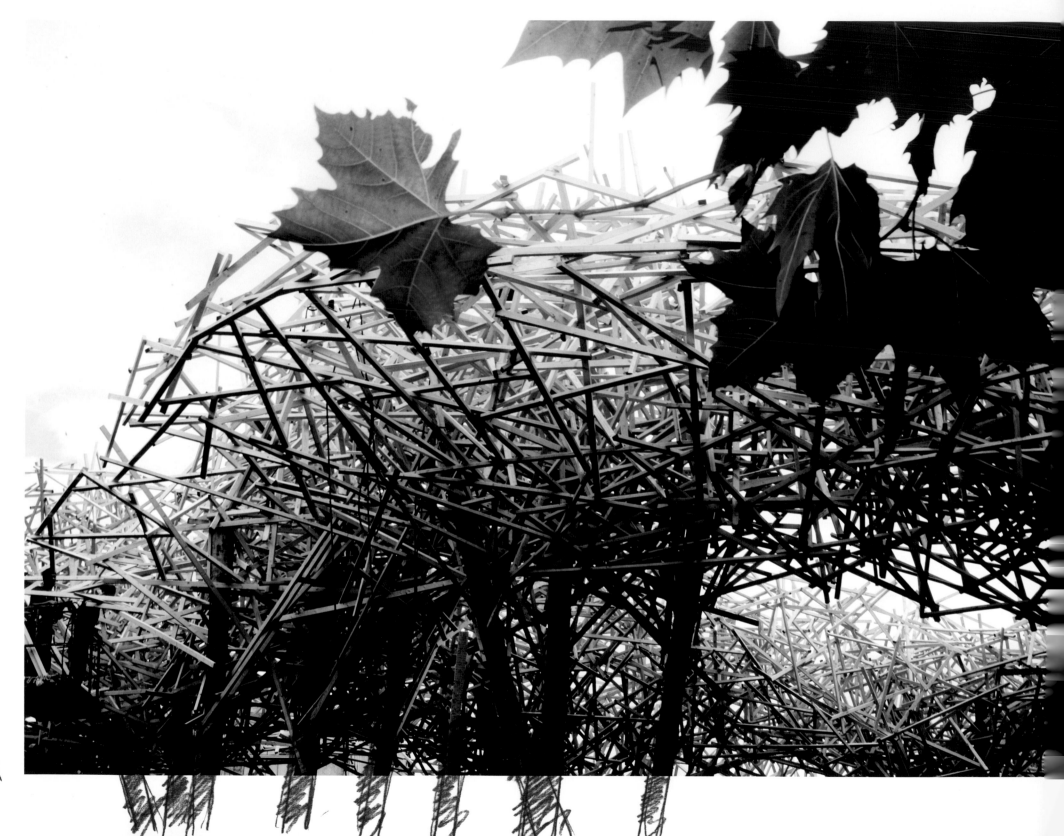

84

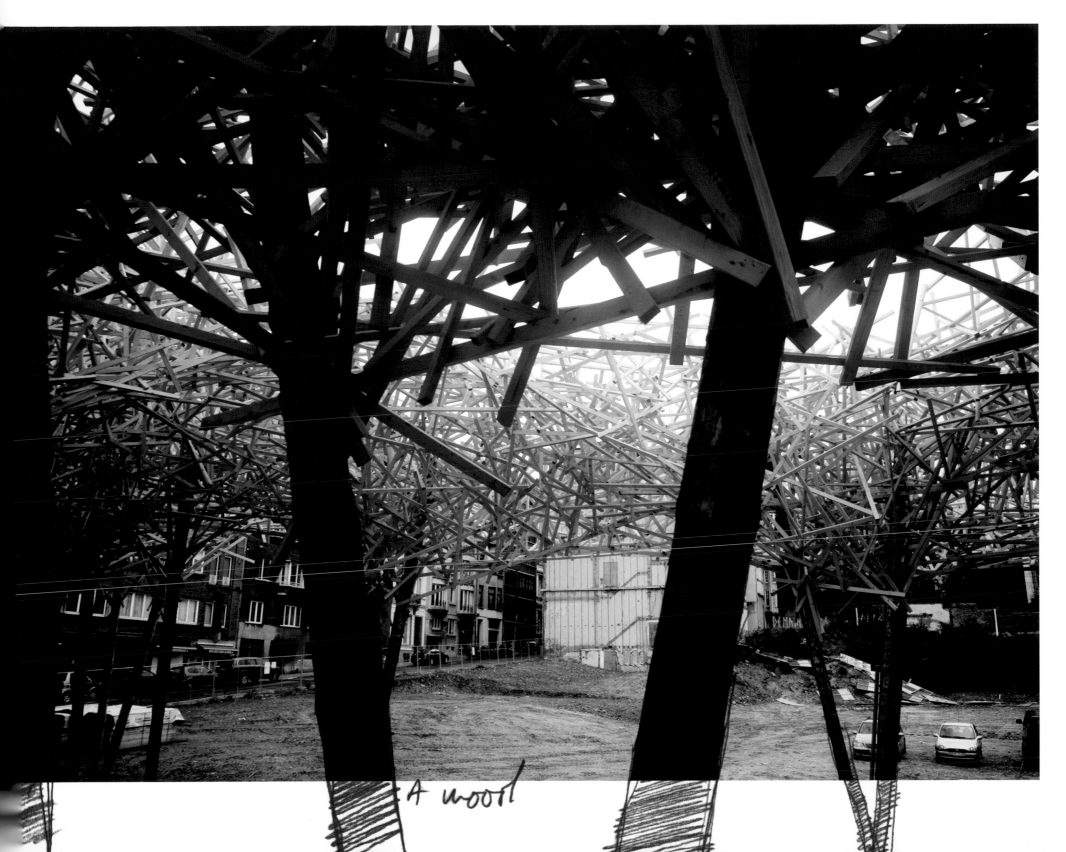

A wood

85

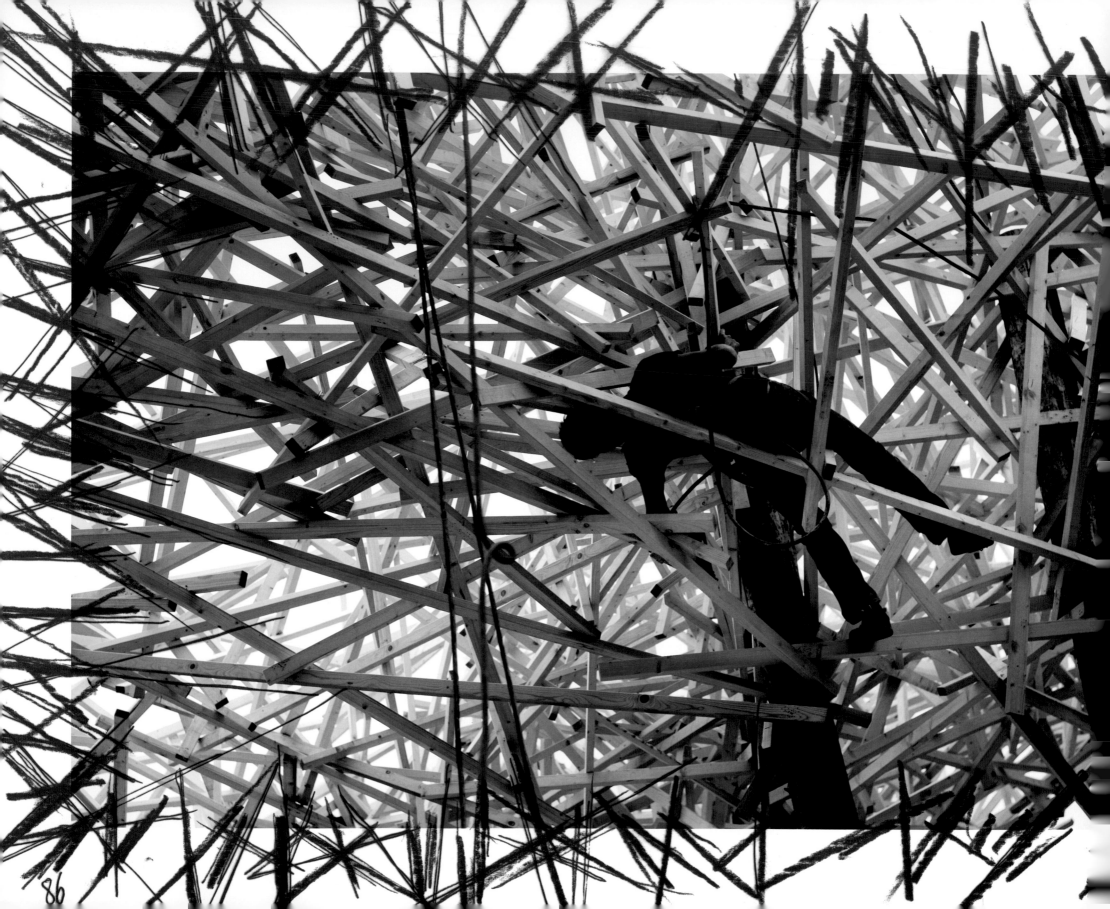

86

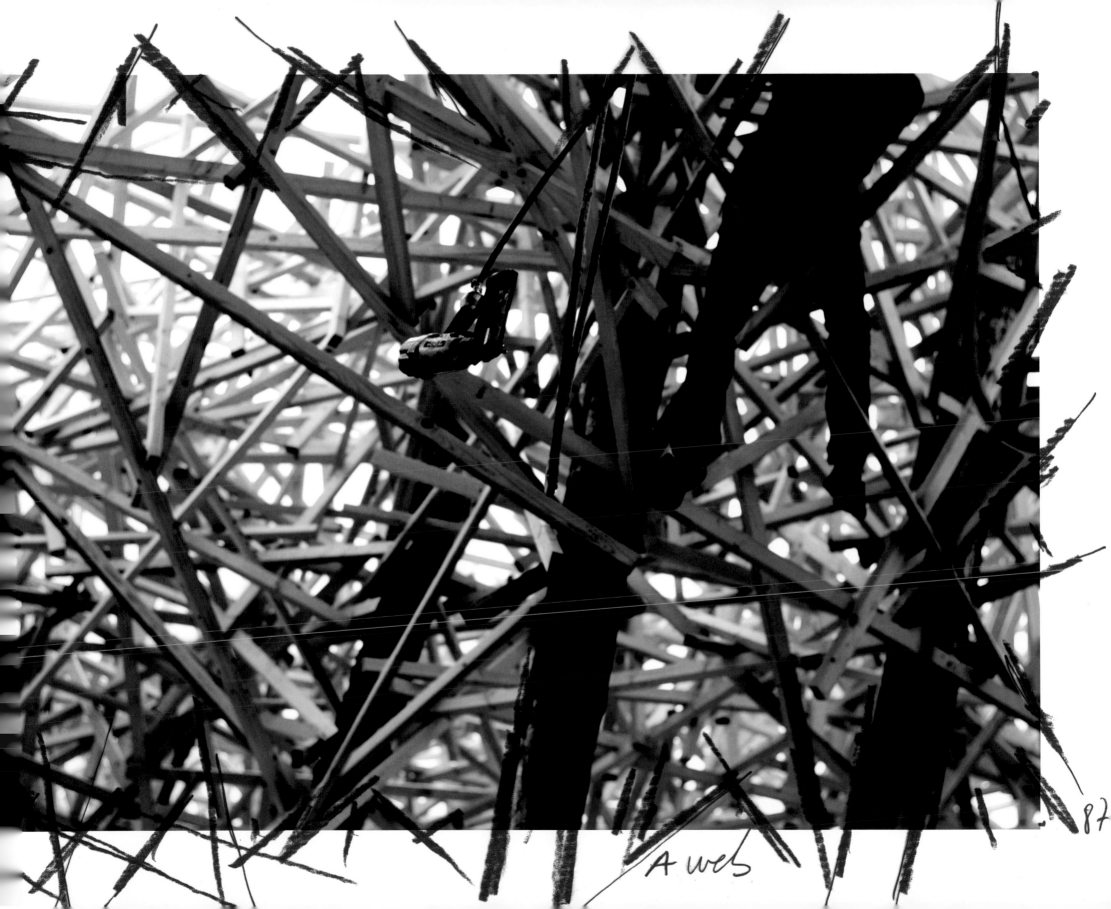

A web

87

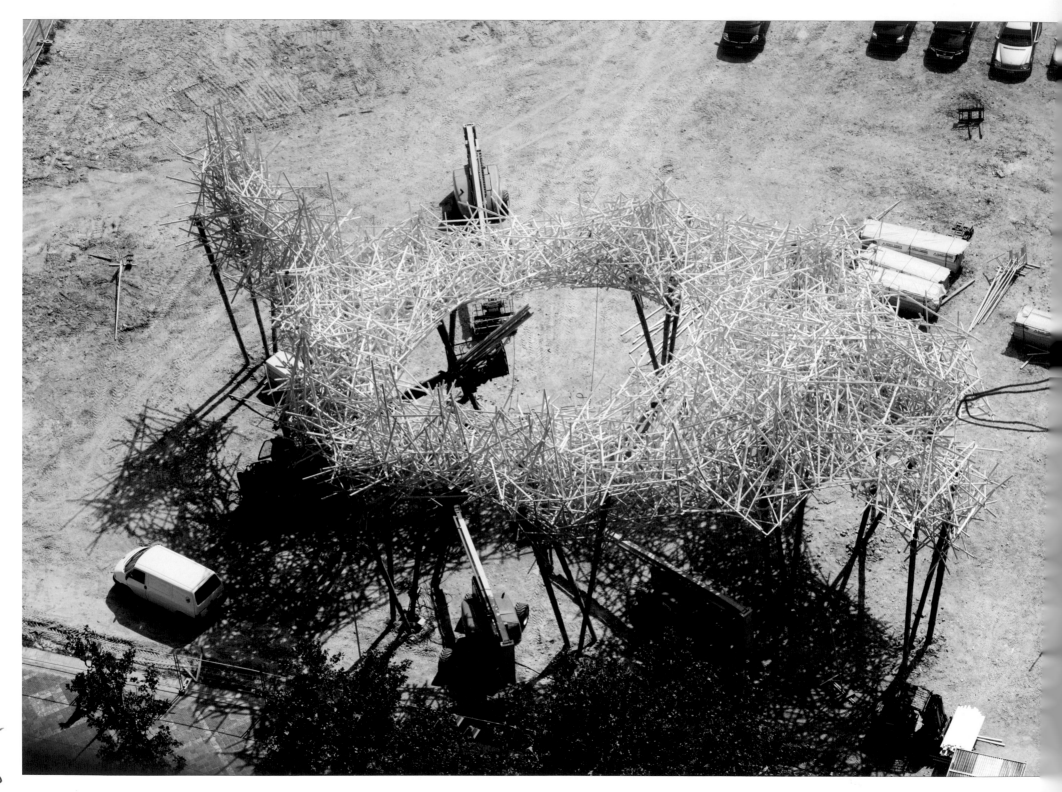

"

While at a certain point – and despite its city marketing mission – it could certainly also be considered
to be 'a deconstructive manifesto', showing a middle finger to what is still considered to be Belgium's most stylish
and smartest shopping neighbourhood, the artwork successively mutated from something that resembled a field of gallows
into a giant crown of thorns, a nest, a cloud or a shuttle, to end up with a final form that closely resembles a manta ray,
not accidentally the largest, but also the most elegant fish ever seen.

"

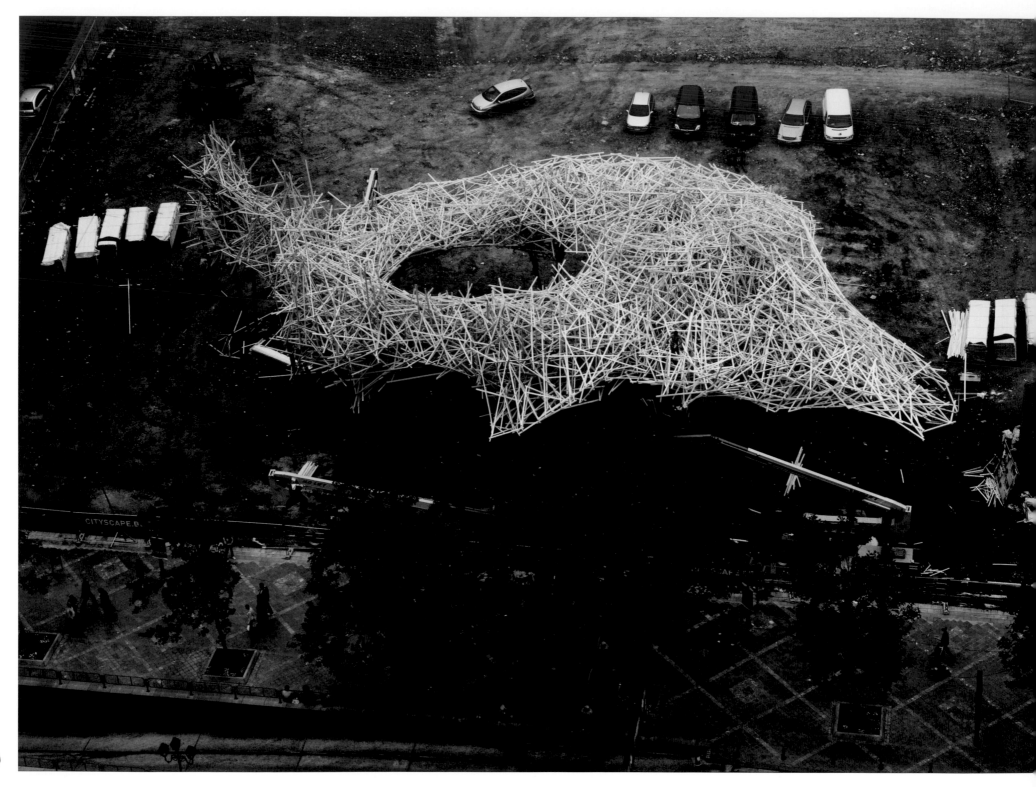

90

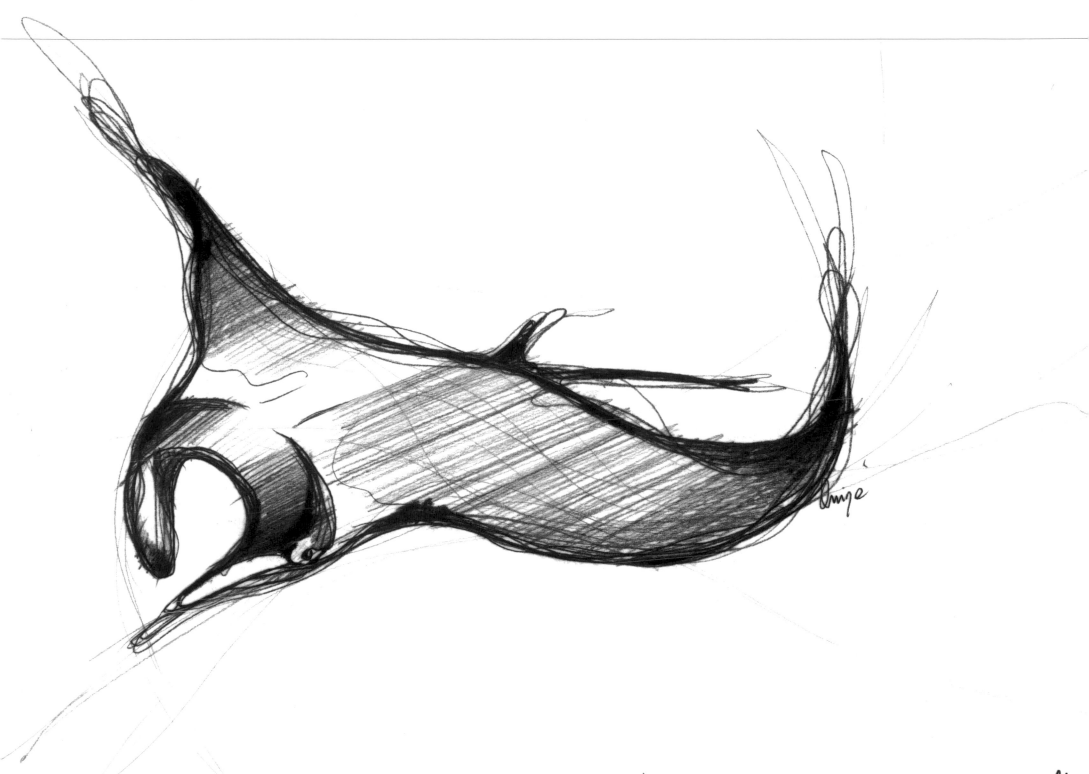

A Manta eray

91

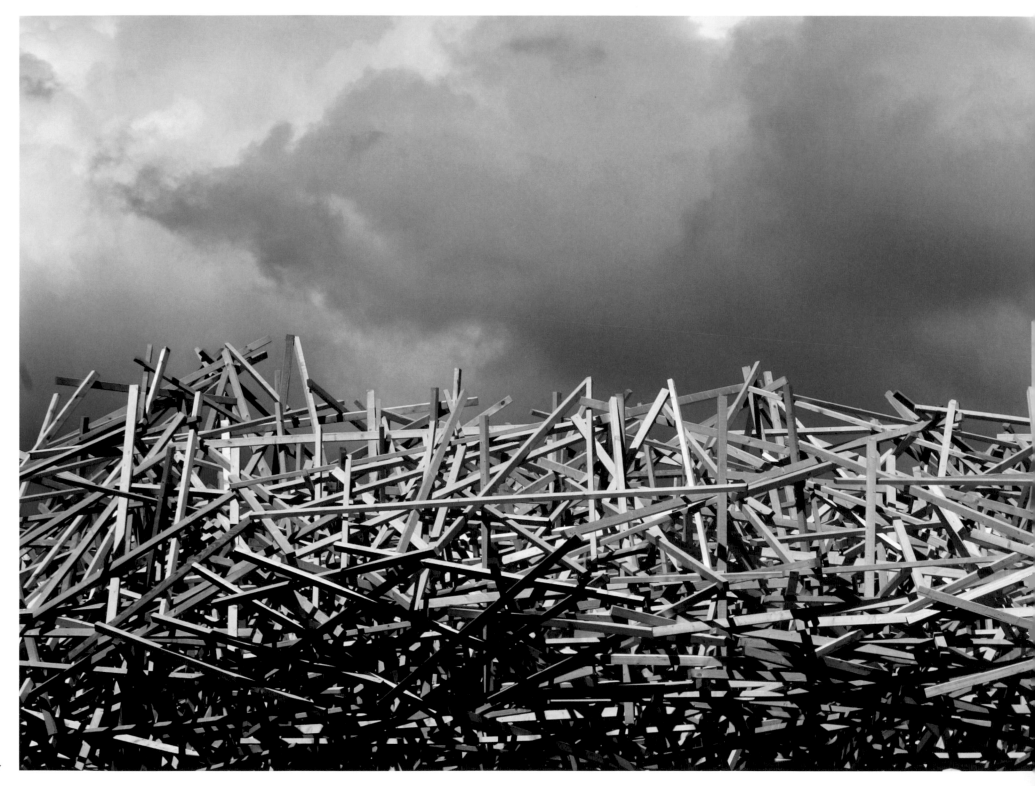

92

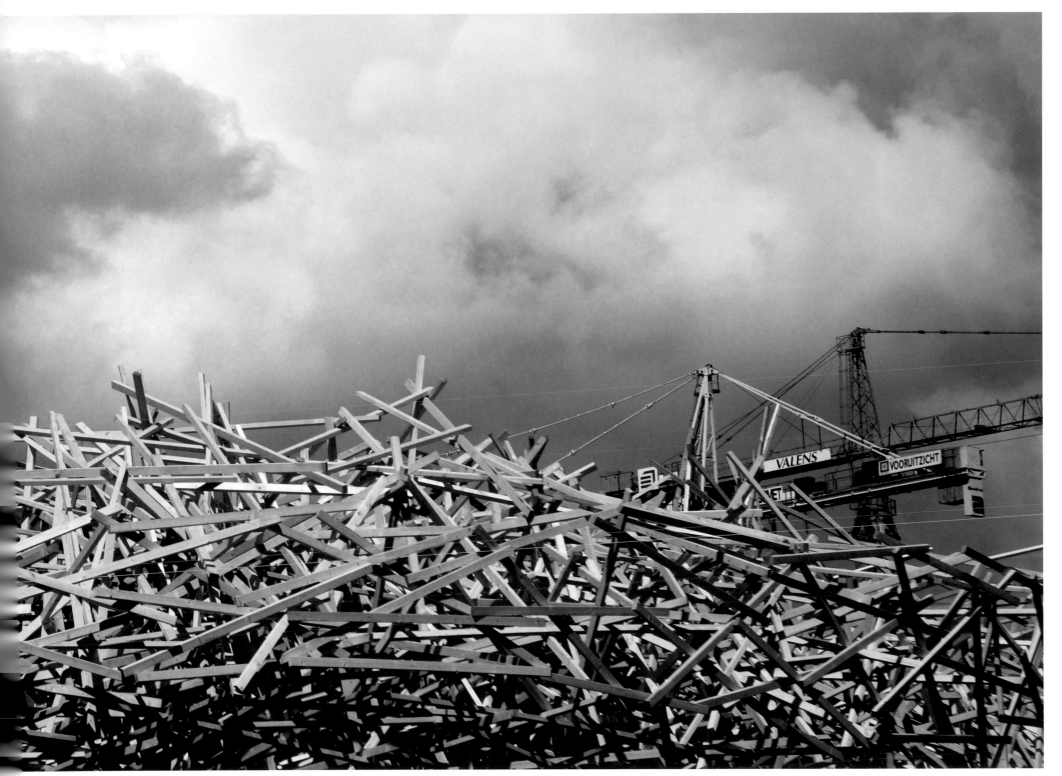

93

massive

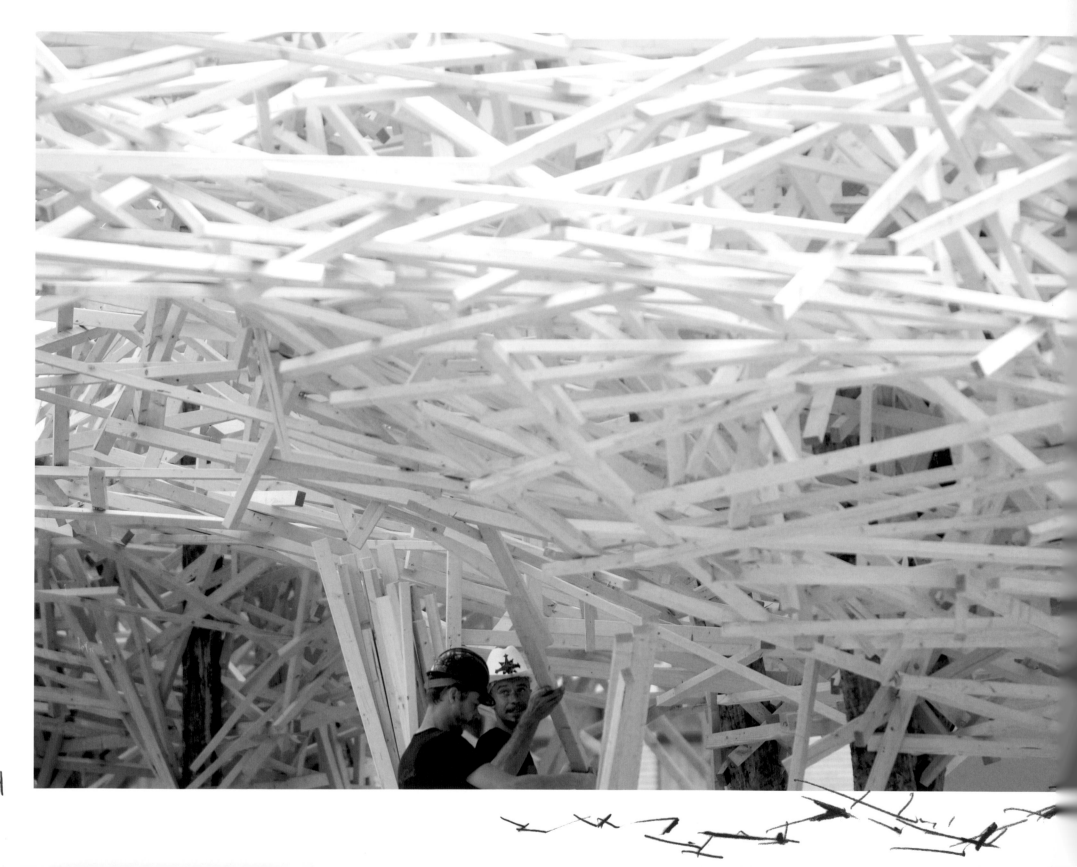

94

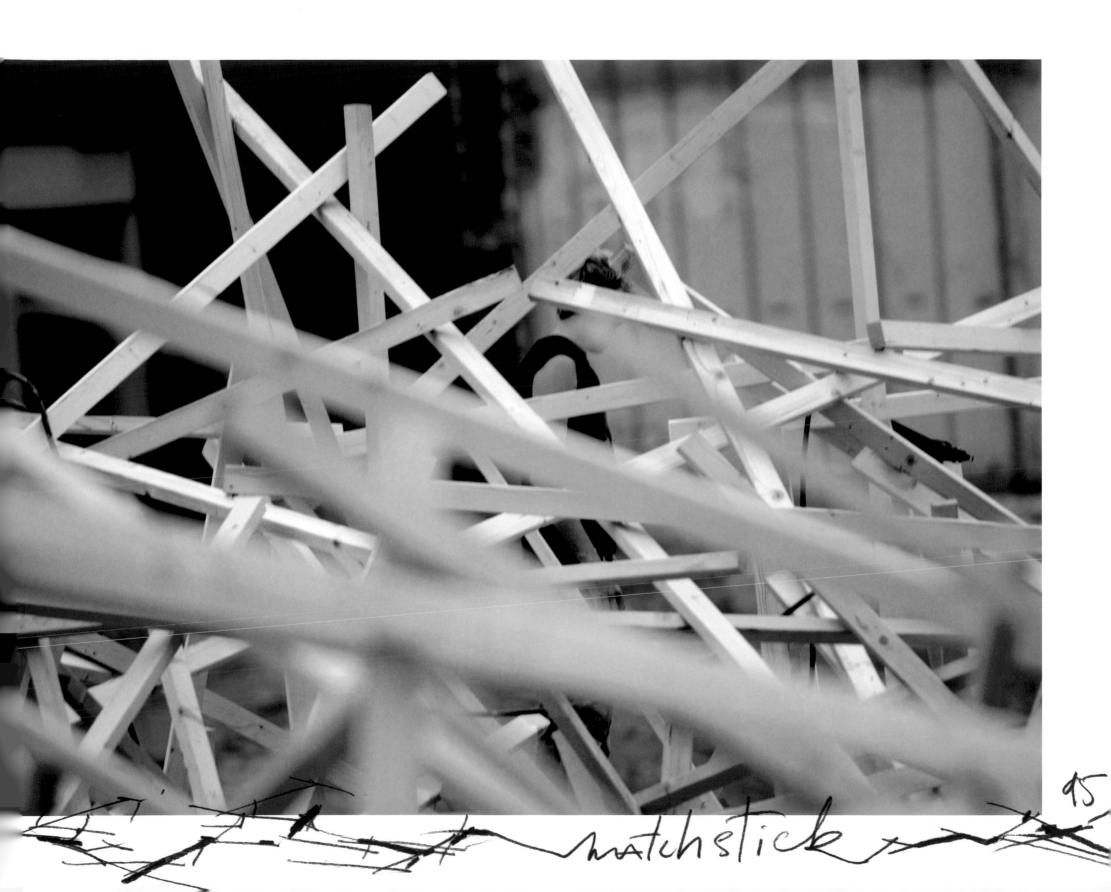

matchstick

95

96

AMAZing

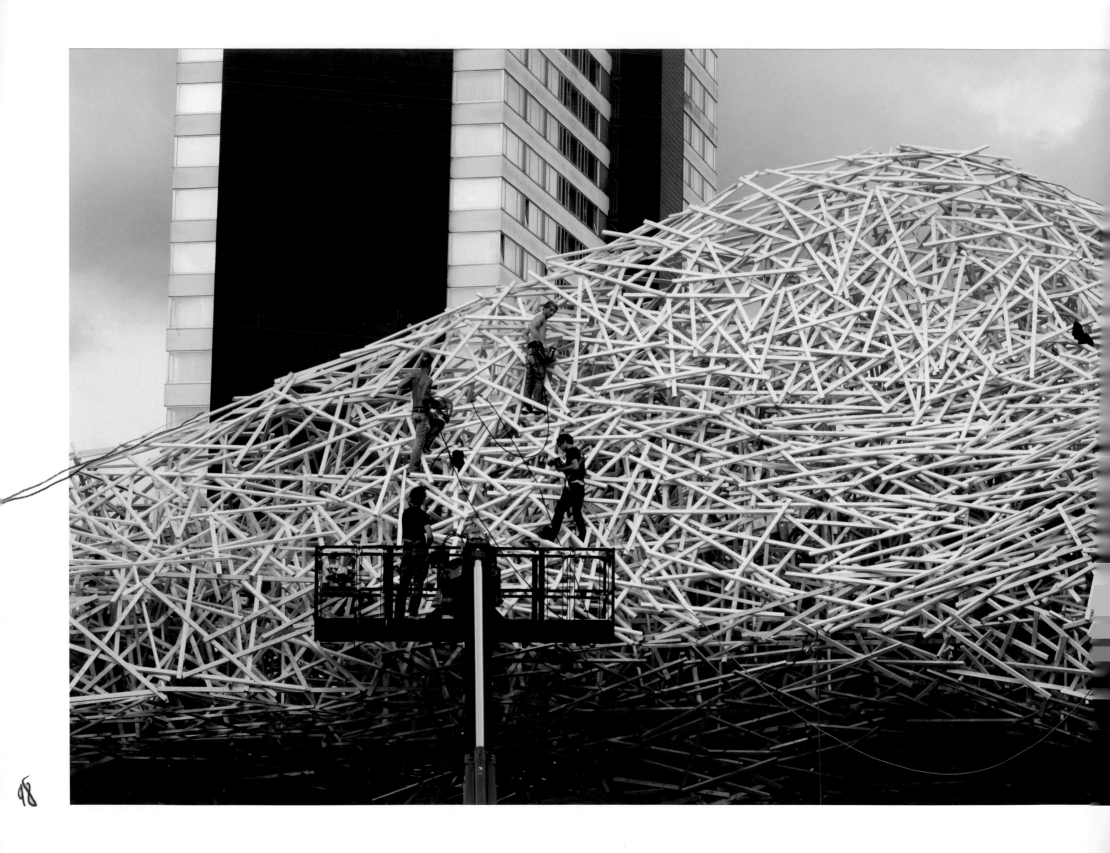

"

More and more, the sculpture came to resemble a termite hill on stilts, as team members kept pinning down the long and short slats in a frantic and risky rhythm. Like birds building a nest, a wooden lattice, criss-crossed, and with little overview once they were up there, they intuitively and flawlessly improvised, as if driven by a collective subconscious. This alone turned Cityscape into a beautiful metaphor during the creation process: for while the insects remain frail and insignificant on their own, together they form a formidable army. Its seemingly chaotic movements and manoeuvres prove to be of incredible beauty and efficiency, creating continuously changing formations, patterns and networks that are strong and meaningful.

"

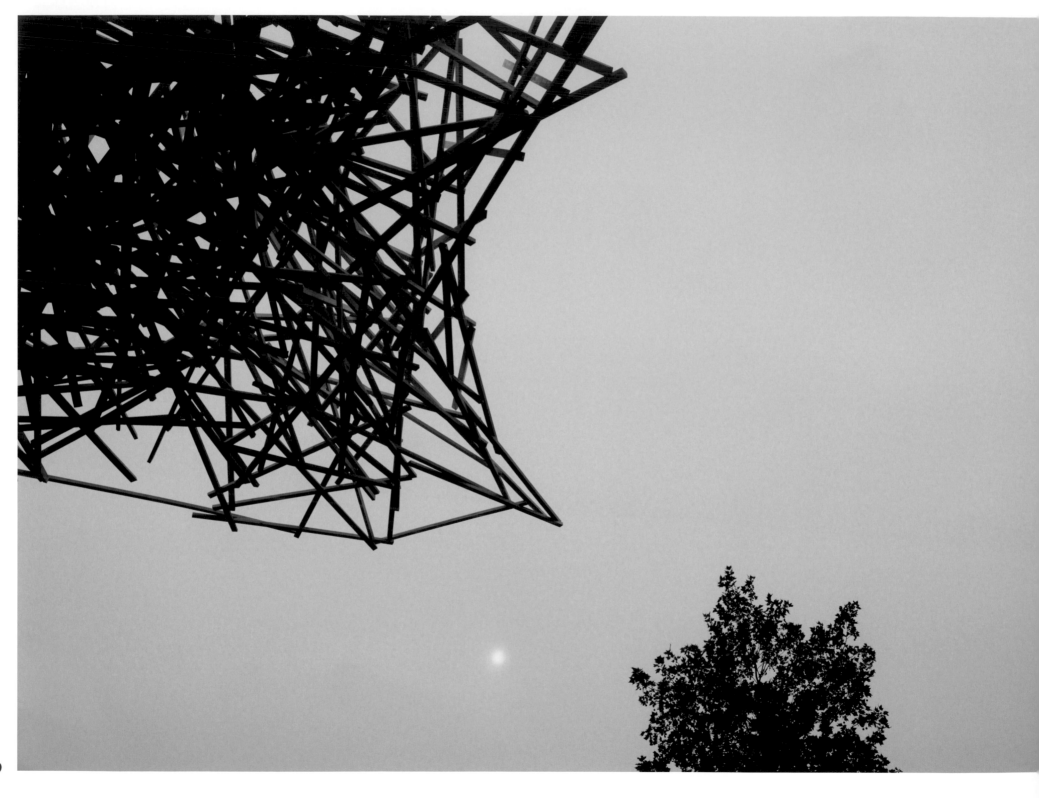

100

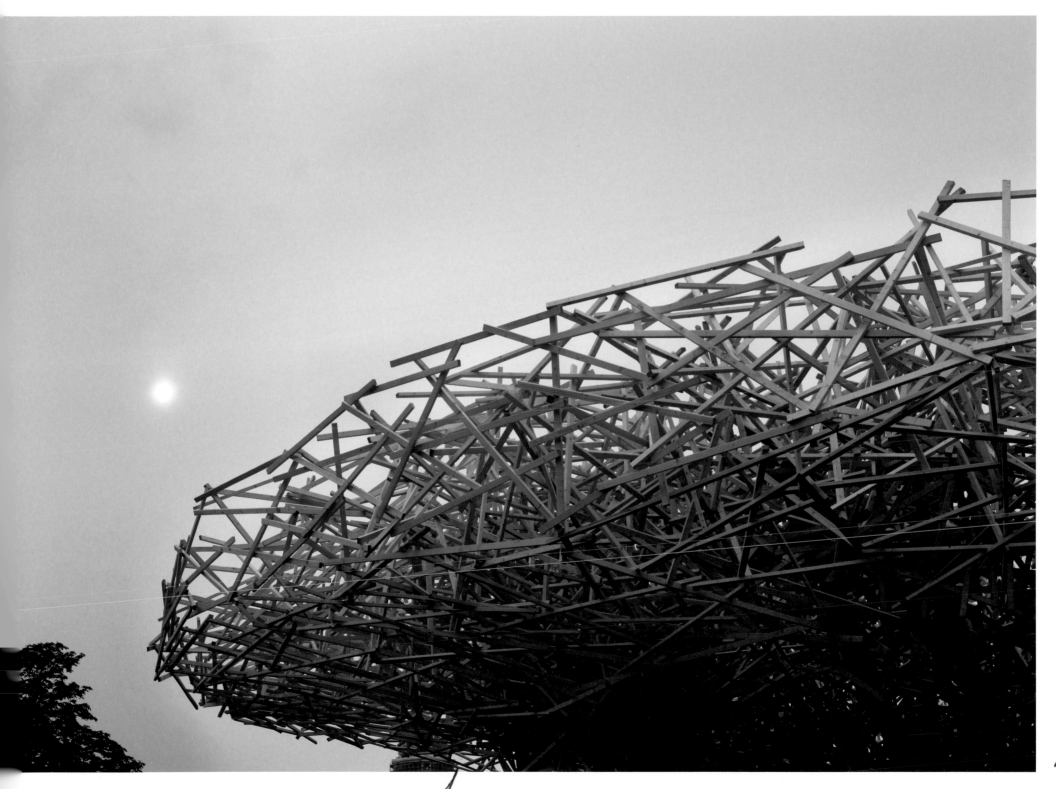

101

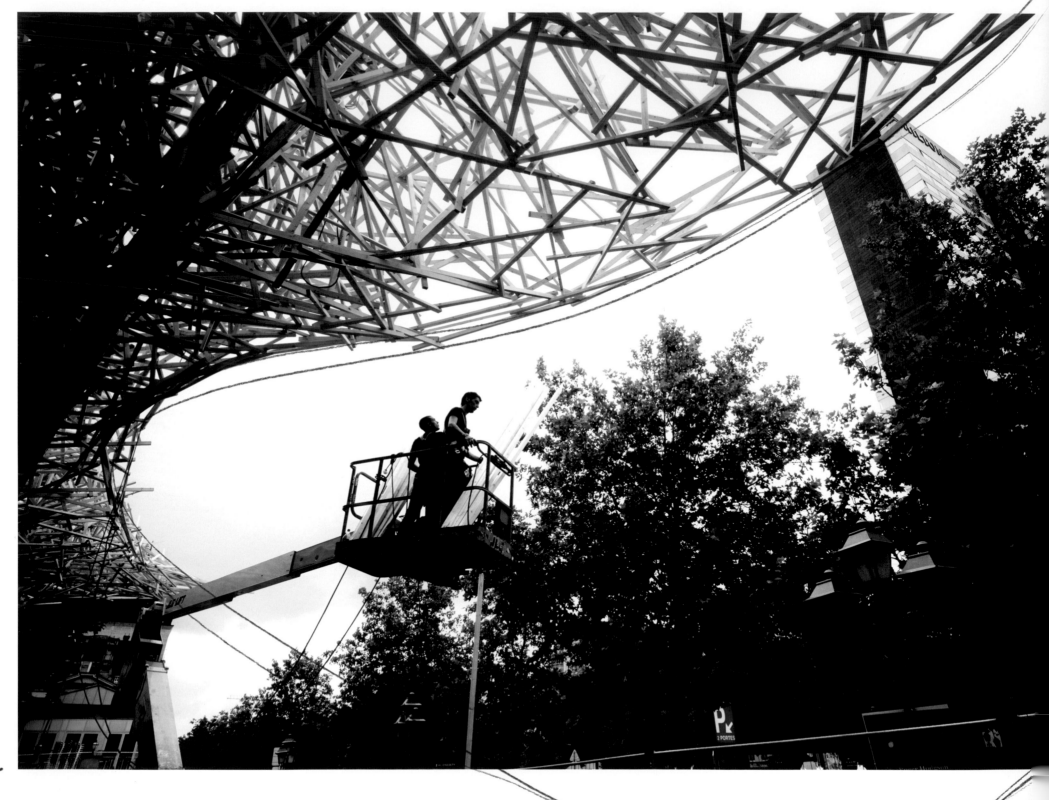

102

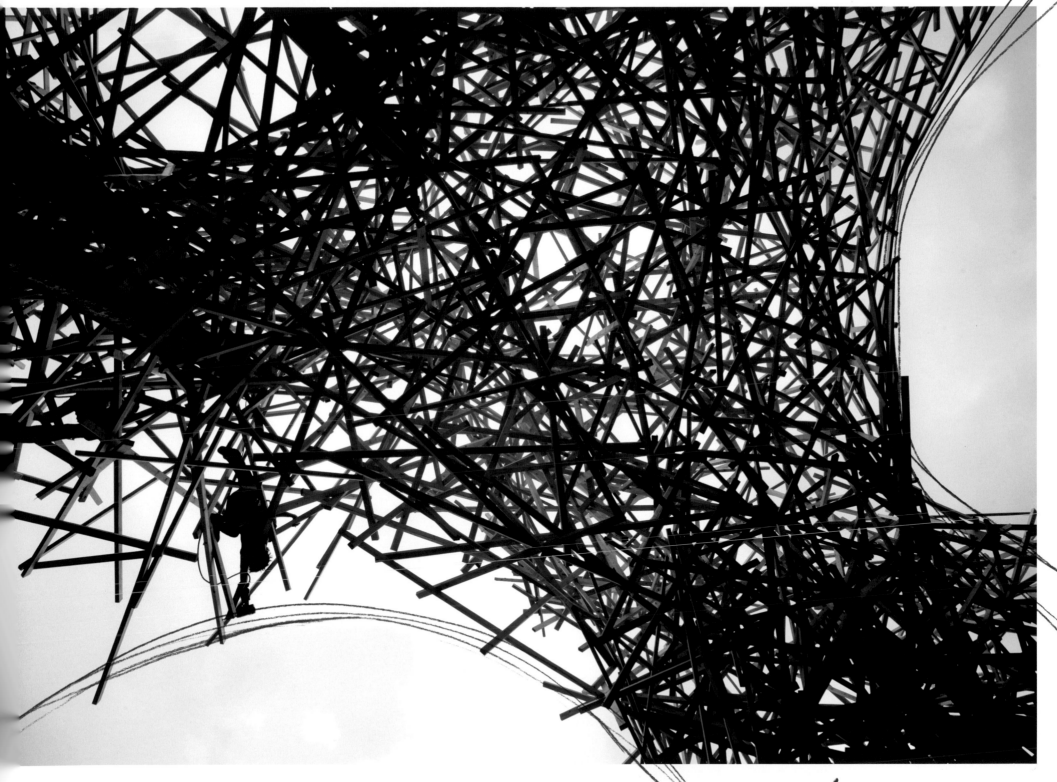

103

Curry

Risky

105

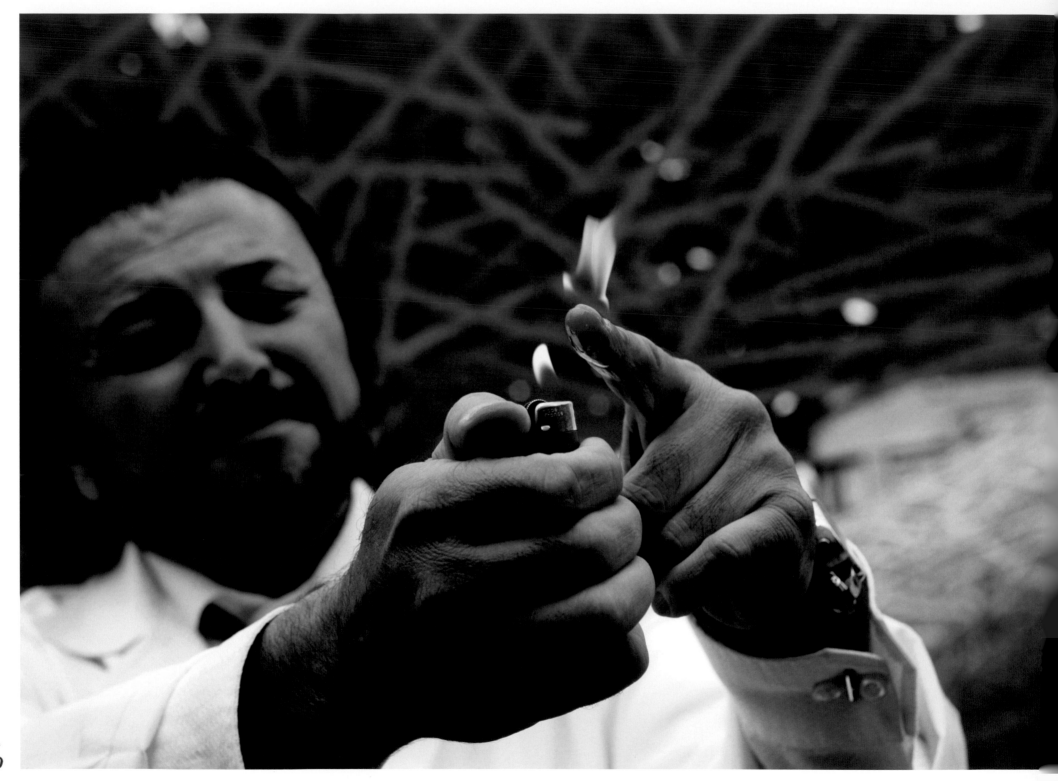

106

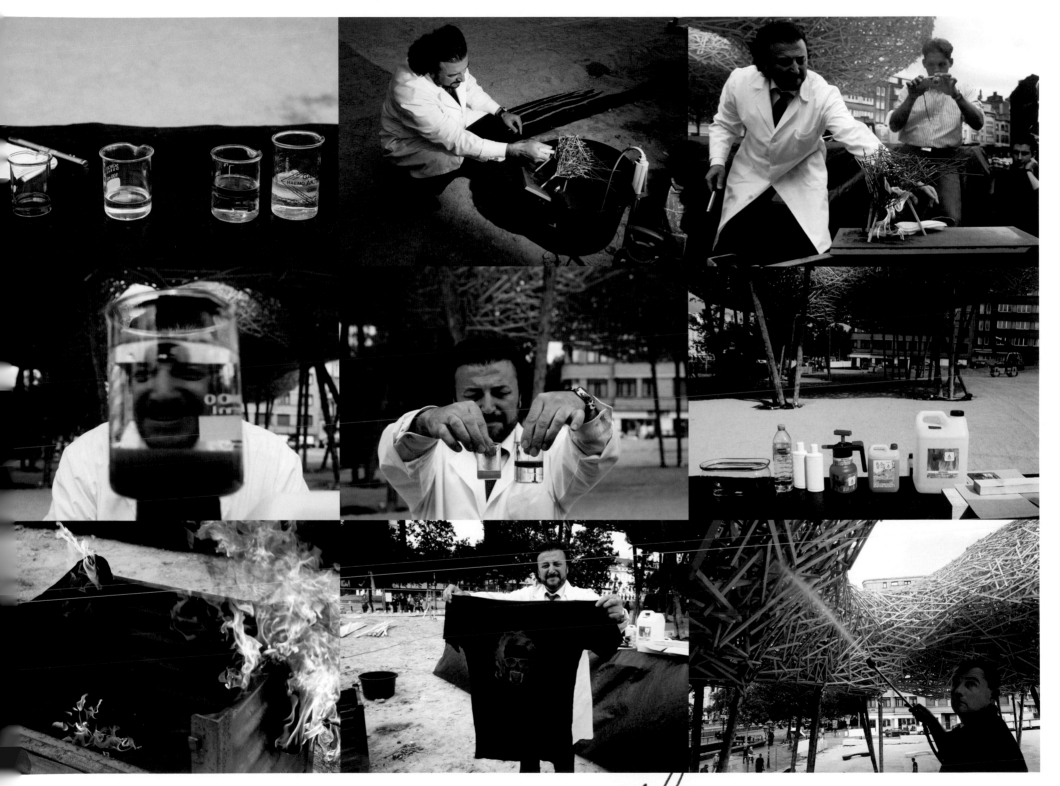

safe

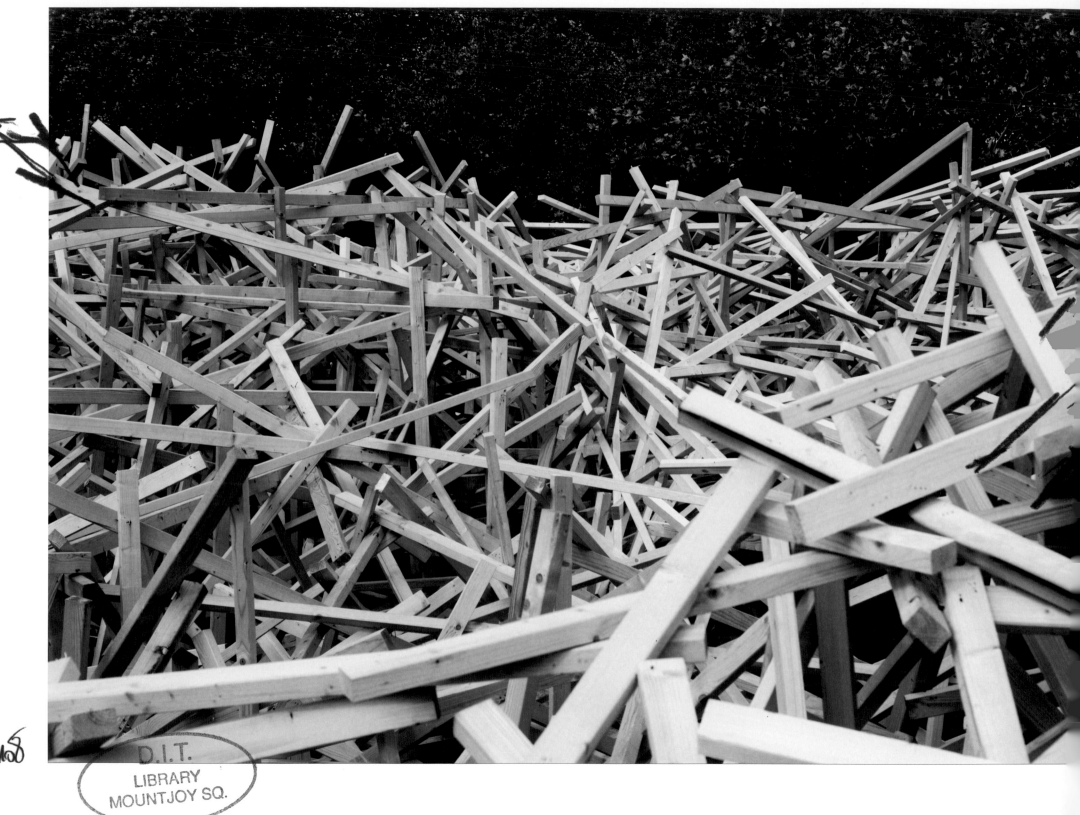

Madam, Sir,

Thank you for calling us a bunch of good-for-nothing arseholes and criminals, and for the many other distinguished titles bestowed upon us in your e-mail. It's just a pity that you sent it to us without adding a name or address. Otherwise we,and I think I can speak on behalf of all the 'apes' that built Cityscape, would be only too happy to leave our trees to come and thank you personally.

Or we could have invited you to the strange kind of cocktail bar that was set up the day before yesterday near Cityscape by the eminent Turkish scientist and our dear friend Ayhan Doyuk, alias the Alchemist of Water. We feel extremely proud that we could offer Ayhan the opportunity to travel from Turkey to Belgium in order to demonstrate the working of Flame Safe, a revolutionary new concoction that was sprayed over the sculpture, rendering it fireproof. Entirely concocted from ecological ingredients, Flame Safe could be tremendously effective in the fight against forest fires.

Suffice it to say, Arne and every member of our team shares your concern for the environment. This concern played a decisive role in the Cityscape project. In fact, so much so that it was even part of the plan to arouse the kind of reaction and indignation you have expressed – be it only because we seek to stimulate a dialogue on the use of materials. The fact that the sculpture was almost exclusively built of wood – 33 stilts that support beams with a total length of more than 60 kilometres and a total weight of 72 tons – stems partly from Arne's vision of the ideal house of the future, made of wood as an alternative to concrete and other materials, which cannot be recycled and which unnecessarily exhaust the earth's resources. The wood we used was bought from suppliers who are members of PEFC, the Pan European Forest Council, an organisation that actively fights continuing deforestation by using part of its members' turnover from cut wood to plant new trees. Once Cityscape is dismantled, the wood will travel to Germany and be ground and recycled into chipboard, only after the 240,000 nails used to hold the sculpture are extracted using magnets.

Therefore, in conclusion, when you advise us to 'choose another life' (something we have considered many times over the last few days, but not for the reasons you mention), I would like to suggest that you 'choose another enemy', in order not to waste any more negative energy.

Yours sincerely,
FRÉDERIC VAN DOOREN
Architect of Cityscape

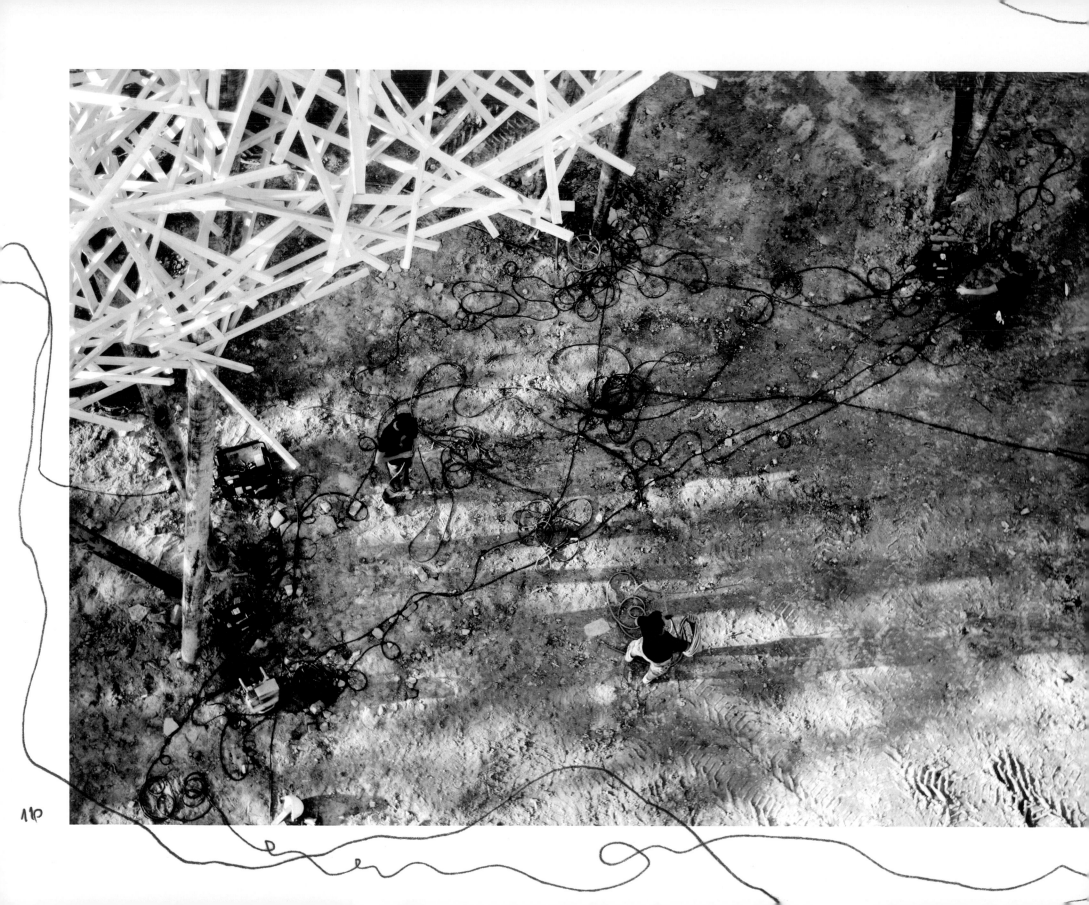

110

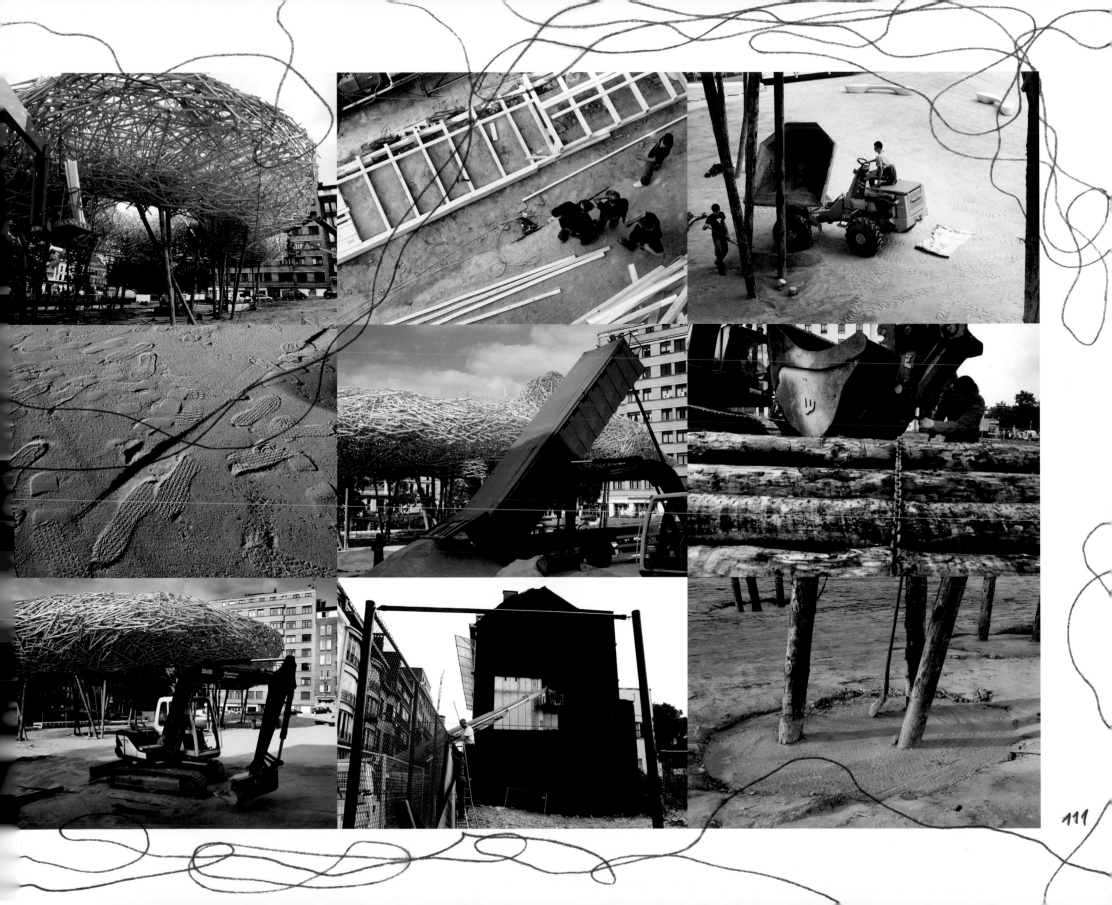

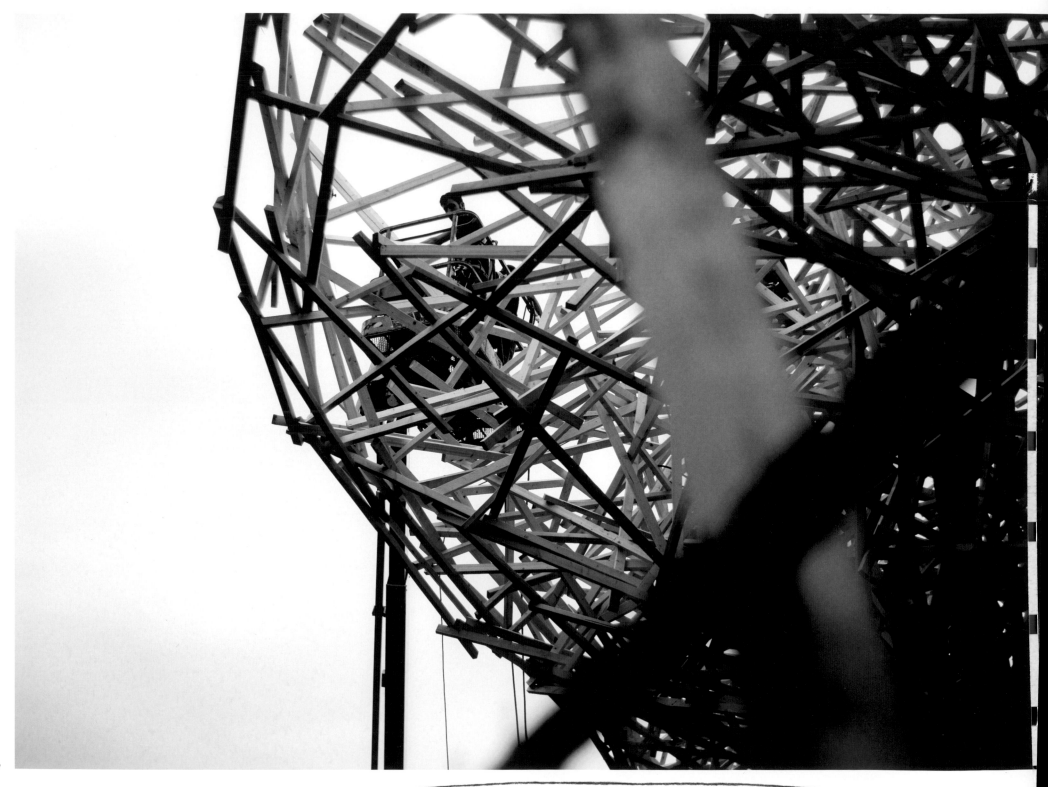

112

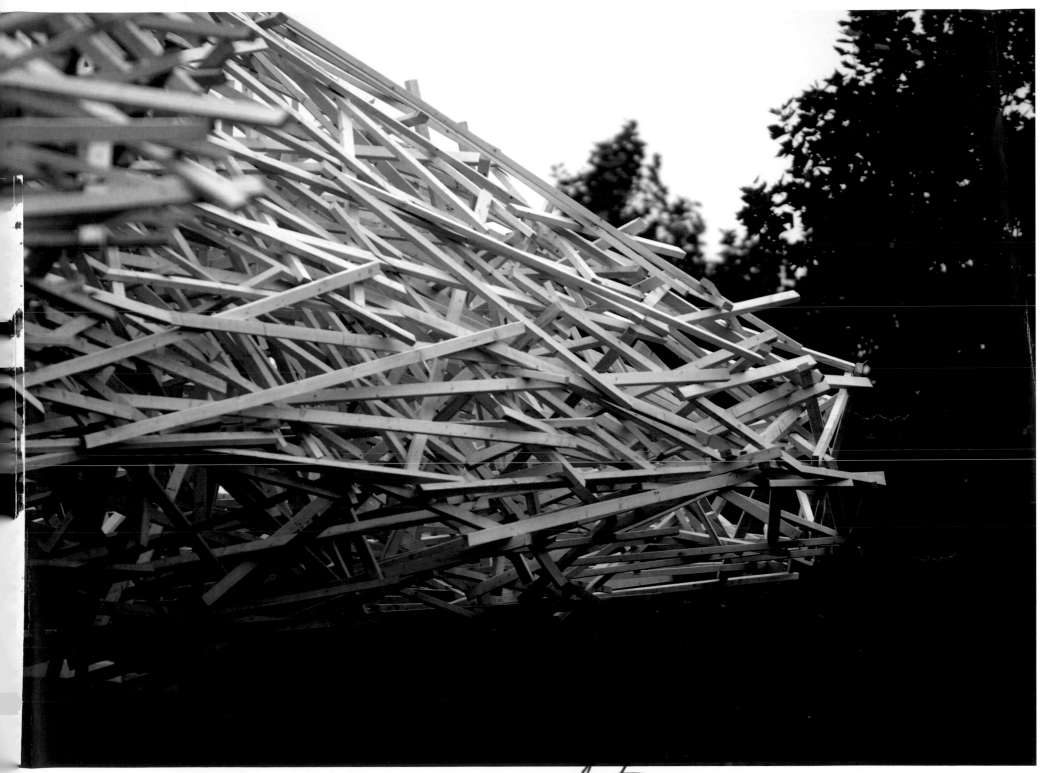

A sculpture

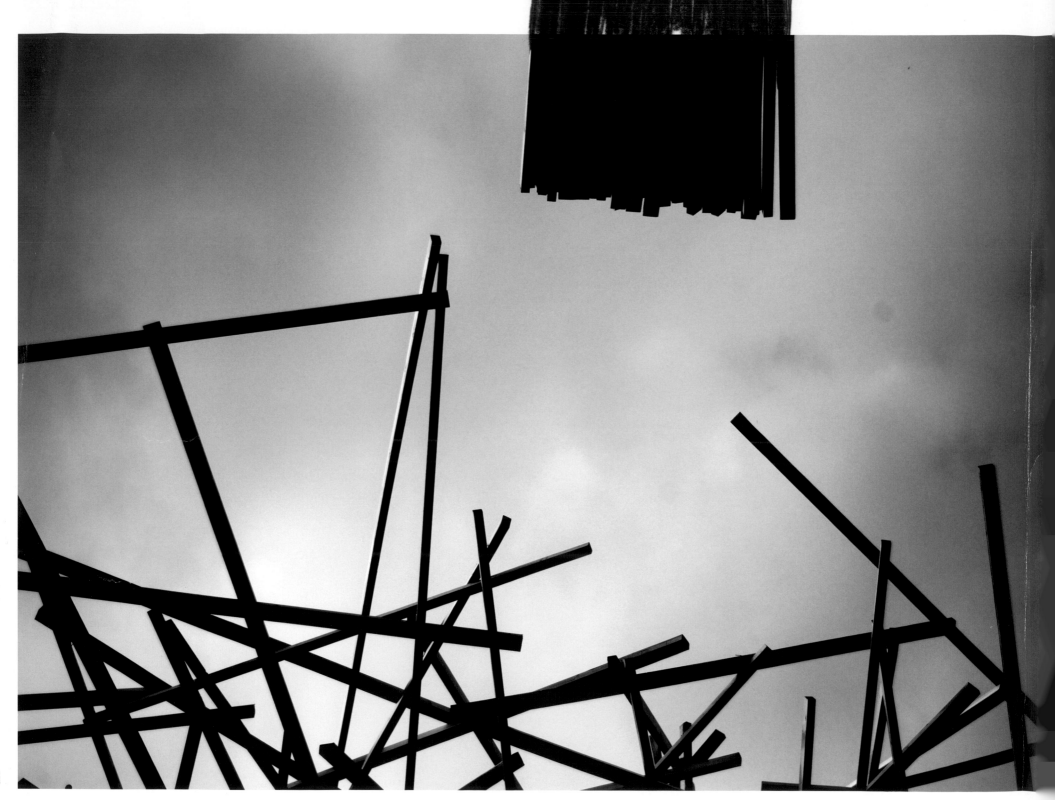

114

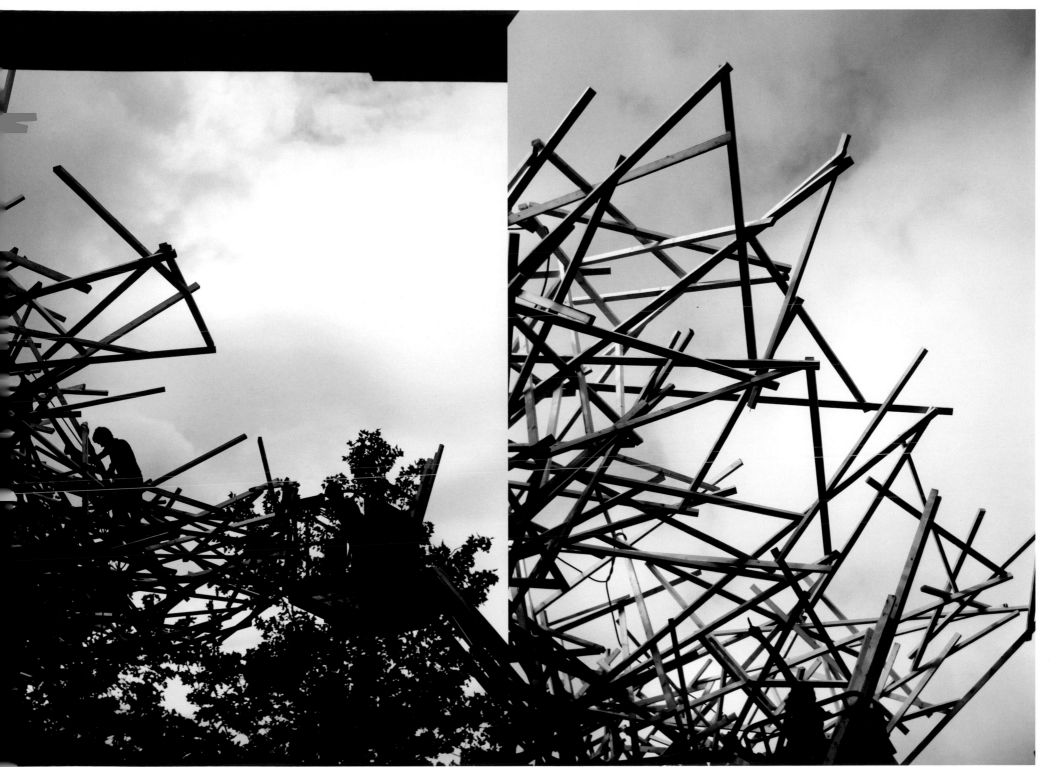

A rupture

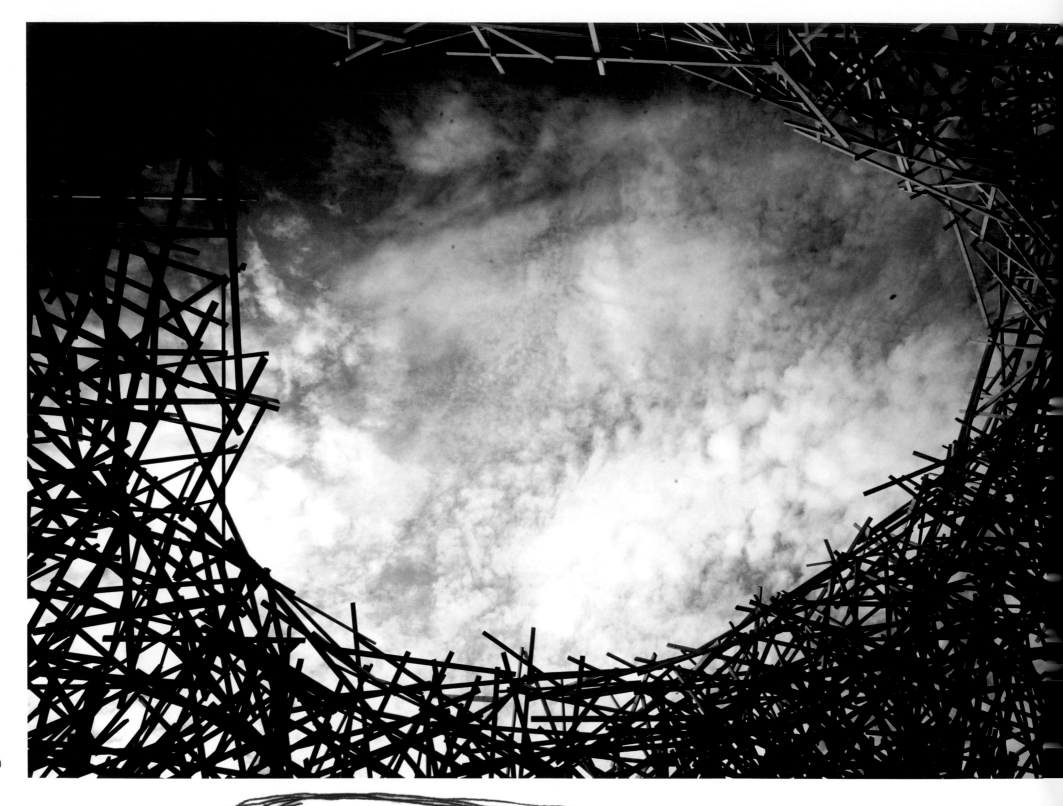

116

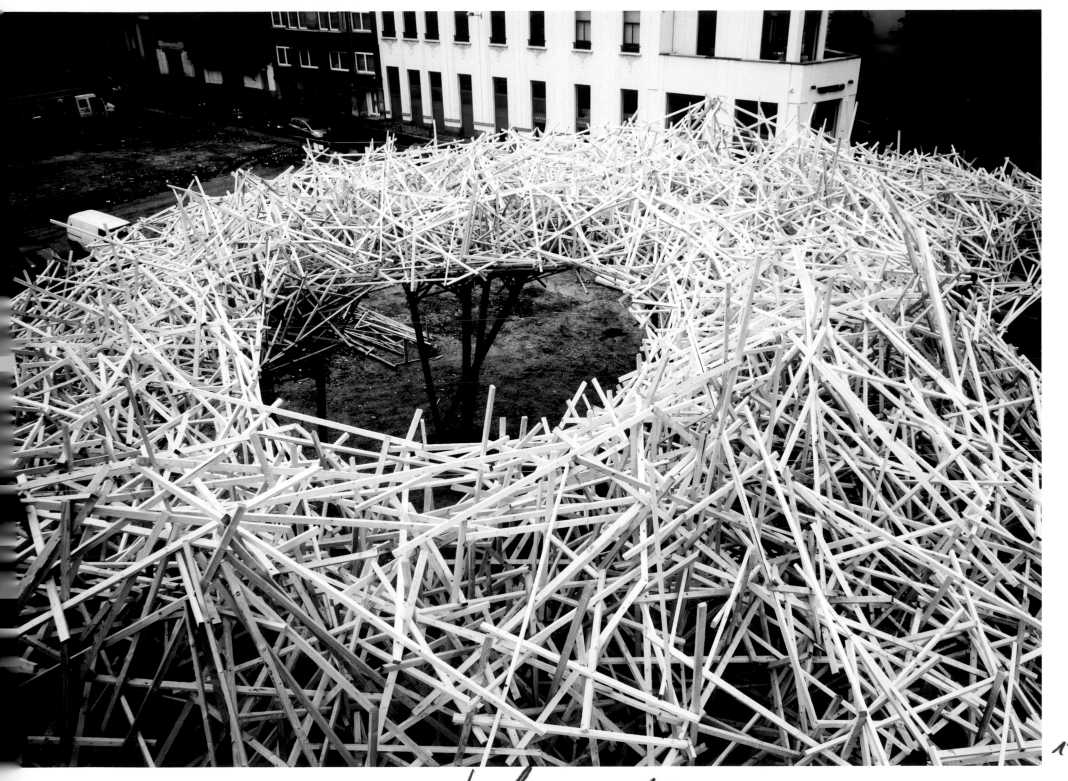

A hole in time

117

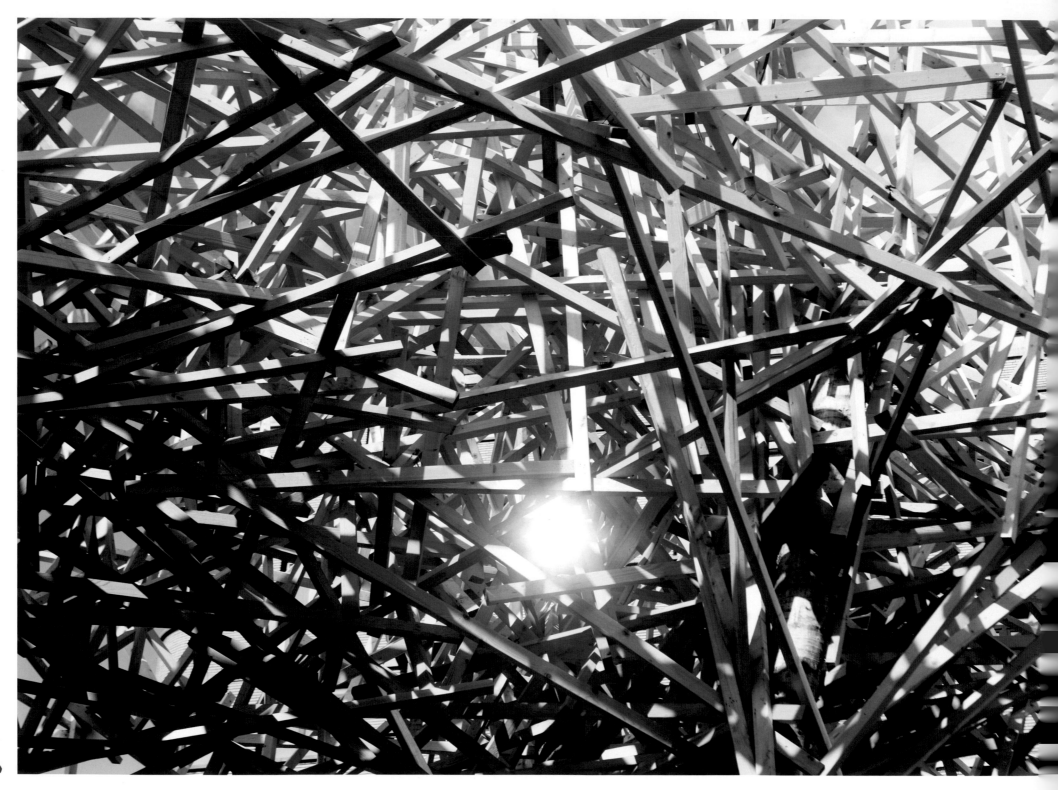

incarting instantaneity

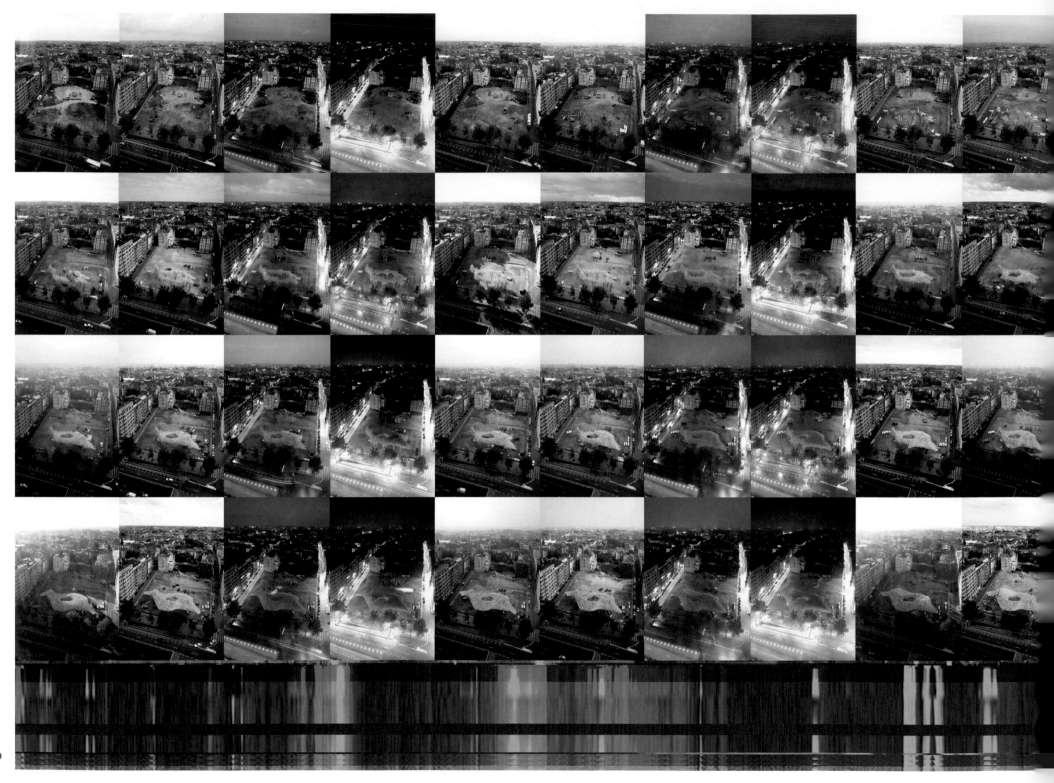

120

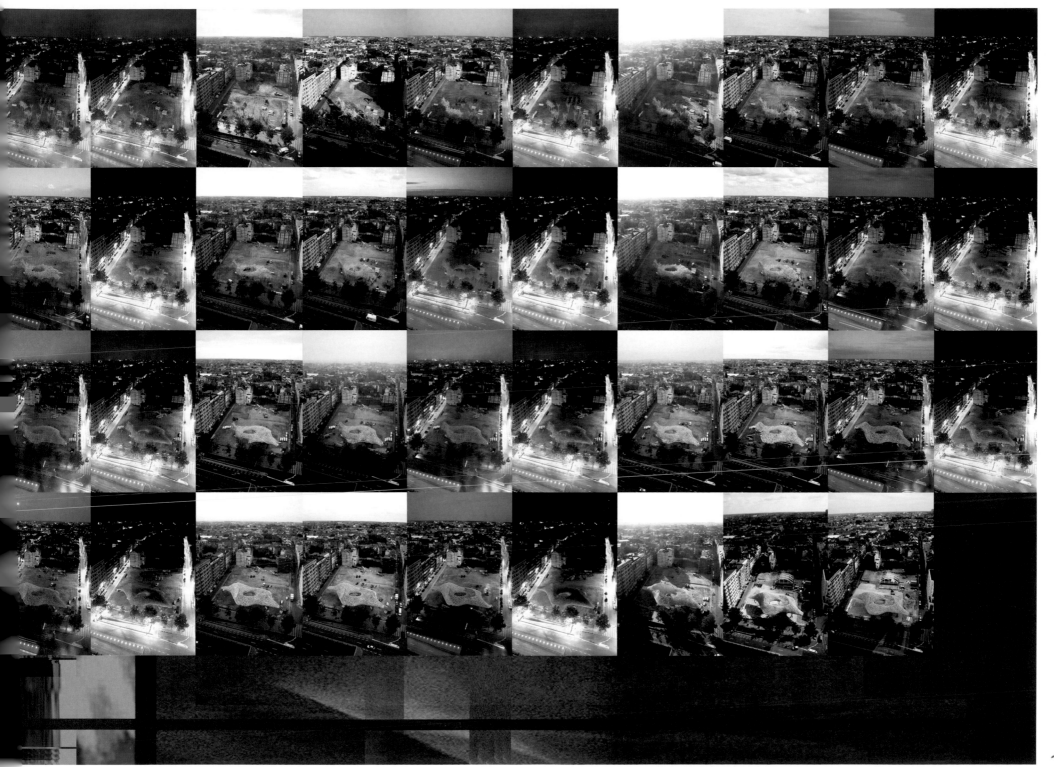

Frozen movement

121

122

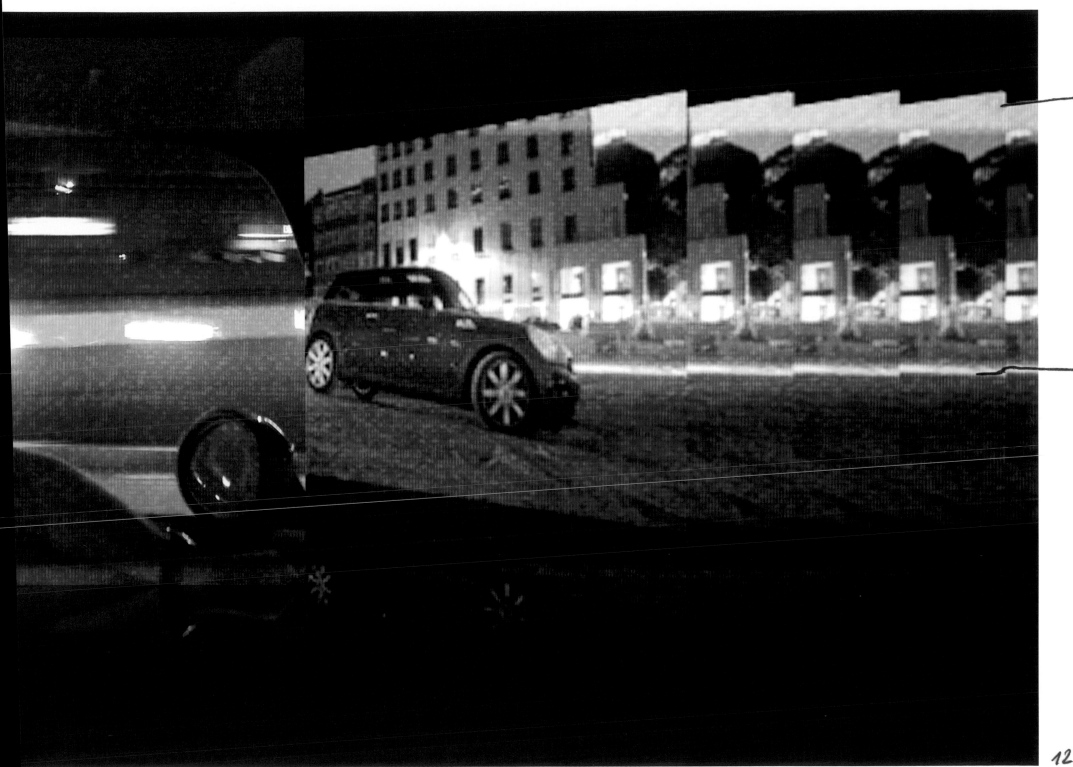

Becoming momentum

123

124

Becoming monument

125

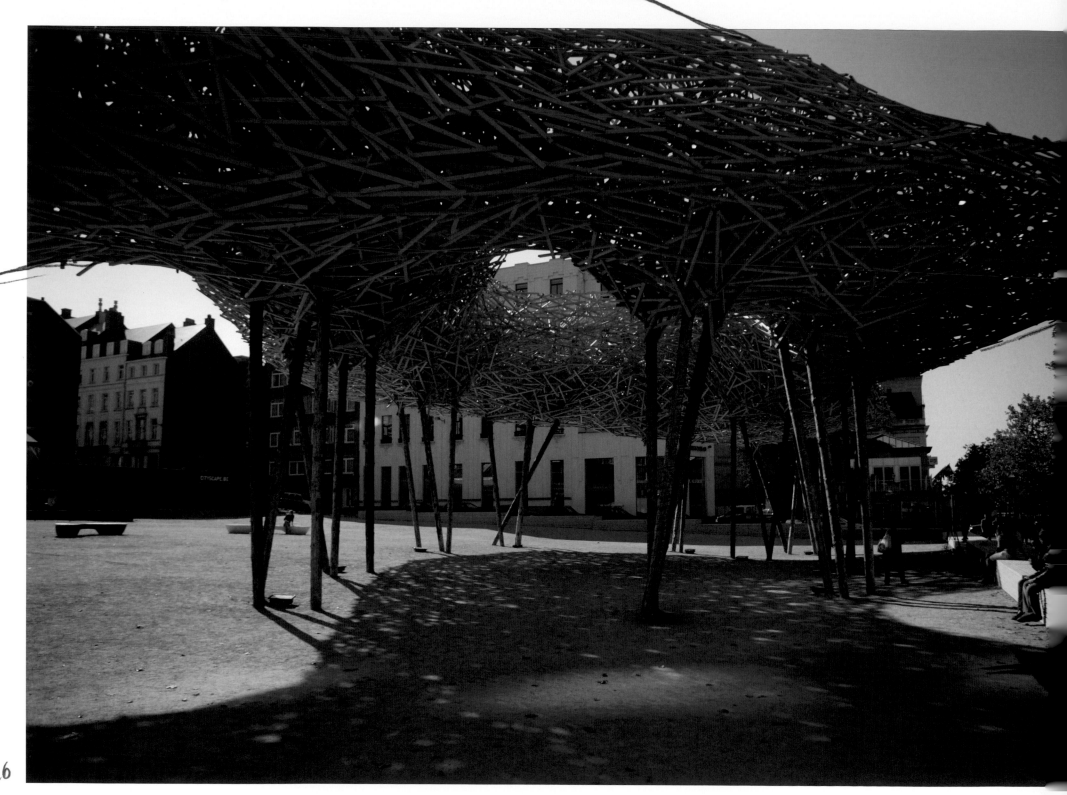

126

"I had a dynamic sculpture in mind that would incarnate the instantaneity of that one moment when you shout FREEZE, and bring everything to a standstill. I wanted Cityscape to be a caesura, a hole in time, an eye in the storm, the motionless centre of all permanent movement, a rupture, where the hectic would cease to exist, offering a pause and shelter, a peaceful spot that people can walk in and out of, meet, be silent, contemplate, dream away and recover in. But on the other hand, I also wanted the sculpture to remain in continuous movement. Even when viewed from a distance, the sun creates an ever-changing play and pattern of light and shadow, giving the whole structure a quavering, hovering and floating appearance.

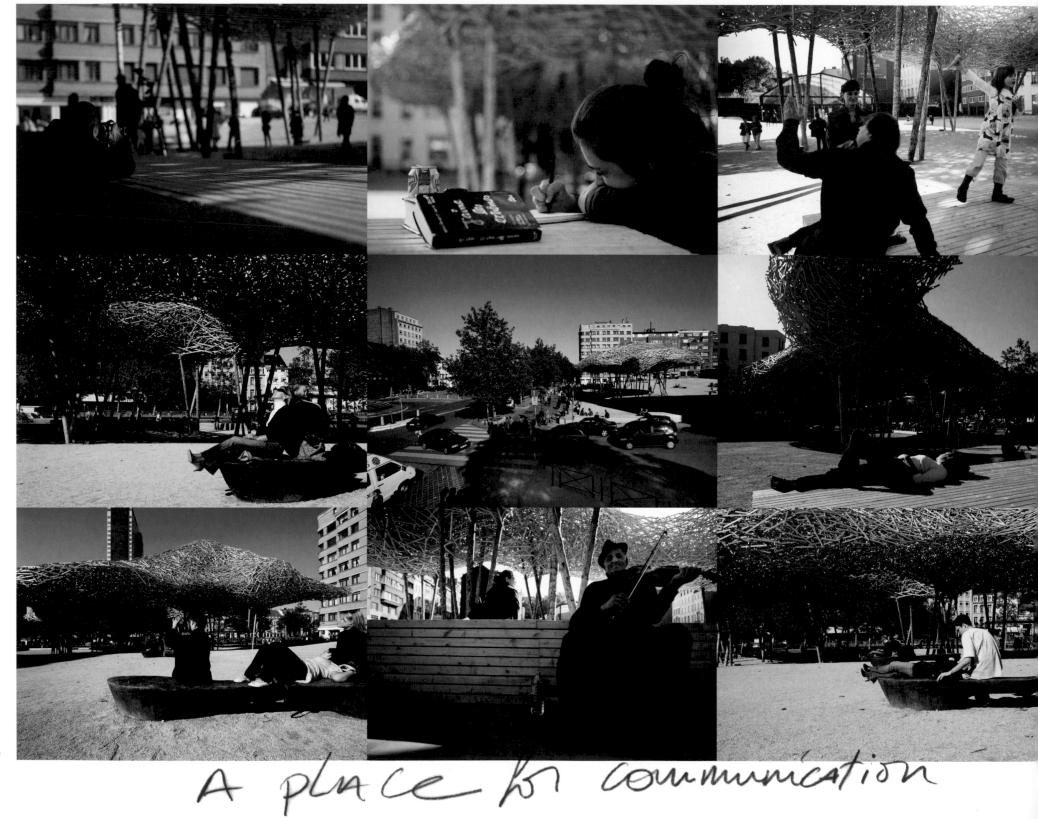

128

A place for communication

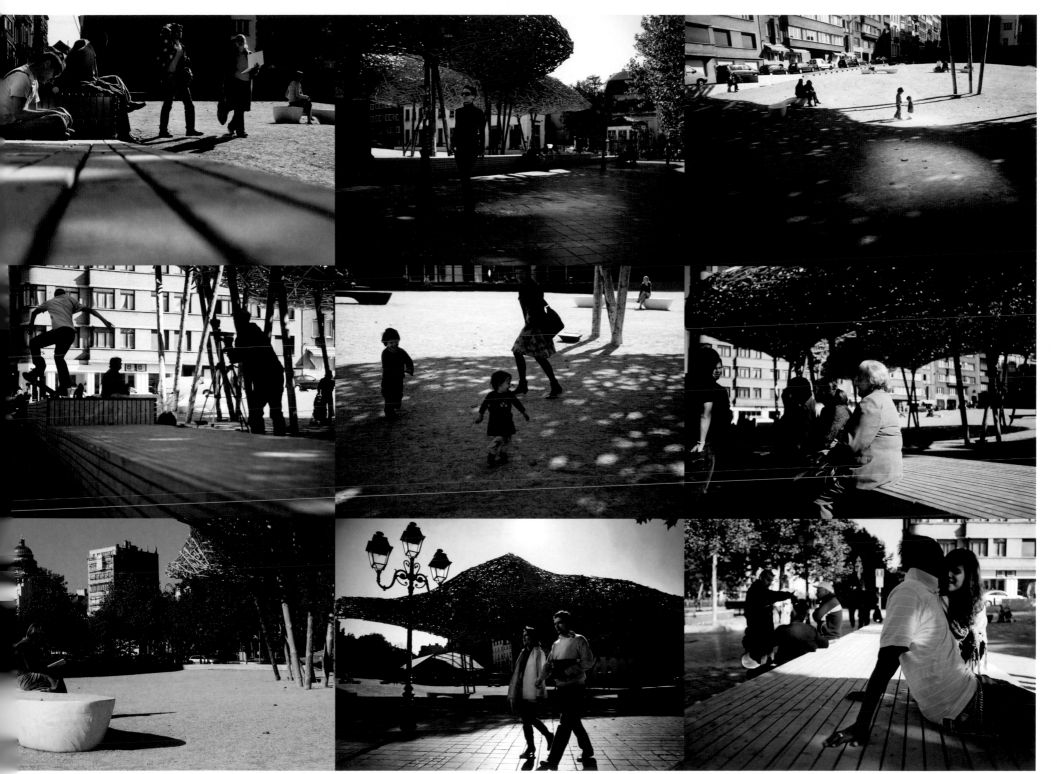

And contemplation

129

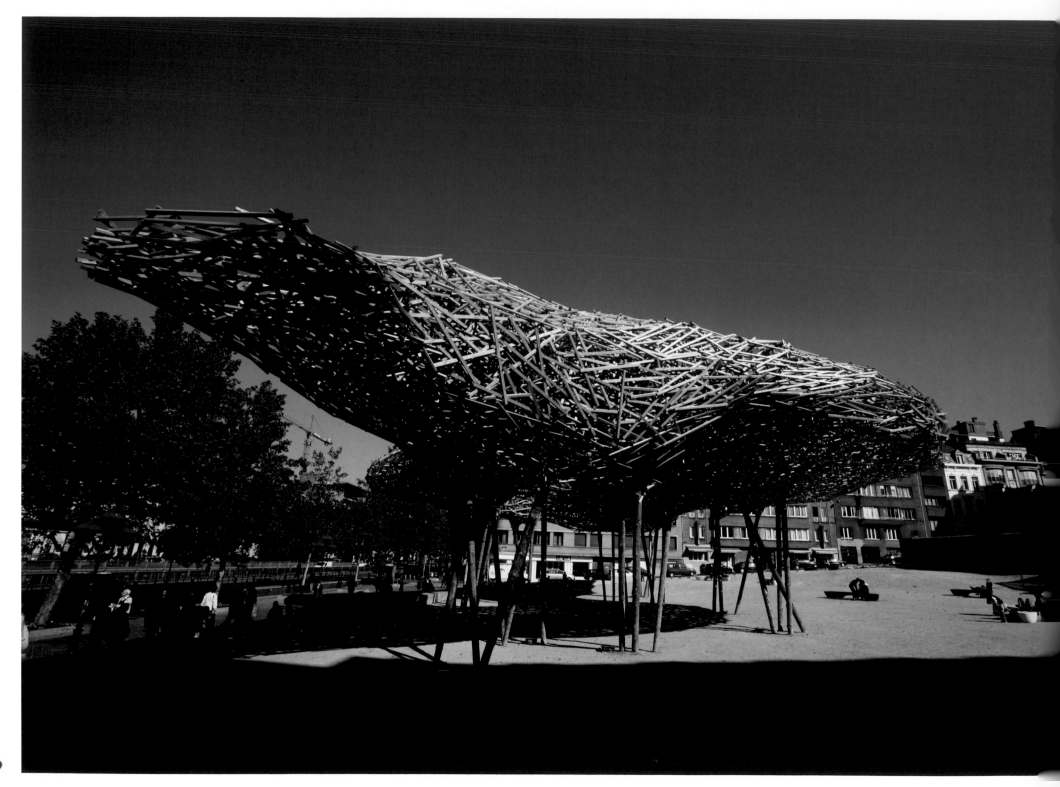

130

131

making the impossible possible

132

> *The final result also has the astounding precision of a startled flock of starlings, that hangs perfectly still in the air, just for one moment, in perfect formation, before dissolving in a seemingly chaotic pattern, but without touching each other, in perfect control. It is a moment in which the DNA of disorder reveals its order. Elements or particles that seemed to be organised at random suddenly synchronise and combine into a revelation of the sublime.*

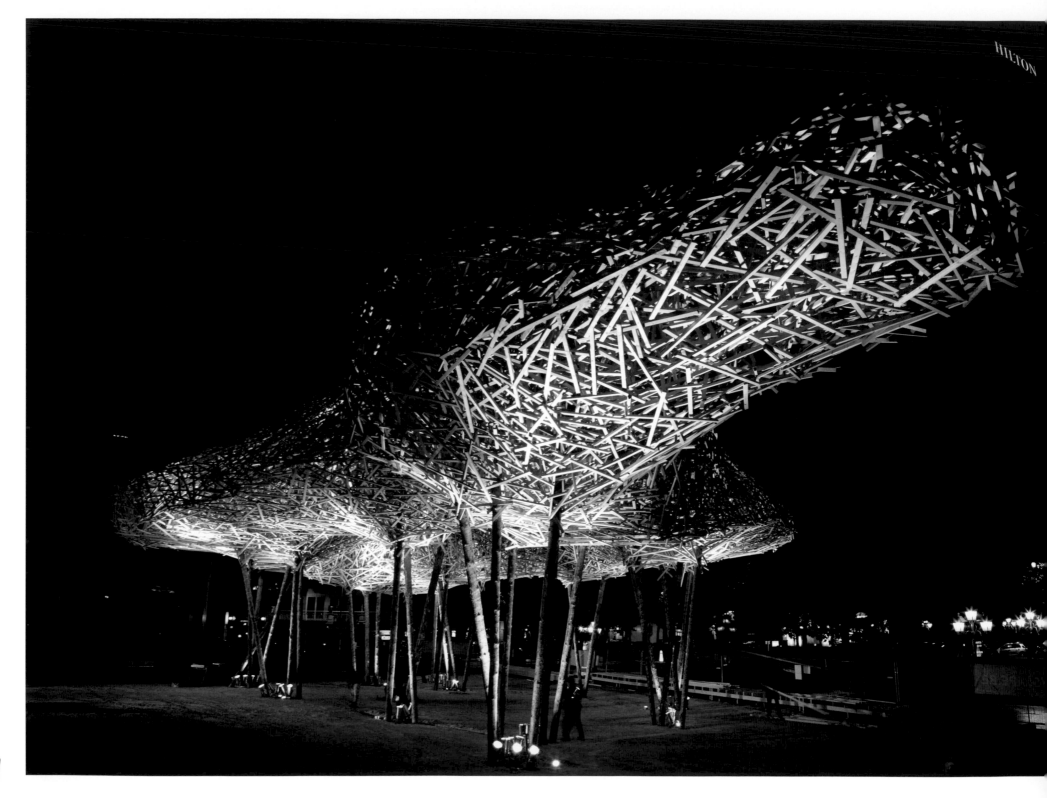

HILTON

134

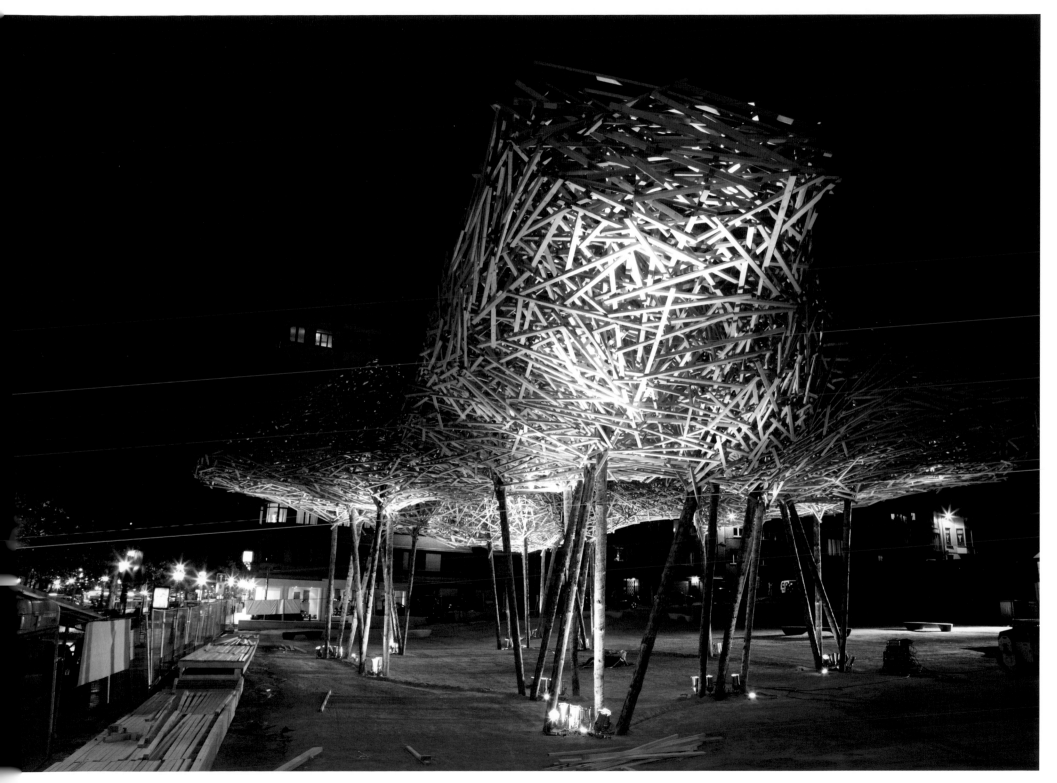

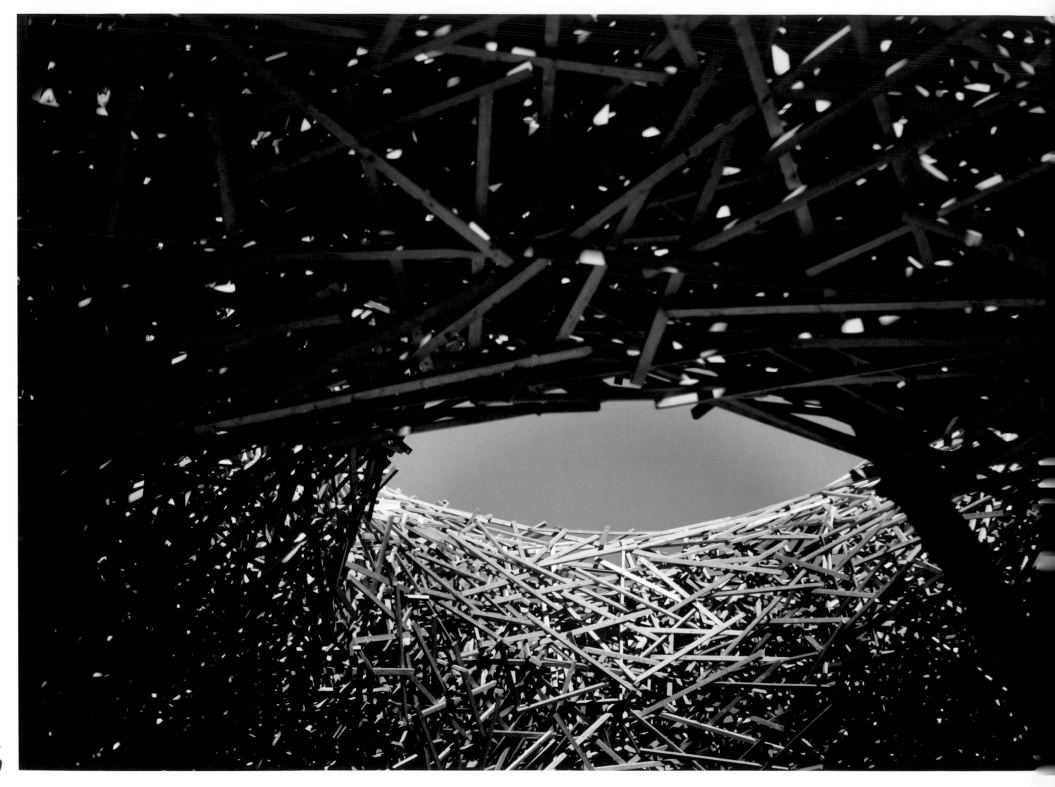

136

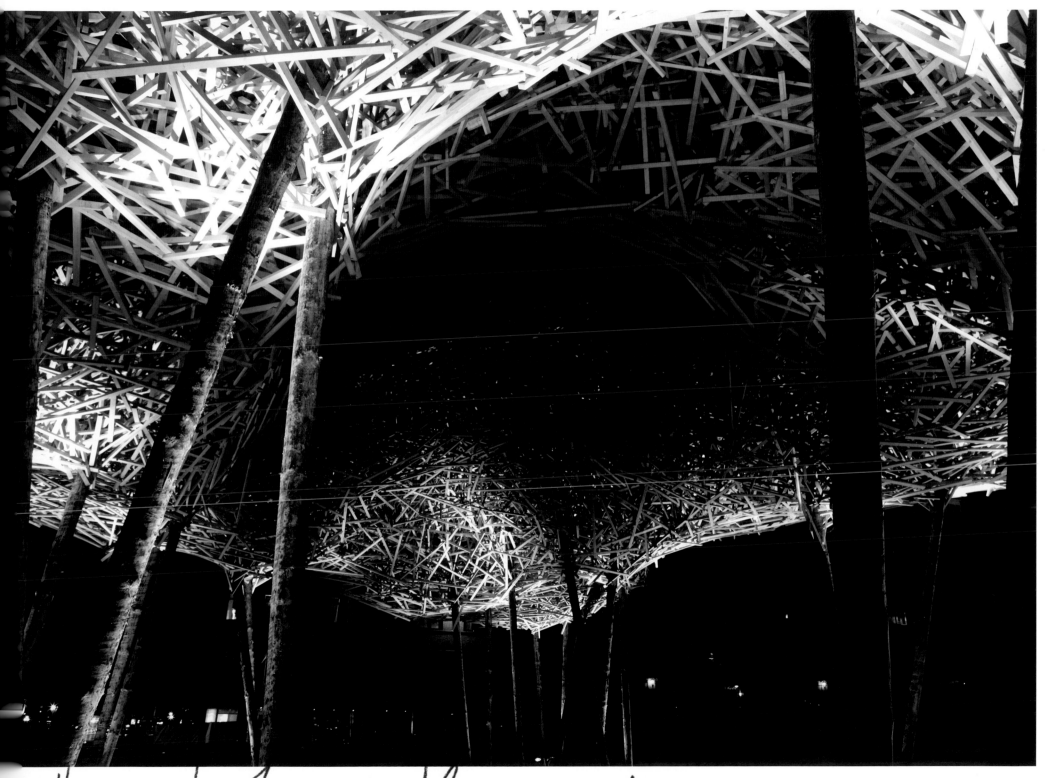

the end of an Endless saga

137

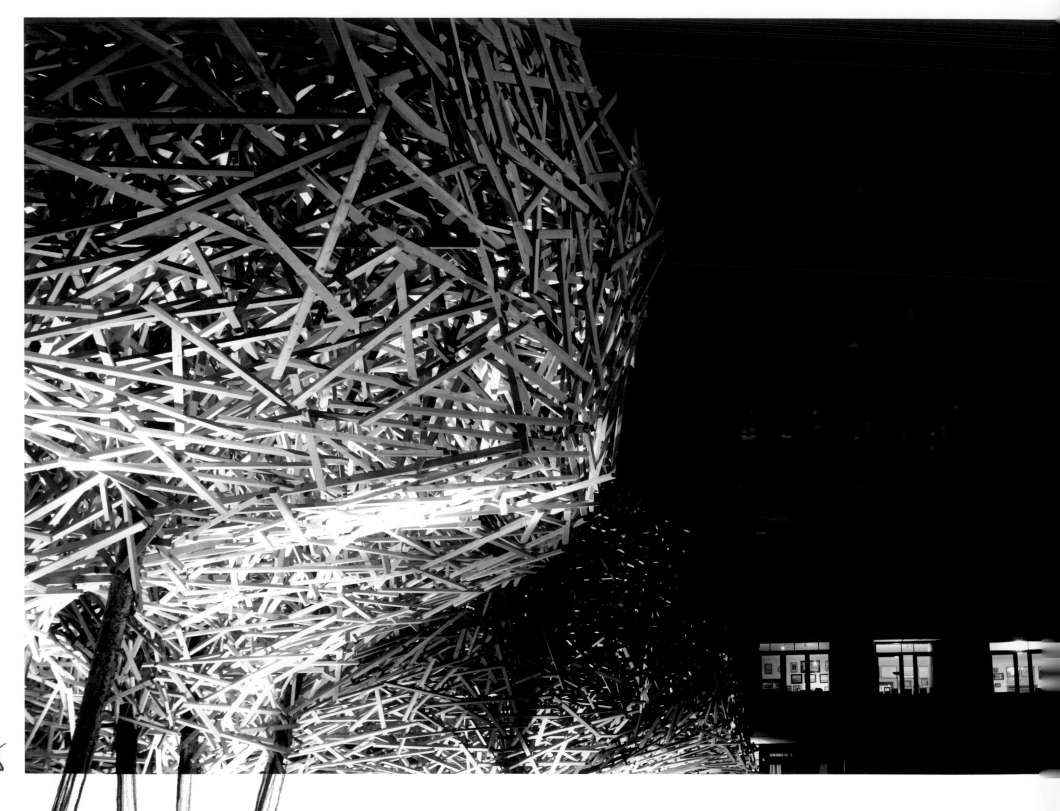

138

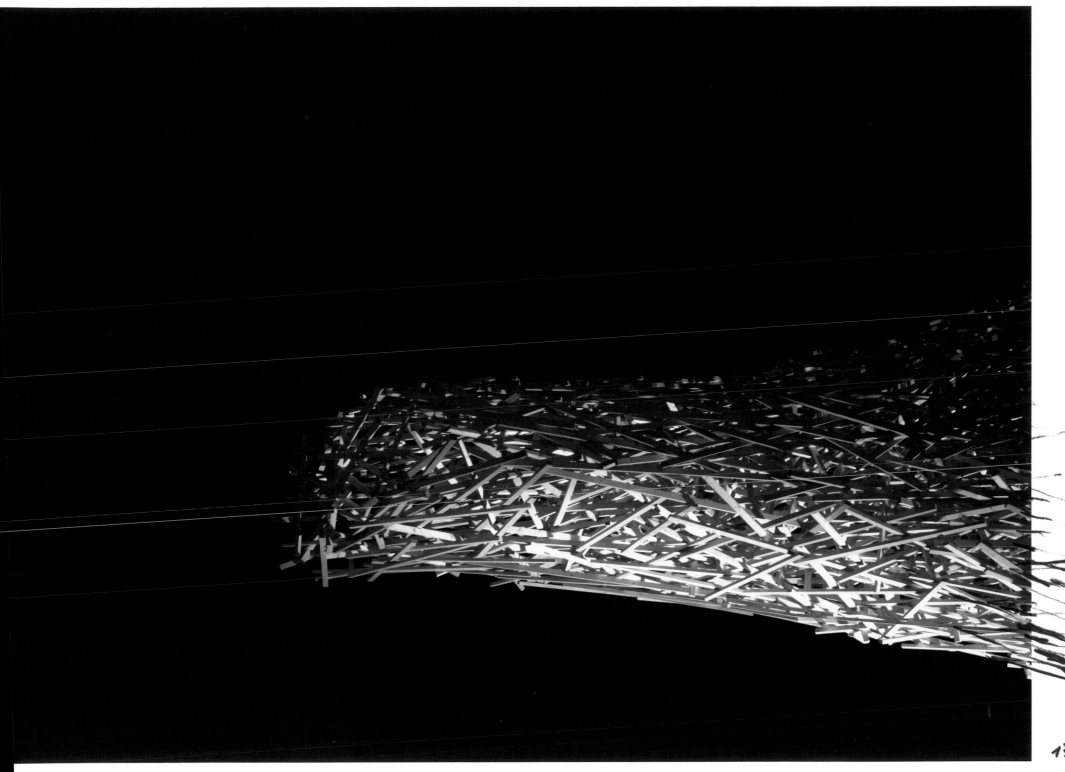

139

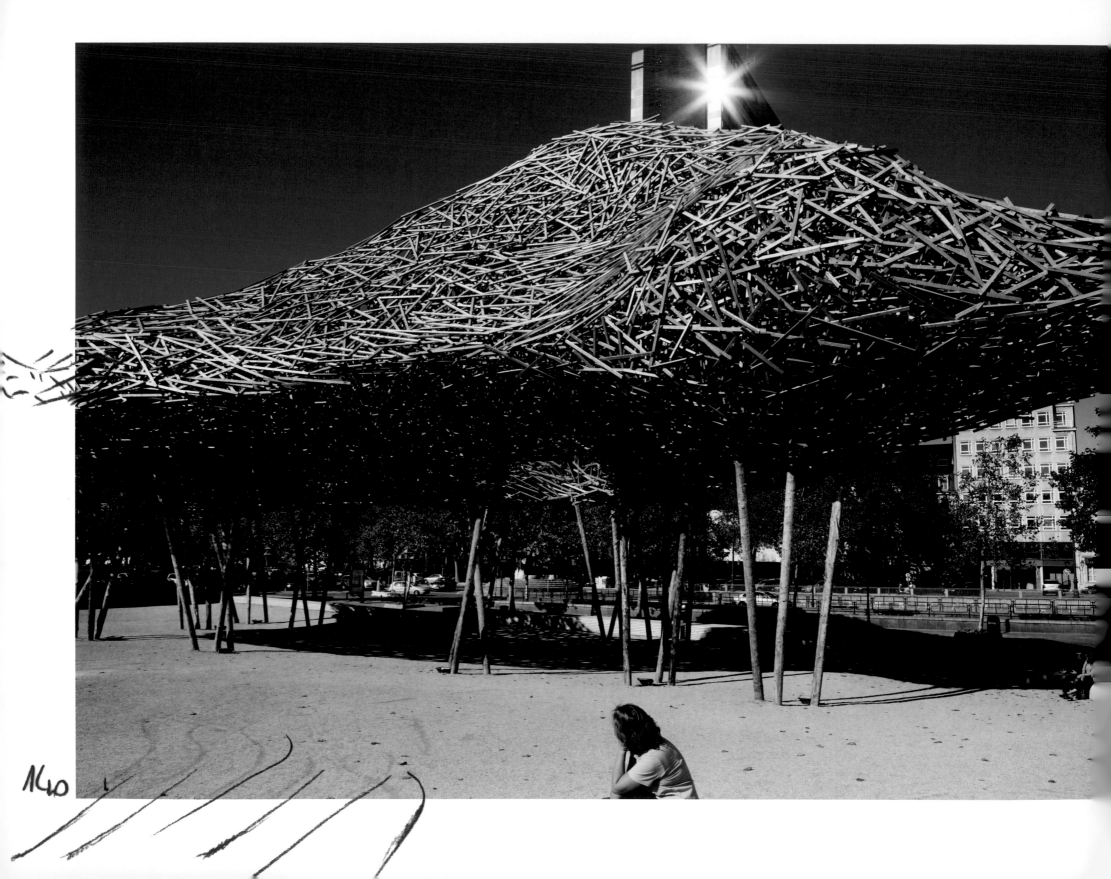

140

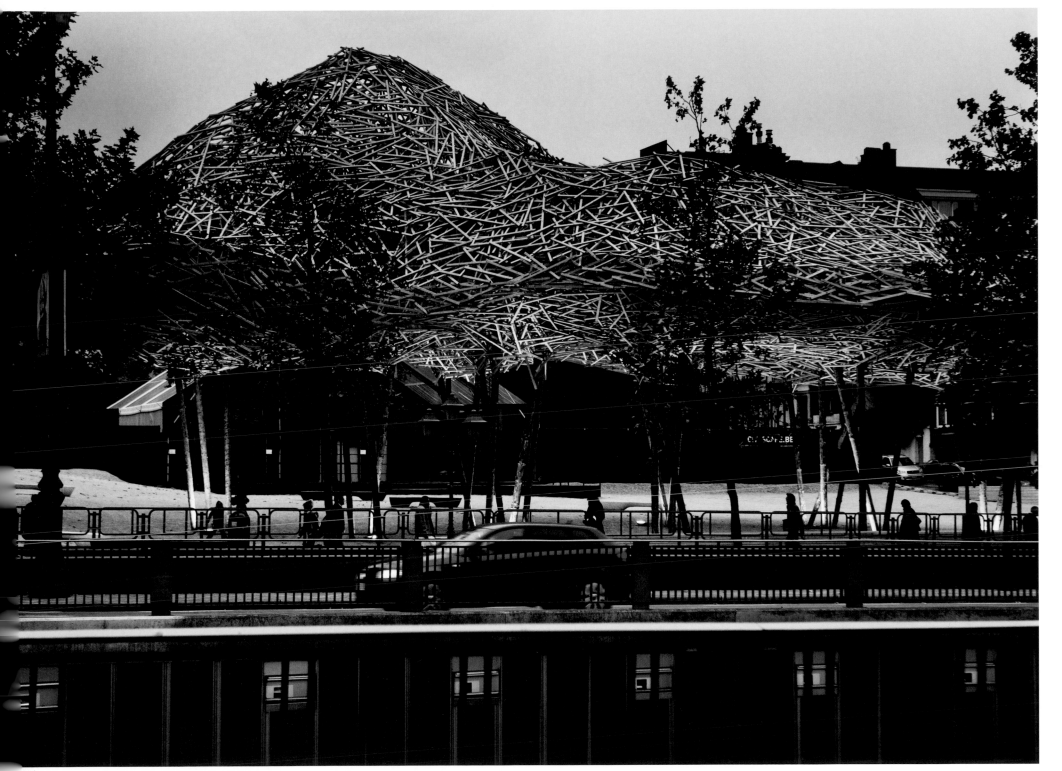

A new Beginning ⟶

010820395

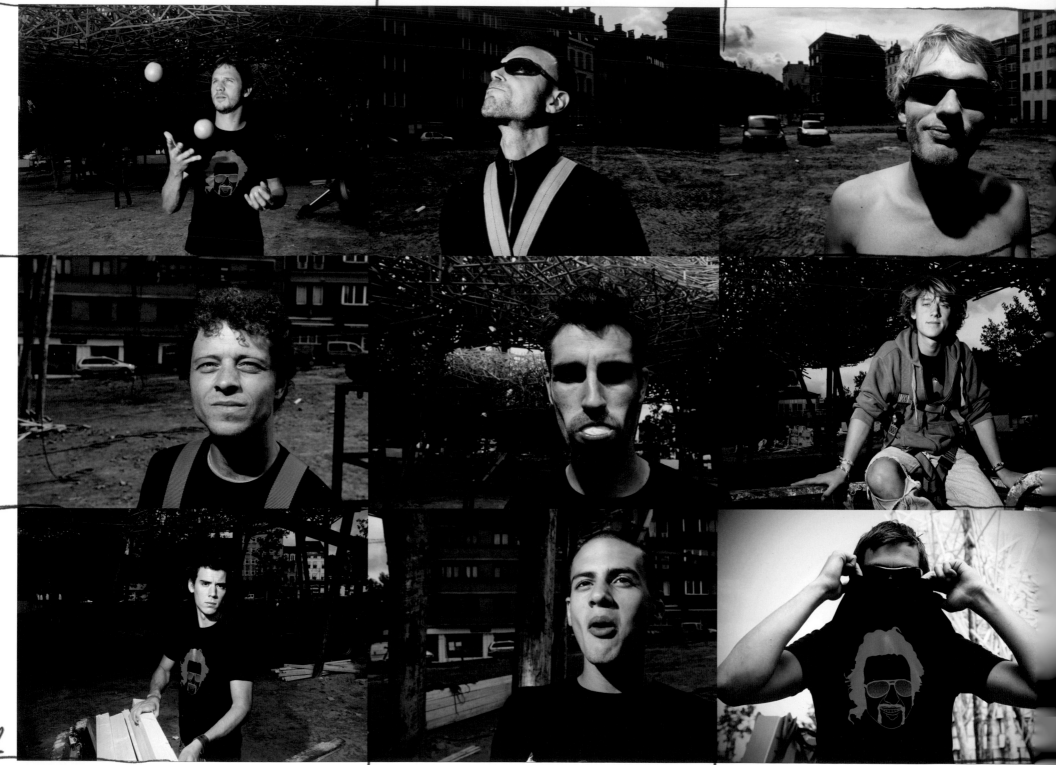

142

CONDUCTING BLINDLY

I'd like to thank the many public and private partners whose synergy made it possible to realise this project in only a few months time, at a speed and rhythm that was totally unknown to Brussels. Above all there's MINI, a major Maecenas to the project. The modesty with which MINI profiled itself during the whole project, despite the heavy investment, may be an example to every other sponsor, wherever. The same goes for ProWinko, the Dutch real estate company that put the wasteland on which the Cityscape was built at our disposal. On the public side, there's first and foremost the Commune of Ixelles and the Brussels Capital Region, specifically the Minister of Economy, Employment and Scientific Research Benoît Cerexhe, who was a Cityscape adept from the very beginning, and soon became 'a blood brother'. There's also Brussels Louise of course, an association steered by François Schwennicke en Bernadette Erpicum, and aimed at reviving the neighborhood between the Porte de Namur and the Porte Louise. On initiative of Patrick Grauwels, without whose enthusiasm and effort the whole thing would never have gotten off the ground, Cityscape became Brussels Louise's very first project.

Last but not least, there's the team that built the Cityscape. With a company that grew to more than 60 employees and workers, I'm fortunate to be able to call upon the services of many experts across a diverse range of disciplines – from architecture and graphic design, to carpentry. To these, I only have to give a very rough outline of a score and then I can conduct and trust them almost blindly, like a symphony orchestra. The result is a perfect symbiosis in which each member, including myself, merges into a larger whole. In that sense, even the making of Cityscape is nothing more than a reflection of the harmonious chaos I'd like to propagate as a model of future society.

ARNE QUINZE

CITYSCAPE THE SCULPTURE

ARTIST

Arne Quinze

AN INITIATIVE OF

Patrick Grauwels

MAECENAS

MINI BELUX, A division of BMW Belgium Luxembourg

Philip Eeckels, Roland Moens, Philippe Dehennin

PARTNERS

BRUSSELS LOUISE VZW/ASBL

François Schwennicke, Philippe Zone, Bernadette Erpicum

BRUSSELS-CAPITAL REGION

Benoît Cerexhe, Minister of Economy, Employment & Scientific Research

COMMUNE OF ELSENE/IXELLES

Nathalie Gilson, Alderman Urban Matters, Johan Van Mullem

PROWINKO

Rick Bakker, Philip Vanperlstein, Stéphane Coël

PRODUCTION & MANAGEMENT

IROAD/CHALLENGER

Patrick Grauwels, Michel Malschaert, Marc Schulman

ENGINEERING

UTIL | Rolf Vansteenwegen

CONSTRUCTION TEAM

STUDIO ARNE QUINZE | QUINZE & MILAN

Fréderic Van Dooren | Project Leader

Alexander Winderickx | Site Foreman

Wannes De Bruyker

Tobias Van der Borght

Tommy Catteeuw

Peter Vincke

Steven Godemont

Lam Moreels

Jan Opdekamp

Christophe Vandenbossche

Nic Geeraert

Glenn Grauwels

Florian Van der Borght

Gaetan Van Wylick

Mathieu Van Wylick

Olivier Tanesy

Rijn Quinze

Arne Quinze

Isabelle Speybrouck | Co-ordination

Tom De Gres | Managing Director

Sharon Neirynck | Press & Communication

BLOG & WEBSITE

Thierry van Dort | Photographer

Lionel Samain | Photographer

Dave Bruel | Film

PieterJan Mattan | Webmaster & Graphic design

Patrick Grauwels | Writer

Max Borka | Writer

Sharon Neirynck | Co-ordination

SUPPLIERS AND PARTNERS OF QUINZE & MILAN

NIJS BVBA | Groundwork & lay out terrain

VANBIEZEN | Wooden piles, Willem Van Delft

BREMS TIMBER | Pinewood, Jaak Beckers

ENW NIJS | Electricity

TERMOTE&VANHALST | Steeplejacks

SENCO CERCLINDUS | Nails

MUSTDECOR | Paint

RAGOEN | Fencing

MAGRAF | Advertising

DUVEL | Our fluid

DE ARK WOODWORKS | Wooden benches

URBASTYLE | Concrete benches

A.D. PERFECT SYSTEMS | Fire proofing

Cityscape has been made fireproof with AquaElix Flame safe

CITYSCAPE IS DEDICATED TO THE MEMORY OF MR FRANÇOIS SCHIEMSKY

CITYSCAPE THE BOOK

Arne Quinze | Concept & Text

Max Borka | Concept & Text

Thierry van Dort, Lionel Samain, Dave Bruel & Patricia Mathieu | Images

Sharon Neirynck & Arne Quinze | Graphic design

Janni Milstrey for dgv | Production management

Patricia Mehnert | Proofreading

SIA Livonia Print, Riga | Printing

Published by Die Gestalten Verlag, Berlin 2008

ISBN: 978-3-89955-203-4

© Die Gestalten Verlag GmbH & Co. KG (dgv), Berlin 2008

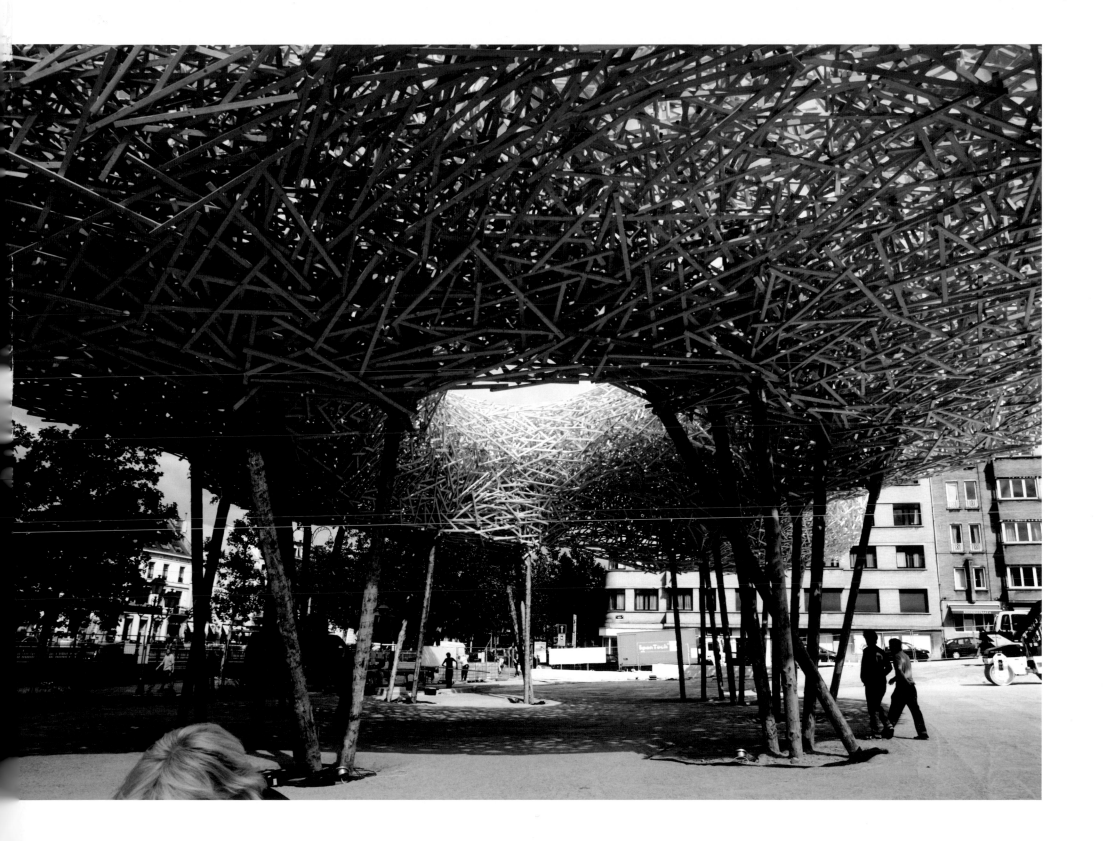

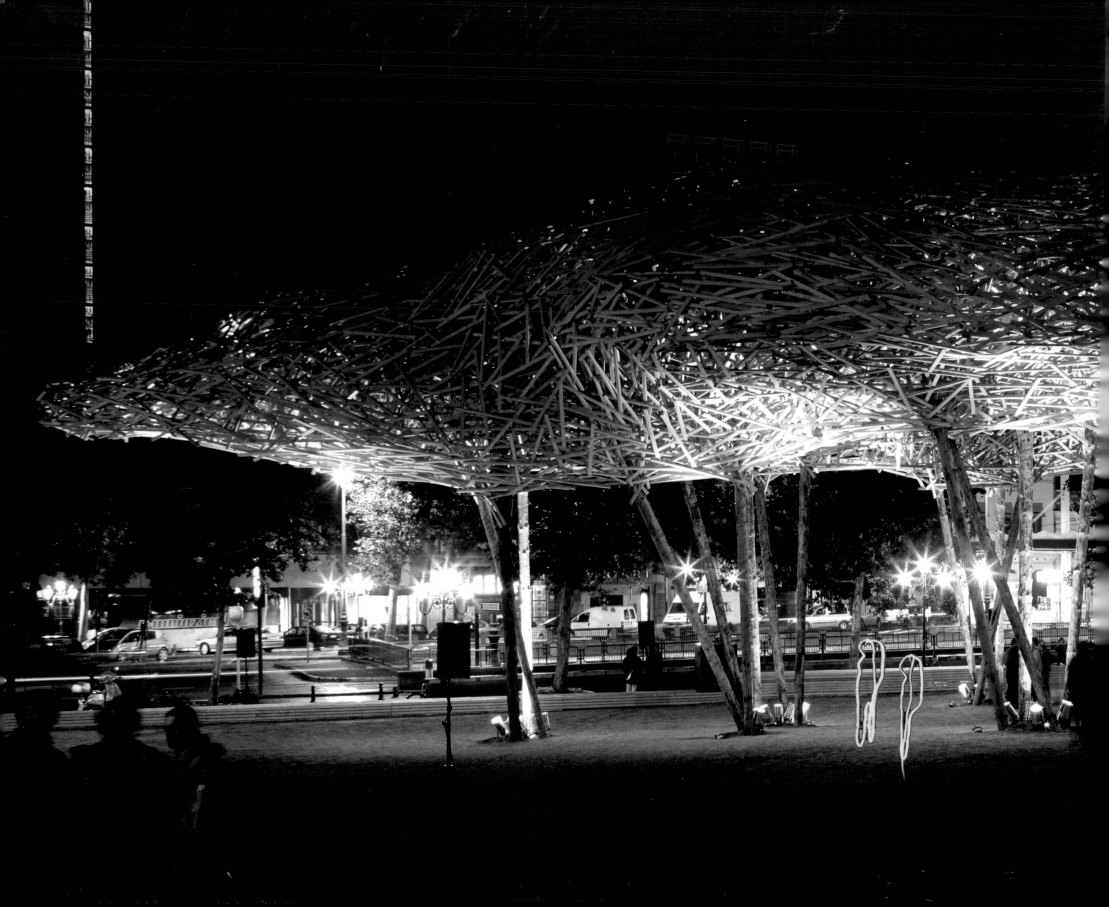